COLLAGE A COMPLETE GUIDE FOR ARTISTS

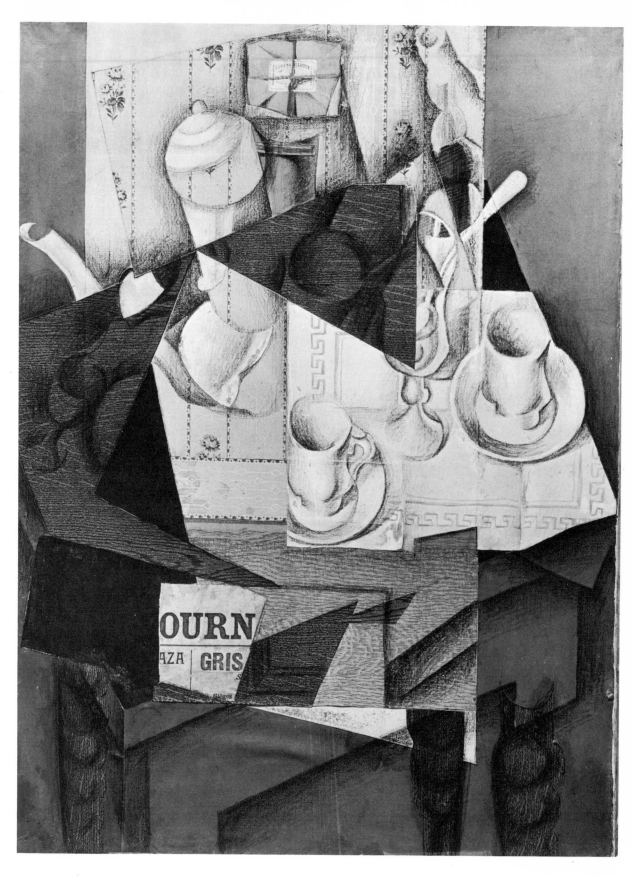

Breakfast by Juan Gris. 37⅞″ x 23¼″. Collection, The Museum of Modern Art, New York. Acquired through the Lillie P. Bliss Bequest. This Cubist still life exploits pasted paper, crayon, and oil on canvas to create a *trompe l'oeil* effect. Note the artist's "signature" in the newspaper clipping on the left.

COLLAGE A COMPLETE GUIDE FOR ARTISTS

By Anne Brigadier

WATSON-GUPTILL PUBLICATIONS / NEW YORK

PITMAN PUBLISHING / LONDON

For Timothy, Jane, and John Howland, and for my husband, Maurice

Copyright © 1970 by Watson-Guptill Publications

First published 1970 in New York by Watson-Guptill Publications,
a division of Billboard Publications, Inc.,
165 West 46 Street, New York, N.Y. 10036

Published in Great Britain 1972 by Sir Isaac Pitman & Sons Ltd.,
39 Parker Street, Kingsway, London WC2B 5PB

Manufactured in the U.S.A.

(U.S.) ISBN 0-8230-0650-6
(U.K.) ISBN 0-273-31802-0

Library of Congress Catalog Card Number: 71-118982

First Printing, 1970
Second Printing, 1972

Edited by Judith A. Levy
Designed by James Craig
Color photography by Susan E. Meyer
Composed in eleven point Baskerville by Atlantic Linotype Co., Inc.
Color offset in Japan by Toppan Printing Co., Inc.
Black and white offset by Halliday Lithograph Corp.
Bound by Halliday Lithograph Corp.

ACKNOWLEDGMENTS

I wish to thank Leonard Bocour of Bocour Artist Colors for his interest in my work and techniques, and for recommending me to Donald Holden, Editorial Director of Watson-Guptill Publications. I would also like to express my gratitude to Mr. Holden for his advice and help with the actual mechanics involved in the proper presentation of a book. To Judith Levy, I am indebted for her able assistance in simplifying my voluminous manuscript.

CONTENTS

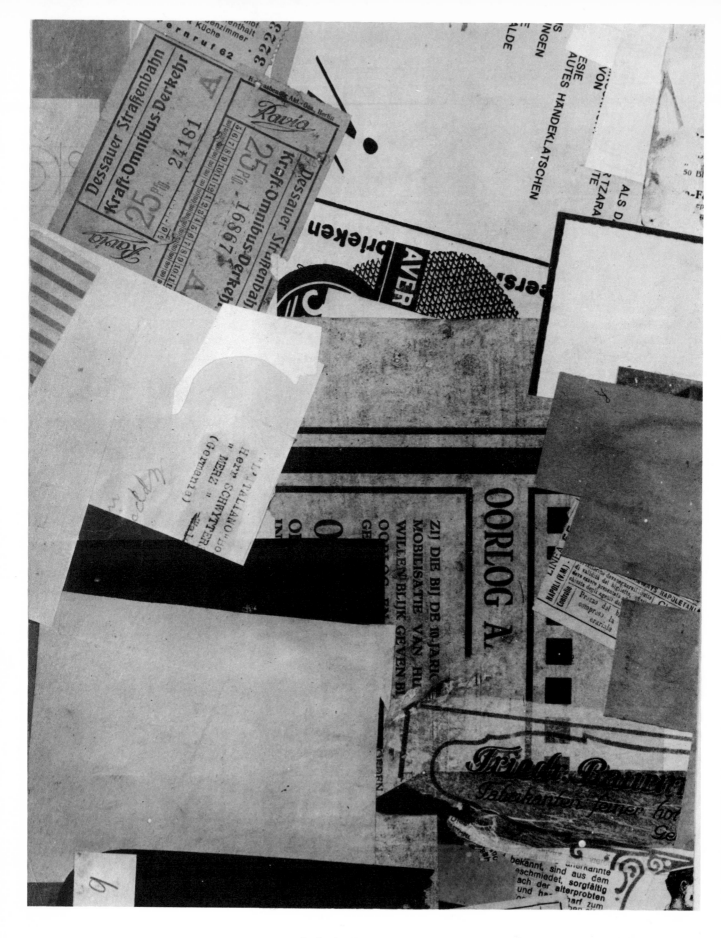

Oorlog by Kurt Schwitters. 12¼" x 9¼". Courtesy, Sidney Janis Gallery, New York. A variety of printed papers—tickets stubs, stationery, newspaper, and used typewriter paper—create a geometric collage enlivened boldly by graphics.

COLLAGES OR PAPIERS COLLÉS are pictures composed by gluing papers and various other objects to a ground, with the intention of transforming even the most commonplace materials into creative works of art. A collage can be a free and spontaneous expression of an impulse, or a controlled portrayal of an idea.

ORIGINS OF COLLAGE

The term *collage* is derived from the French verb *coller*, to stick or to glue. Gluing, or using a pasting technique to make pictures, is nothing new or unique. One can recall early examples of sentimental memorabilia pasted onto a ground and enclosed under glass. Although such paste-ups have always been common, they've generally been more akin to folk art than to fine art—with some exceptions.

In the fifteenth century, the Italian painter Crivelli suspended an actual gold key from a real cord in a painting of a Madonna and child. In 1899, another Italian artist, Mancini, introduced metallic clarinet keys, bits of glass, and pieces of foil into an oil painting. At the beginning of this century, two French painters, Georges Braque and Pablo Picasso, used the paste-up technique as a method of resolving painting problems that arose during this critical period in art. It's the revolutionary use which these French artists made of collage which credits them as its originators.

COLLAGE AND CUBISM

From 1906 to 1914 there was great turmoil in the arts, with widespread revolt against existing traditions and important new art movements beginning to take shape. In 1907 Braque and Picasso began a life-long friendship that was destined to have an immeasurable effect upon the entire art world. Inspired by the painting and writing of Paul Cézanne, and sharing a theory that principles of painting and architecture were related, the two spent many years analyzing and experimenting with Cézanne's theories, hoping to liberate their own paintings. By this time they had become recognized as the leaders of a group experimenting with similar theories.

Cézanne had stated that "paintings should be constructions after nature." The examples of Cézanne's own paintings—plus a narrow interpretation of his phrase "construction after nature" to mean that all forms in nature could be broken down into cones, spheres, cubes, and cylinders—led Braque, Picasso, and their followers to paint geometrically. Subjects were reduced to planes viewed simultaneously from various angles (instead of from a single perspective). By these and other means, the artists hoped to arrive at the inner structure or reality of whatever object they painted. This experimental period, known as Analytic Cubism (1910–1912), produced paintings that resembled geometric constructions in which subject matter became distorted, and finally unrecognizable.

Concerned about the disappearance of subject matter, the artists returned to painting recognizable objects with realistic textures. They imitated wood grains, sand, wallpaper patterns, newsprint, and other textures. Picasso ran a steel graining comb over thick, wet oil paint to

Chapter One

NOTES ON THE HISTORY OF COLLAGE

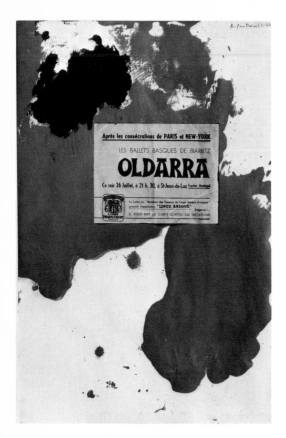

Les Ballets Basques de Biarritz
by Robert Motherwell. 34" x 22". Courtesy,
Marlborough-Gerson Gallery, New York. Oil,
painted over a paper ground, is punctuated
by a ballet *annonce,* used in its entirety.

simulate hair and beards. Braque used a similar comb to imitate the grain of wood.

It was, therefore, natural and logical to progress from imitated to actual material. Thus, Braque and Picasso began to incorporate papers, cloth, tobacco, and theater-ticket stubs into their work. At first, these materials were used only as plastic elements in oil paintings. Collage became both an end in itself and the source from which other forms of collage developed.

Picasso speaks of his first venture into collage: "It was in a small painting, a still life surrounded by an oval frame made of rope, that for the first time I introduced as a tangible element a small piece of oilcloth resembling chair caning."

In 1912, when *papiers collés* first appeared in Paris galleries, bits of cloth, paper, or tobacco labels were introduced. Ink, pencil, and charcoal drawings were added over pasted papers to resolve their compositions. Such materials had never before been considered legitimate artists' materials, and the public—seeing them so used for the first time—was hard put to accept these experimental collages as serious works of art.

Picasso commented on the kind of material an artist might use, pointing out that "there is no such thing as any material being worthy or unworthy as a means of creative expression, as long as the artist infuses it with creative feeling." In accordance with this dictum, Braque, Picasso, and other artists took advantage of the most commonplace odds and ends—glass, buttons, nails, wood, coins, grass, metals, leather, fur, theater-ticket stubs, posters, upholstery fringe all appeared in their collages.

COLLAGE, DADAISM, AND SURREALISM

Historically, collage was the medium through which Analytic Cubism made the transition to Synthetic Cubism. However, its influence did not end there, but gave impetus to the Dada movement. The Dadaists used the medium in a different way and for different reasons than the Cubists. Essentially a revolt not against form, but against traditional ideas in art and society, Dadaism attacked the political *status quo,* particularly the warmakers (the year was 1914). Determined to shock the public, the Dadaists succeeded in this end by making collages out of rubbish and by exhibiting urinals and bottle racks as works of art. Though in 1920 an exhibit in Germany was closed by the police, this show succeeded in breaking down many conventional attitudes, becoming the spearhead for an international movement known as Surrealism, which involved such artists as Max Ernst, Kurt Schwitters, Hans Arp, Marcel Duchamp, and Man Ray.

Though the Dadaists used such two dimensional materials as paper and paint, their collages, for the most part, were three dimensional constructions or assemblages made from manufactured articles called "ready-mades." Wheels, cooking and eating utensils, zippers, wood forms, nails, springs, machinery parts, stuffed animals, even boxing gloves made their way into Dada art.

Max Ernst defined collage as "an exploration of the fortuitous encounter upon a non-suitable plane of two mutually distant realities,"

meaning that when two ordinary, but unrelated entities are juxtaposed in a situation where neither belongs, they can be transformed.

INFLUENCE OF COLLAGE TODAY

Unquestionably, collage has exerted a tremendous influence on contemporary art. Whether philosophical, psychological, or technological factors are responsible for the popular appeal of collage today is a matter for art historians to debate. One fact is certain: the technique of collage has paved the way for present-day interest in three dimensional collages, Static and Kinetic constructions, assemblages, mobiles, junk sculptures, lighted constructions, shaped canvases, cut-out paintings, and a host of other exciting experiments.

COLLAGE AND YOU

Many artists find that collage materials and techniques help free them from the rigidities, limitations, and restrictions imposed by oil and canvas. Indeed, one of the most pleasing and rewarding aspects of working in collage is the ability it seems to give artists to maintain a feeling of spontaneity in their work. Collage also has the advantage of immediacy; it allows the artist the luxury of visualizing final results quickly. There's no need, as in oils or even acrylics, to wait for paint to dry. And, of course, collage encourages the creative transformation of the most ordinary materials. Collage is an excellent medium for the timid beginner to build up his confidence as a preliminary to painting. It's also an exciting medium for the skilled artist, who can manipulate it in a serious and controlled manner. And, finally, collage techniques and materials frequently offer the key to resolving paintings that have been stacked away as failures.

Simple enough for the youngest child or the most inexperienced adult, yet challenging enough for the professional artist, collage is an ideal medium in which to learn the fundamentals of design, color, and composition; to express the wildest flights of imagination; and to experiment with unlimited freedom.

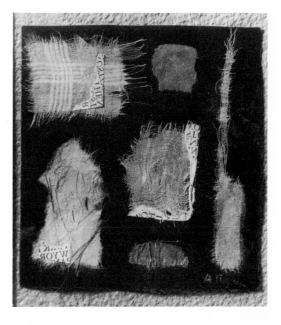

Number 460A by Anne Ryan. 4½" x 4". Courtesy, The Betty Parsons Gallery, New York. Textural variety and interest enliven this tiny collage, which is made entirely from pasted cloth and papers. Notice how the artist has integrated the loose threads into the design, contributing a dynamic quality.

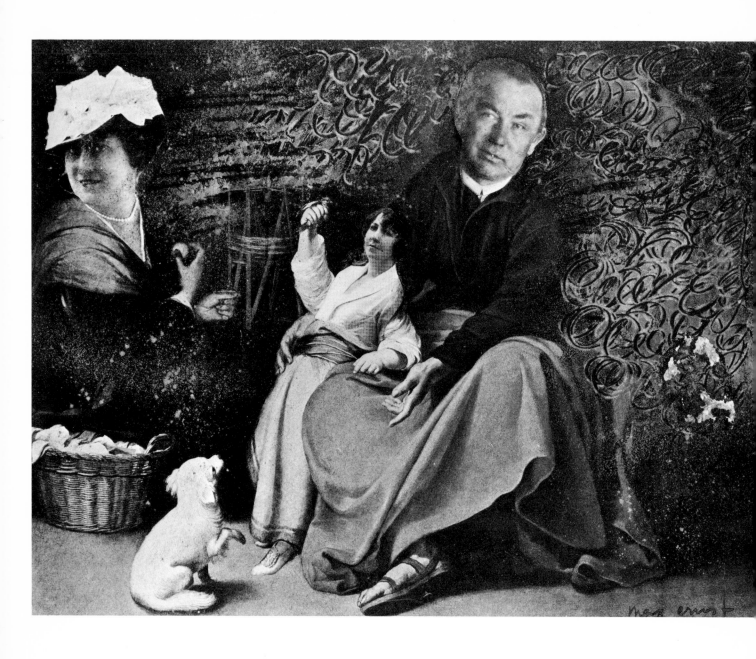

Collage by Max Ernst. 7⅛″ x 9½″. Collection, The Museum of Modern Art, New York. In Surrealism, unrelated but otherwise ordinary objects are unexpectedly placed in the same context. Collage is the perfect medium for this kind of juxtaposition. Here, Ernst has cut out sections of fine art reproductions and magazine illustrations, and has rearranged them in an amusing, but jolting way.

VERY LITTLE EQUIPMENT is required for collage making. There's no need for expensive, precision-built tools, or costly brushes and paints. What you do need is quite simple and modest. In fact, your total expenditure for collage materials is likely to be minor—and may even be negligible—compared with the cost of supplies in other media. If you can think of collage as the least prepossessing of the arts, it somehow follows that the tools and materials it calls for are equally unassuming. However unpretentious, these discards or disposable materials can be transformed into works of art.

HOUSEHOLD ITEMS

Suppose you had an instant urge to make a collage. You could begin right now, without purchasing anything, for the materials and tools you'd need are probably in your home. You'd need a pair of scissors, a single-edged razor, or a knife sharp enough to cut paper; glue or paste; cardboard (from a laundered shirt would do); a magazine; a newspaper; letters, envelopes, and stamps; colored and brown wrapping paper; some old wallpaper or posters. This collection would more than suffice to make innumerable collages.

MORE SOPHISTICATED MATERIALS

However, to enrich your exerience and to lead you into more probing creative activity, you should consider working with a wider variety of materials. Here's a brief list of materials and tools you'll want for more experimental techniques. They'll all be discussed in greater detail in future chapters.

Grounds: A ground is the support to which you paste your collage materials. There are many different kinds—from the commonplace shirtboard, mentioned above, to more durable and rigid grounds of heavy board or wood.

Primers: Some grounds need a coat of priming paint to help papers and other materials grip well, or as elements of color in a composition.

Adhesives: You have a wide choice of adhesives for gluing. One of these, acrylic emulsion, functions as a paste and as preservative that will protect a collage.

Brushes: You'll need some inexpensive brushes to paint the primer on the ground and to apply glue. If you prefer, you can use a roller for priming.

Art papers: These are beautifully colored and textured papers that you can incorporate into any collage. Some are domestic; some are imported; many are available at your local art supply store.

Fabrics: Some artists make their collages exclusively from fabrics; others combine cloth with a variety of materials. Some collagists actually dye the fabrics themselves in order to obtain just the shade they want.

Wax: A wax technique adds depth to a collage and preserves it as well. Beeswax, purchased from art supply shops, is used for this process.

Chapter Two

INTRODUCING MATERIALS AND TOOLS

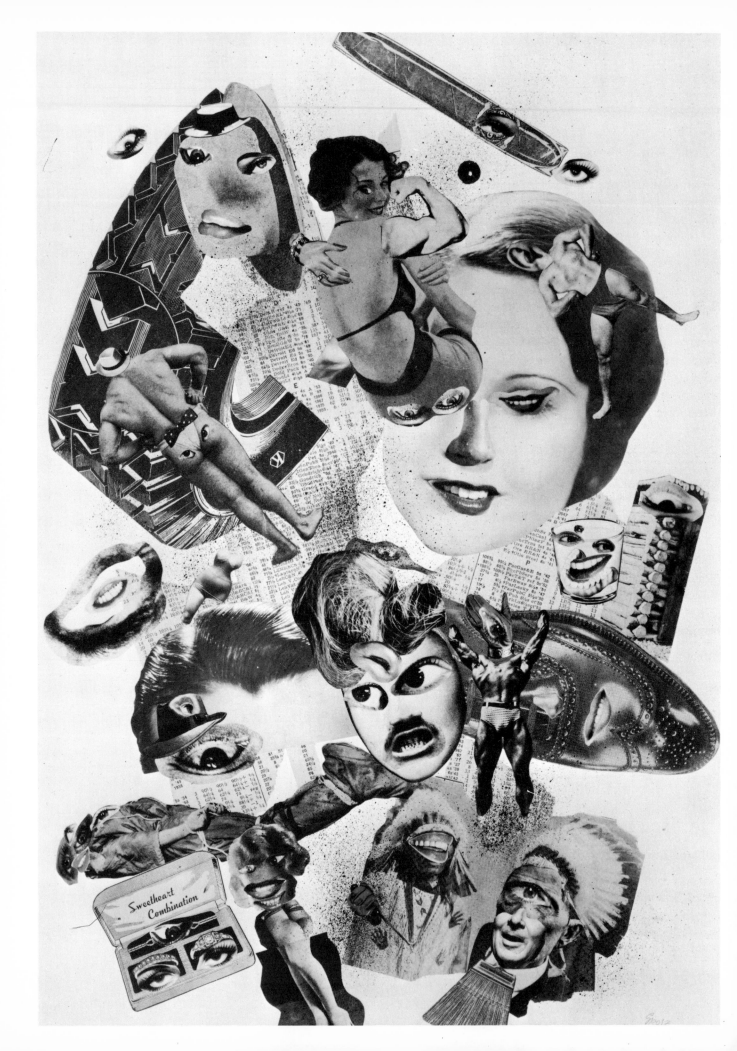

Irons: To melt and apply the wax, you need a kitchen, travel, or burnishing iron.

Enamel or aluminum pans: If you want to make endpaper prints—the decorative "marble" papers used in old books—to use in collage, you'll need an ordinary pan, 12″ x 18″ or larger.

Oil colors: A few tubes of oil colors are necessary for printmaking.

Pins or tape: When organizing a collage, some students like to pin or tape down their materials to prevent them from shifting.

Kitchen wax paper: Wax paper will prevent a wet collage from sticking to a weight which is placed over it to speed up the drying process.

Man with a Hat by Pablo Picasso. (Above) 24½″ x 18⅝″. Collection, The Museum of Modern Art, New York. In this Cubist collage, the artist has combined papers—including newspaper—with charcoal line and black ink.

Keep Smiling by George Grosz. (Left) 28″ x 20″. Courtesy, Tirca Karlis Gallery, Provincetown, Massachusetts. The fantastic distortions of this Surrealist collage are composed from magazine illustrations, stock market reports, and lightly sprayed paint.

Clarinet by Georges Braque. 37½″ x 47⅜″. Private collection. Pasted papers, newsprint, charcoal, chalk, and oil on canvas. Note how the artist has used the *faux bois* technique to suggest the grain of wood.

TRADITIONALLY, the term *found object* has meant materials or objects used by artists just as they're found in nature. Minerals like rocks, pebbles, and stones; flora and fauna such as seeds, cones, dried flowers, grasses, driftwood; organic remains like fish vertebrae, feathers, shells, coral, and sand are all found objects. They hold interest for the artist because time, tides, wind, and sun have fragmented, textured, ground, or bleached them in fascinating ways that cannot be duplicated by man.

Over the years, the meaning of *found object* has come to include manmade objects such as paper products, wood, metal, machinery parts, nails, nuts, bolts, and other such materials which artists glue, weld, cement, or embed into a ground.

WHAT TO LOOK FOR AND WHERE

Be on the alert at all times, in all places, and your collection of found objects is guaranteed to grow. The pavement of any city street will yield an enormous number of small metal objects to the discerning eye. Examine the walls of buildings that are being torn down and you may find faded and torn wallpapers piled, layer upon layer, on top of each other. Be on the alert for old billboards with peeling posters. A colleague once removed a piece of paper from such a billboard. In tearing it from the wall, part of the underlying brick color came off with it. As a result, the back of the poster turned out to be more interesting than the front which had originally caught his eye. Visit junkyards, dumps, and machinery shops for unwanted parts. In an old, junked car, I once discovered an advertisement whose embossed lettering had molded and weathered into textures you could never duplicate.

A walk along the shore at low tide can bring you untold treasures: shells and fish vertebrae worn into fascinating shapes; bits of colored glass and crockery that have been subtly colored and shaped by the forces of nature; rusted metals, cardboard signs, roof tiles, papers, linoleum—an endless and unpredictable array of discarded materials become attractive collage possibilities when rescued from the sea and dried out.

What you look for, of course, depends on what sort of a collage you have in mind. Technical considerations may help you define the kind of found objects you want. For example, if you decide on a simple gluing technique, you'll confine yourself to two dimensional collage. In such a case, your materials are likely to be magazine papers combined with other papers or other flat materials. If these flat objects happen to be made of wood or metal, you'll have to use an adhesive which embeds the object, such as a molding paste or epoxy (see Chapter Six on adhesives). If you want to incorporate bits of machinery, be prepared to weld them—and to find or set up a workshop equipped for welding. This technique brings you into construction, not collage *per se*.

ASSEMBLING YOUR MATERIALS

Gather whatever number and variety of materials you predict you'll use in a given collage (if you're a beginner, you'd be wise to limit your

Chapter Three

FOUND OBJECTS

Allegro by Samuel M. Adler. 34¾″ x 28¾″. Collection of the artist. In this construction, a wood support is used to nail, screw, and glue strips of wood onto its surface. The wood strips have been painted in grays and earth colors with oil and damar varnish to unify the composition.

materials until you become somewhat more experienced). Then divide your materials into groups according to the adhesive they call for. If you're working exclusively with two dimensional materials like paper, string, and fabric—all of which can be glued with the same adhesive —you'll have only one group. On the other hand, a more complicated array of two and three dimensional objects may call for several adhesives, and therefore several groupings. Chapter Six on adhesives discusses these considerations fully.

LISTS OF FOUND OBJECTS

Here are some lists of typical objects to look for and collect.

Paper materials
Billboard papers
Blotting paper
Butcher paper
Cardboard
Cards
Catalogues
Charcoal paper
Cigarette packs
Cleansing tissues
Construction paper
Corrugated paper
Diary papers
End papers
Graphic arts paper
Graph paper
Labels
Letters
Magazines
Mimeograph paper
Music sheets
Newspaper
Notebook paper
Posters
Prints and fine arts reproductions
Rice paper
Road maps
Roofing paper
Sales slips
Sandpaper
Stamps
Stubs
Tags
Tar paper
Theater tickets
Tissue paper
Typing paper
Wallpaper
Watercolor paper
Wrapping paper

Fabric materials
Brocades
Burlap
Cheesecloth
Cotton cloth
Edgings
Fishnet
Horsehair
Lace
Linen cloth
Monk's cloth
Needlepoint
Oilcloth
Ribbons
Rope
Silks
String
Tapes
Thread
Upholstery fringe
Velvet

Minerals and metals
Asbestos
Bolts
Bottle caps
Brass objects
Buttons
Clock parts
Coins
Crushed stone
Marble
Metal rings
Nails
Nuts
Pebbles
Safety pins
Sand
Sardine can keys
Scissors

Screws
Sheet aluminum
Small machine parts
Steel springs
Steel wool
Tableware
Tacks
Wheels
Wire
Wire mesh

Organic materials
Animal teeth
Bark
Coffee grounds
Cones
Coral
Cork
Dried flowers
Feathers
Fish vertebrae
Grass
Hair
Herbs
Instant coffee
Leather
Leaves
Seaweed
Seed pods
Snakeskin

Sponges
Starfish
Wood

Miscellaneous manufactured articles
Cement
Charcoal
Crayons
Crushed glass
Dry pigments
Film strips
Inks
Mirrors
Oils
Pencil sharpenings
Plaster
Sheet glass
Spackle

Plastics
Cellophane
Celotex papers and wrap
Celotex sponges
Crushed plastic glass
Nylon and Dacron fabrics
Nylon string, rope, thread
Plastic beads
Plastic glass (colored and clear)
Plastic mesh screen
Plexiglas
Simulated wood products (plastic wood)

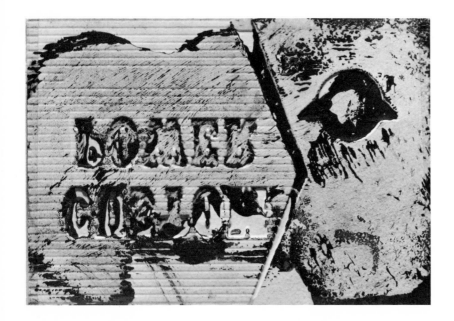

The reverse side of an advertisement that was found in a junked car offers character, pattern, and texture—desirable qualities in any collage material.

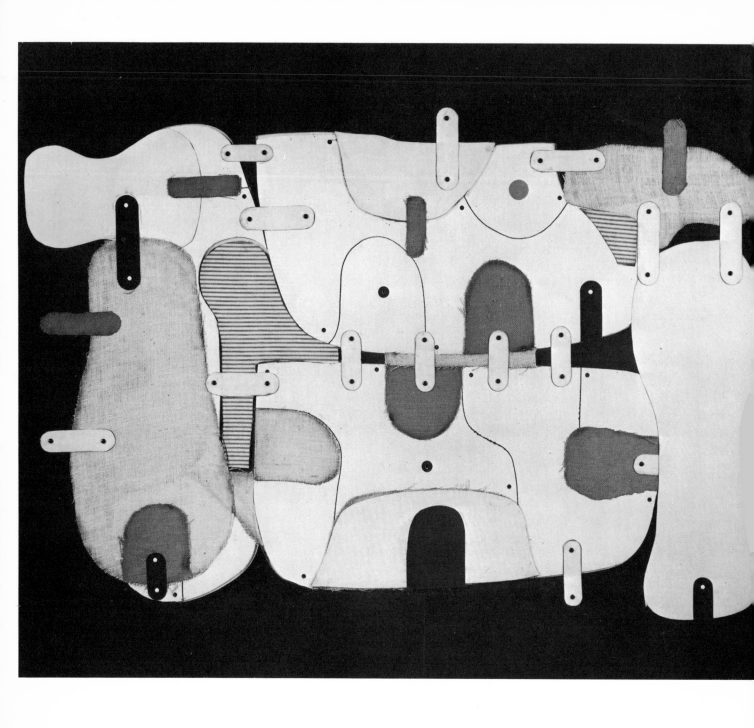

L-2-69 by Conrad Marca-Relli. 57″ x 69½″. Courtesy, Marlborough-Gerson Gallery, Inc., New York. This mixed media collage on canvas combines cut canvas, paint, and corrugated board.

A GROUND is simply the background or supporting surface on which you paste your collage. There are two general types: cardboard and paper grounds, available at art supply stores; and hardboard grounds, made from wood or wood synthetics, available at lumber yards. Both categories include many varieties to choose from. Each offers distinct advantages and disadvantages which you need to know so that you can always select the ground that best suits your needs. Some grounds must be framed under glass; others require mounting on a second ground; still others present gluing problems. In all cases, life expectancy is a major consideration—you do want your collages to last.

Chapter Four

GROUNDS

CARDBOARD AND PAPER GROUNDS

There are many different varieties of grounds that fall into this category. They'll be taken up one at a time.

Illustration board: Illustration board is fine drawing paper mounted on stiff cardboard backing. Its surface may be smooth or rough; its quality varies according to the rag content of the drawing paper and the type of backing used. Available in a wide range of sizes, thicknesses, and prices, a 20″ x 30″ board may cost as little as 45¢. Collages made on illustration board must be framed under glass for protection.

Bristol board: White surfaced Bristol board is available in thicknesses ranging from one-ply to five-ply; in sizes ranging from 10″ x 15″ to 30″ x 40″; and in price from 18¢ on up. Collages constructed on Bristol board must also be framed under glass for protection.

Foam core board: This ground, made from smooth, white paper mounted on synthetic foam, offers white surfaces on both sides which resist warping and therefore make a good collage ground. However, you must be careful not to cut into this ground when you use a sharp instrument. A new product (currently priced at $1.00 for a 22″ x 28″ sheet, and at $2.75 for a 30″ x 40″ sheet), foam core board is ¼″ thick and can be cut quite easily to size.

Poster and mounting board: Poster board, also known as mounting board, is a type of cardboard produced in various shades of white, as well as in several colors—including black, gray, yellow, red, and blue. It comes in several thicknesses, can be purchased in large sheets easily cut to size, and is moderate in cost. As the names imply, these grounds are generally used for making posters and for mounting prints or photographs. Any collage constructed on poster or mounting board must be framed under glass to prevent buckling and for protection.

Mat board: As the name suggests, mat board is used to make mats for framing pictures. It's available in many colors and in several shades of white; comes in various thicknesses; and is manufactured in both smooth and pebble finishes. Moderately priced, mat board requires framing under glass.

Chip board: Chip board is a light gray cardboard available in three thicknesses, the heaviest of which is the most suitable for collage work.

Upson board: Upson board, available at lumber yards, is made from heavily pressed papers. It's sold in 4′ x 8′ panel sizes which can be cut

21

or sawed, and is manufactured in two thicknesses—$\frac{3}{16}''$ and $\frac{1}{4}''$. The thicker of the two is more suitable for collage. The off-white finish of Upson board makes priming unnecessary.

Watercolor boards: To avoid buckling, use only the heaviest watercolor boards. Good watercolor boards or papers—especially those made of rag—are usually expensive. These are sometimes referred to as ragboards. Choose this type of board if you intend to frame your finished collage under glass.

Graphic arts papers: These are printmaking papers, used for making lithographs, woodcuts, etchings, etc. Use them the same way you'd use watercolor paper or board, framed under glass.

Heavy-bodied papers: Any heavy-bodied paper such as brown wrapping paper, gift papers, etc. can be used as a collage ground, provided that you mount it on a firmer ground such as Masonite or any hardwood board.

File cards: File cards are white, unlined cards sold in packages of 100 and used for office records. They make suitable grounds for casual greeting cards, where preservation of your work isn't a paramount concern. Framed under glass, however, they'll last for a long time.

Linen mat boards: Linen mat boards are heavy cardboard, finished on one side with a fair quality linen cloth. The reverse side of the board has a smooth gray cardboard finish.

Canvas board: Most often used by art students, the painting surface is cotton canvas and the reverse surface is hard cardboard. Art supply dealers carry them in several sizes—from 8″ x 10″ to 24″ x 36″. They frame easily, needn't be mounted, and are inexpensive. Canvas board is very much like linen board, but less costly.

Stretched canvas: Stretched canvas, ordinarily used for painting, makes a desirable collage ground. A tightly stretched canvas offers good resistance while you're pasting. Be careful, however, not to use a sharp instrument on this ground, for fear of cutting into the canvas.

HARDBOARD GROUNDS

Hardboard grounds are rigid boards made by submitting wood chips or wood fibers to great pressure. Originally intended for the building trades, these boards were long ago discovered by artists who quickly realized their advantages—virtual indestructibility and low cost. Hardboard grounds, domestic and imported, are marketed under various trade names such as Masonite, Presdwood, and Weldwood. They're all quite similar in construction, behavior, and price.

Lumber dealers stock hardboard grounds in a variety of sizes (2′ x 3′, 3′ x 4′, and 4′ x 8′ are typical), and in $\frac{1}{8}''$, $\frac{3}{16}''$, and $\frac{1}{4}''$ thicknesses. There are two types of hardboard—tempered and standard. Because of its oiled surface (which gives it a darker tone), tempered hardboard doesn't readily allow materials to adhere to it. Standard hardboard, light tan in color, is far more suitable for collage.

Gesso board: Gesso boards are hardboards covered with several coats

of white gesso primer. After each coat of primer has been applied, the board is sanded smooth—a process which brings up the cost of this material. However, gesso board is an excellent ground for collage and for oil and acrylic painting, and can be purchased at art supply dealers as well as at some lumber yards.

Homespun: Homespun is a relatively new material that has a textured surface suitable for both collage and painting. It's sold in panel sizes which can be cut to measure.

Plywood: Though some artists use plywood, I don't recommend it for two dimensional work because the weight of the board makes it cumbersome to handle and frame. Better suited for three dimensional constructions and assemblages, plywood is not a particularly good choice for papers and cloths.

CHOOSING THE RIGHT GROUND

Your choice of ground should meet the following qualifications: (1) It should be firm and resistant to pressure. (2) It should take priming easily. (3) Materials should adhere to it without difficulty. (4) Its cost should suit your budget. (5) You should be able to cut into an area of the collage without fear of injuring the ground beneath. (6) It should be light enough to handle easily. (7) It should be durable. (8) It should be easy to frame and, preferably, should offer you the choice of using or eliminating glass.

RECOMMENDED GROUNDS

Based on the above qualifications, standard hardboard is the most desirable collage ground—particularly because of its firmness, lightness, and ability to take adhesives. Canvas board, stretched canvas, and heavy boards of all types are next in desirability. The ground least suitable for collage is a lightweight paper that curls, buckles, requires mounting on a firmer ground, and must be framed under glass.

WHAT TO BUY

If you're a complete beginner, I suggest that you work with materials found around the house. After you've made your first experiments with these common materials, then go on to the grounds described throughout this chapter.

Hardboards, available at lumber yards, can be cut to measure or purchased in the panel sizes previously mentioned. Beginners are advised to work with small sizes. Suggested dimensions are 8″ x 10″ and 9″ x 12″ in the three standard thicknesses—⅛″, 3/16″, or ¼″. For more experienced artists, a 2′ x 4′ panel, 3/16″ or ¼″ thick, makes a good working and framing size when it's cut into three pieces each of 16″ x 24″. How much material you buy is a purely personal decision. However, it's advisable to purchase several boards at a time so that you can prime them and have them available at a moment's notice, without having to begin a new operation with each collage. You will find this method most convenient.

Lov by Henry Rothman. 8″ x 12″. Collection of the artist. This collage is made of mildewed papers pasted onto heavy cardboard. The artist moistens old paper scraps in sea water, then leaves them, tightly rolled, in a dark closet to mildew for several months. The spots show this mildew effect.

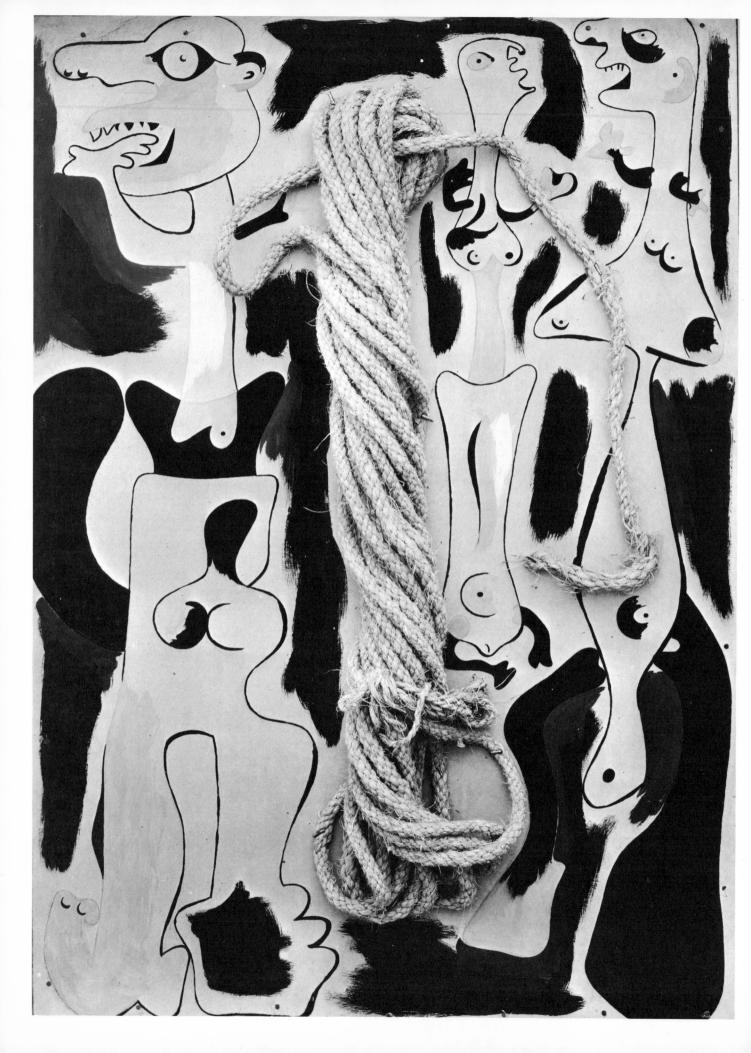

HOW TO USE THE GROUND

The recommended hardboard ground has one smooth side and one rough side. The smooth surface, which is more hospitable to adhesives, is generally used for collage. Because of its uneven surface, the textured or rough side creates pasting difficulties. Papers and fabrics don't adhere as easily to it as they do to the smooth side. Nevertheless, if you give the rough side several coats of gesso primer, its surface will take on a canvas-like appearance whose texture, when exposed, can add interest to your collage.

If you decide to use the unprimed rough side, be willing to exert extra pressure while pasting and add weights to the collage while it's drying (also be sure to place waxed paper between the collage and the weights to prevent sticking).

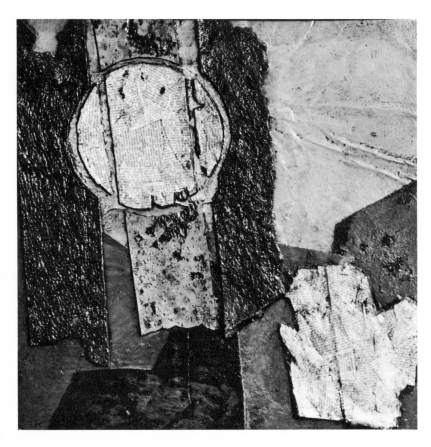

Sun by Roberto Crippa. (Above) 16″ x 16″. Courtesy, Alexander Iolas Gallery, New York. Cork, newspaper, tinfoil, and wax have been combined on a wood support.

Rope and People by Joan Miro. (Left) 41¼″ x 29⅜″. Collection, The Museum of Modern Art, New York. Heavy coiled rope is audaciously combined with an otherwise conventional painted surface of oil on cardboard.

25

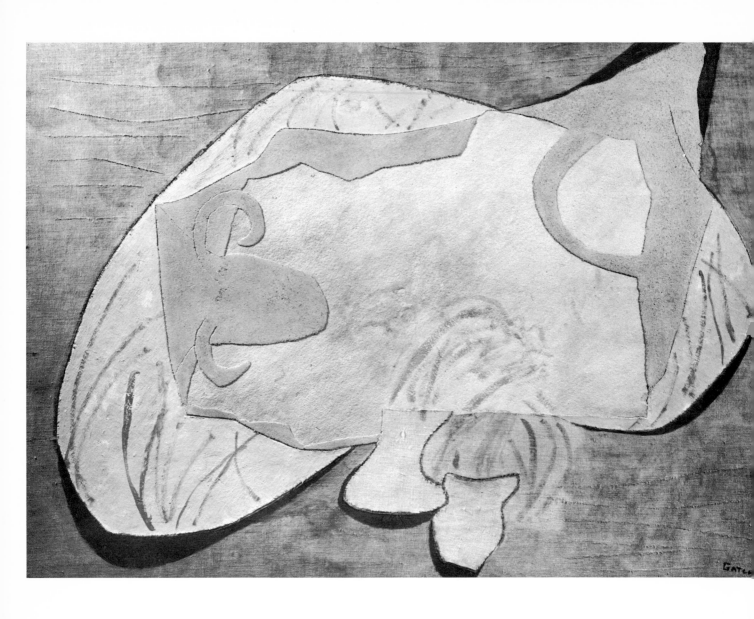

Requiem by Lee Gatch. 29¼" x 42". Courtesy, Staempfli Gallery, New York.
Natural stone and mixed media are combined in this contemporary collage.

PRIMERS

A PRIMER is a substance that's brushed on a canvas, panel, or wall before it's painted, to prevent absorption or to add luminosity. All porous grounds and all slippery grounds that will make pasting difficult should be primed. However, not all collage grounds require priming. Hard paper or cardboard grounds, for example, are generally coated with a white or colored finish that needs no additional surfacing. Papers need no priming; nor do linen boards or canvas boards. Untreated canvas that's to be used for painting or collage, however, should be surfaced with primer. Smooth hardwood boards should also be primed to give them a gripping surface that your materials will adhere to.

SELECTING YOUR PRIMER

There are many types of primers suited to various purposes. For commercial purposes, painters and paperhangers work with rather crude primers (frequently just shellac or glue mix). To prime canvas or panels, artists generally use a white primer known as gesso. Sold in art supply stores in white only, gesso is underpaint, the consistency of a thick batter, that can be thinned with water. Traditional gesso contains a fine grade of animal hide glue, plus either gypsum, sulphate of lime, whiting, or zinc white. Nearly every art supply company now manufactures gesso primer with an acrylic base.

Basically, there are two types of primers: water-based and oil-based. A water-based primer such as gesso is your best choice for collage because it's compatible with the water-based acrylic emulsion that you'll be using later. Avoid oil-based primers just as you'd avoid tempered Masonite hardboard—oil and water don't mix.

To economize, some artists use commercial casein paint as a primer. These paints are sold in paint stores in white and in decorator colors. Commercial casein paint can be used as a ground primer for collage. Keep in mind that any oil paint you use over a casein ground will eventually crack. Casein paint retains water for a longer time than gesso; hence, when used as an underpainting for oil paint, the water eventually works its way through to the surface and causes the paint (when dry) to crack. *In collage this problem is not acute.*

PRIMING THE GROUND

To prime your ground, you'll need at least one inexpensive brush. Buy brushes whose size is convenient to work with and appropriate to the dimensions of the area you intend to paint. Choose flat brushes, in 1″ to 1½″ sizes for small areas, 2″ to 2½″ for larger areas. Some people prefer to work with rollers. Do so if you choose.

Primer (which resembles a thick white paste) is likely to have some fluid on the surface when you open the can. Stir the fluid into the paint, then pour into a clean container only the amount you think you'll use. Thin the primer with water until it achieves a heavy, creamy consistency, then brush it on just as you would any paint, stroking first in one direction, then in the other to make as even a surface as possible.

It's wise to prime several boards at a time, since the drying period

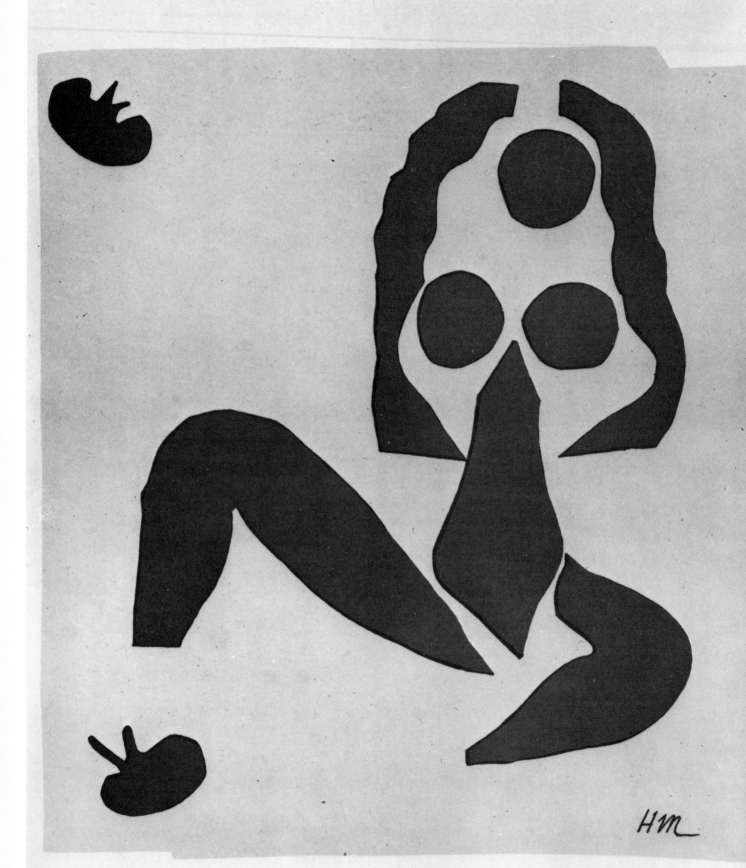

is only about half an hour. By the time you finish priming the last board, the first one may be dry enough to take a second coat. If you've primed the ground heavily, a second coat may not be necessary. However, for gripping purposes, it's always better to apply two thin, even coats rather than one thick, uneven one. It may be a good idea to rub down with sandpaper any ridges that can interfere with pasting.

When you work with primer, have a jar of water handy in which to rest the brush when it's not in use. Wash your brushes thoroughly after you've used primer so that they'll remain serviceable. Keep the cover of the original paint container tightly closed to prevent hardening, and add water whenever it shows signs of drying out.

COLORED PRIMERS

White gesso is preferred as a painting ground because it's the most luminous primer. This luminosity is important in collage when transparent or semi-transparent papers are glued over a primed ground.

At times, however, a ground color other than white can be used to advantage. In such cases, white gesso can be colored any shade you wish simply by mixing in appropriate amounts of acrylic, gouache, or casein paint. Always be sure to prepare enough colored primer for two ground coats. It's a nuisance to stop to make a second batch, and it's often difficult to match the original color.

You might want to use a colored ground if, for example, you're working on a marine subject and decide you'd like to use a blue ground as an integral part of the collage. You'd simply mix some cerulean blue (or any other shade of blue) into the white gesso, then brush it on. In a similar way, you could prepare a ground for a pastoral scene, a still life, or any other subject that comes to mind. If you wish to use the natural tan of the hardboard itself, brush on a coat of acrylic polymer emulsion. This primer will dry to a transparent finish that will grip papers. Acrylic polymer emulsions are fully discussed in Chapter Six on pasting and gluing emulsions.

CHANGING THE COLOR OF AN EXPOSED GROUND

At any stage in your work, you can change the color of a primed ground or exposed area to which you don't intend to glue further material. The medium you choose will depend upon whether the emulsion used to paste nearby forms has overlapped into these exposed areas. Many mediums can be applied over dried emulsion: acrylic colors, oil colors, oil crayons, and inks. However, if you chose to add pastels (which must be fixed), watercolor, or wax crayons, it is necessary first to remove the emulsion with sandpaper or coarse steel wool. This procedure enables you to use practically any medium.

La Grenouille (The Frog) by Henri Matisse. 55½" x 52¾". The artist has placed cut-outs in blue gouache against a plain white ground to achieve this sculptural effect.

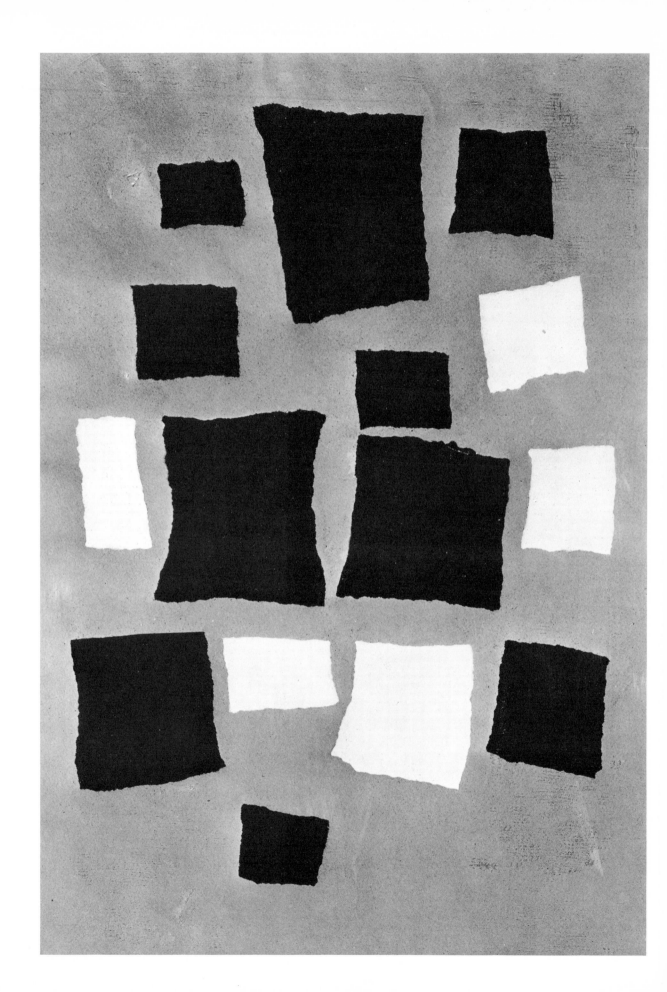

THERE ARE SO MANY ADHESIVES on today's market that unless you're familiar with the differences among them, it's difficult to decide which to select. However varied, they fall into a limited number of types: acrylic emulsions, acrylic gels, acrylic pastes, and acrylic sprays, as well as other adhesive liquids, powders, pastes, and sprays. Adhesives can be purchased in tubes, jars, plastic bottles, cans, and spray cans, in sizes varying from ounces to gallons. Which adhesive you use depends on personal preference, the gluing power of the adhesive, and the material you want to glue.

ADHESIVES

ACRYLIC EMULSIONS

White and creamy, acrylic emulsions are liquid plastic glues which permanently fix collage materials to a ground. Although they're recommended to painters as a medium for acrylic paints or as a final varnish for acrylic paintings, they're equally useful as an adhesive for paper or cloth. Composed of essentially the same resins and reinforcing agents as those in Lucite and Plexiglas, acrylic emulsions behave like plastics, drying quickly to a hard, clear finish. This transparent finish won't yellow and will protect the surface of the collage, eliminating the need for framing it under glass. While other glues can be used only for pasting, acrylic emulsions can serve as both an adhesive and a preservative. In addition to its unique protective and preservative qualities, acrylic emulsion combines well with other media, allowing the artist to glue many different kinds of materials onto the same ground.

Standard brands of acrylic emulsions are available in most art stores. These various brands, all reliable, differ little from one another. You may, however, find differences in consistency and cost; a thicker emulsion may be more expensive than a thinner one. However, a viscous emulsion can be thinned with water to increase its volume, without much loss of quality. Then, too, some companies market two types: regular (glossy) and matte. The emulsion labeled *matte* has an inert substance added to dull it, but you can add water to the regular type to dull the gloss to some degree.

WHITE GLUES

White glues like Elmer's or Sobo are similar to acrylic emulsions in behavior, application, and result. They differ only in their density: they're much thicker, resembling very heavy cream. Available in hardware stores and art supply stores, white glues are sold in small plastic bottles by the ounce, and in larger containers by the quart or gallon. The larger sizes are more practical and economical than the small plastic bottles. Although Elmer's and Sobo are two commonly known brands, many similar glues are also sold which bear their own trade names and are equally effective.

Collage with Squares Arranged According to the Laws of Chance by Jean (Hans) Arp. 19⅛″ x 13⅝″. Collection, The Museum of Modern Art, New York. Irregular squares and rectangles, entirely of colored papers, create a lively abstract design. Notice how the torn edges contribute to the quality of movement and excitement.

ACRYLIC GELS AND PASTES

Acrylic gel adhesives (also marketed under the name jel) have the color and consistency of cold cream or jelly. Gels can do everything that emulsions can, and they have additional functions as well. Painters can combine gel with casein, with acrylic paints, or with other water based paints to produce a tough, oil-like surface that can be subsequently glazed. Some artists find gels useful in overcoming puckering, chipping, or peeling of papers when they work with plastic or acetate grounds.

In my experiments with gels, I've found them very effective for pasting both paper and cloth. If you prefer to work with a nonrunning adhesive, use a gel and apply it with a painting knife. (Papers prepared with wax crayon may adhere more easily to other papers if gel is used instead of acrylic emulsion.) The surface that gel produces isn't quite as hard as a dried emulsion surface; and gels which are sold in tubes as well as in pint and quart size jars cost a bit more than emulsions. However, since both gels and emulsions are acrylic products, they can be used interchangeably. That is, you can apply a coat of emulsion directly over a dry gel or vice versa. Similarly, gels must be well sealed in their containers to prevent hardening. When you work with gels, remove only enough from the container to fill your immediate needs.

MOLDING OR MODELING PASTE

Not to be confused with modeling clay, molding or modeling paste (trade names) are acrylic products that are much heavier in consistency than gels. Thick, white; and opaque, these pastes dry harder and faster than gels, but may be mixed with gels to retard their drying time. Though generally used to build raised textures on paintings or collage grounds, they also make excellent adhesives in which to embed small or moderate size three dimensional objects—porous or nonporous materials such as wood, metal, stone, and plastics.

EPOXY

Epoxy is a powerfully strong adhesive used in industry and for home and boat repairs. It will bond wood, metal, and many other materials with ease. Epoxy is sold in tubes, cans, and sprays, and comes in clear and colored varieties. One type is sold in two tubes that must be mixed together. Because epoxy hardens quickly (almost within minutes), tools must be carefully cleaned immediately after use. Many artists use epoxy on canvas or on other grounds when they intend to combine metal, wood, or other materials that are unmanageable with ordinary adhesives because of the character or bulk of the material. Hardware stores and marine supply stores stock the tube variety, and Sears, Roebuck lists it in its catalogue. The product is manufactured by many leading companies.

ADHESIVE SPRAYS

Adhesive sprays are manufactured with and without acrylic ingredients. They differ little—if at all—from the paste, powder, and liquid

Light emerald green tissue applied to primary colors gives as many as four variations of a single color.

Two basic colors of tissue combine to produce a third rich hue.

Primary colors of yellow and blue tissues combine to produce a green.

Orange is created by adding a yellow tissue to a red one.

Tonal values deepen when several layers of tissue of the same color are superimposed.

Three layers of yellow tissue.

Three layers of blue tissue.

33

Part of a poster peeled from a brick wall retains traces of the brick.

A cerulean blue over cadmium red will generally give purple; reverse the order to get maroon.

Tissues in primary colors—red, yellow, and blue—overlaid to get orange and green.

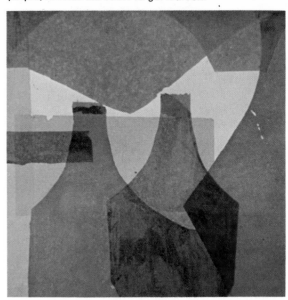

Another example of the wide variety of colors achieved by adding emerald green tissue to the primaries.

Colored magazine papers—torn and scraped—and combined with colored tissues.

Tissues used as a ground for a patterned Japanese Fantasy paper.

A single layer of tissue over a magazine paper.

Billboard paper used both as a ground and superimposed on tissue.

A more elaborate collage of colored tissues and origami papers.

Rectangles of origami papers combined with tissues.

Kitchen aluminum foil used in combination with colored tissues.

Strips of gold foil alternated with deeper-toned tissues.

Japanese Chiri paper with subtle brown flecks offset by brighter tissue.

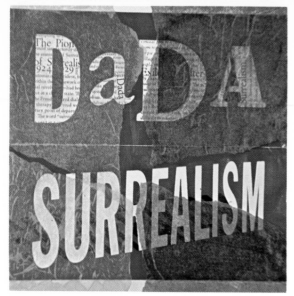

Red, yellow, and green tissues—mostly on a red ground, but partly on white. Note different effect.

Black construction paper cut out to show window of veined tissues in three colors.

Ink applied to tissues with pen, marking pen, and brush.

Papers torn in irregular shapes create a more fanciful design and color range.

White base laid with three colors of tissues and topped with black cut-outs.

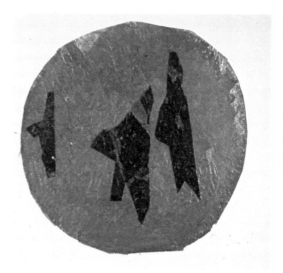

Black tissue patterns are enclosed with acrylic emulsion between layers of red tissue.

The bleeding effect of tissues was put to use by pressing dry colored tissue onto wet white paper.

Smooth finish paper in a two color mix of burnt sienna and black dipped in oil-water print bath.

Torn tissues grouped to produce open forms.

Natsume paper shows texture on both sides, both used here in a red and black mix.

Spraying with some forms blocked out and left unsprayed, on colored tissues and magazine paper.

A second printing of a two color mix made on smooth mimeograph paper.

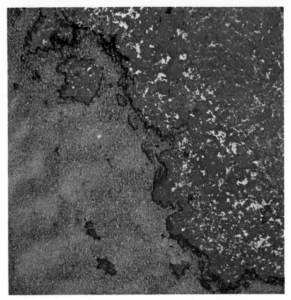
Inexpensive drawing paper used for a two color mix.

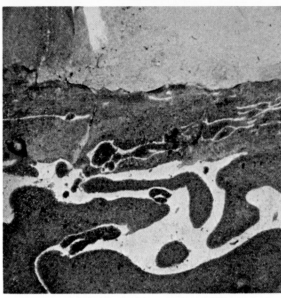
Pattern created by interlocking pieces of Chiri and cloud papers (Japanese).

Two color printing showing effect of letting one color dry (black) before applying the second (red).

Unique effect results from rubbing palette leavings against paper.

Bleeding tissues placed on white ground, then removed; resulting work dipped in oil-water print bath.

Rubbings made from a print prepared on glass.

Sponge print using several colors on the same area.

Spray adds forms to a print made from paint on glass.

Sprayed black, white, and yellow oil paint.

Oil in water print over a fabric with a yellow pattern on a white ground.

Sprayed forms over a print made from oil color floated on water.

Deeper tones result from an oil in water print on a yellow and orange fabric.

Wet tissue (bleeding) was used to color areas on cloth; objects not colored leave dramatic silhouettes.

Magazine paper made wet, then crushed, dried, waxed, and re-crushed.

Tissues glued over patterned cloth, leaving the pattern visible in varying degrees.

Dry magazine paper waxed and crushed.

Another combination of patterned cloth and tissues, enlivened by bright accents.

Three colors of hot wax crayon are applied in separate operations on a single sheet of paper.

Paper coated with hot orange wax is redipped in melted black wax crayon.

Lighter colored crushed wax paper, with more black added, creates more contrast.

Wax and oiled crayons are added directly from heated pan to unwaxed paper.

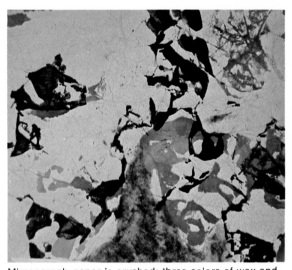

Mimeograph paper is crushed; three colors of wax and wax crayon added. Red and yellow produce orange.

Crushed wax paper with color added to darken the cracks.

Wax emulsion and bits of wax crayons.

41

Pure white beeswax on unprimed canvas. Pigment was added to the wax for black shapes.

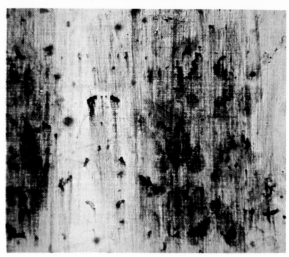

Wax crayon shavings strewn between two pieces of bedsheeting, then pressed with a hot iron.

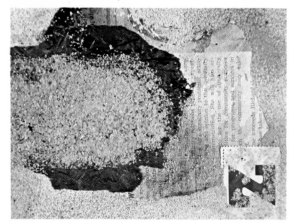

Sand, tissues, and newspapers used with sprayed papers.

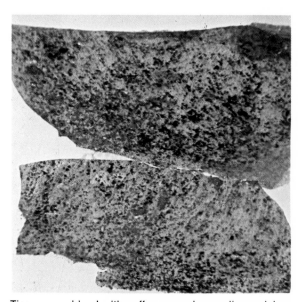

Tissues combined with coffee grounds; acrylic emulsion and dry color superimposed.

Sand, built up to a heavy thickness, is used over black paper sprayed with white.

Oil in water print and sand on Natsume paper.

Oriental papers, tissue, and coffee grounds combined, superimposed by uneven application of acrylic emulsion.

Magazine paper and sand on Natsume paper.

Cheesecloth, string, and tissue glued over sand.

Sand on red and yellow tissue, then sprayed with black enamel.

Red and green oil crayon rubbed over sand which has been coated with acrylic emulsion.

String, sand, and blue crushed marble.

Black enamel sprayed on sand sprinkled on yellow tissue.

Wax crayon on Yamato paper coated with wax.

43

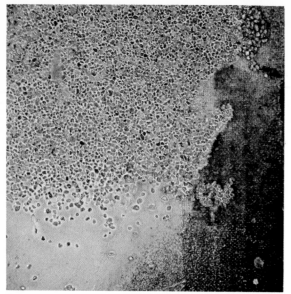

Brown and black cloth, brown tissues, and sand sprayed with white enamel.

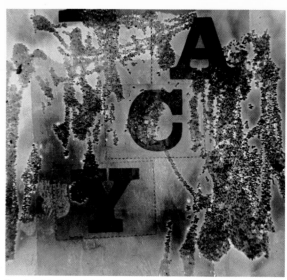

Smoked lightweight paper with a glue emulsion strewn with sand.

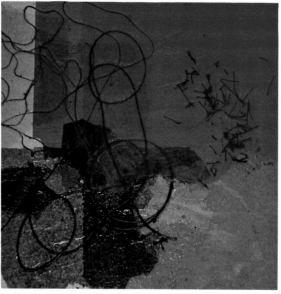

Various lengths of thread and string in contours over colored tissues.

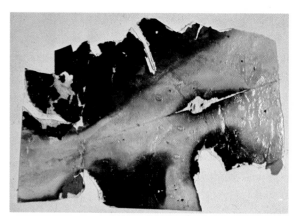

Random edges and tones produced by partly burning paper.

Combination of dill seed, sand, and bits of string.

Five layers of colored tissues were glued over each other, then torn at random points.

Detail of collage illustrated below, showing colored openings in black tissue.

Six papers torn, cut, and scraped into irregularly-shaped forms. Acrylic emulsion holds them in place.

Color added to cut out areas of paper surface.

Use of a sharp instrument to lighten and texture a dark area.

Six layers of various papers, glued, and scraped for a rough textural effect. Acrylic emulsion holds the surface.

Dry pigment has been tapped with a palette knife onto wet acrylic emulsion.

String glued to a surface and covered with tissue; then pulled out when glue was thoroughly dry.

Two oriental papers were combined, with coffee grounds added. Wet acrylic emulsion was mixed with dry pigment.

Fine thread—using the same technique as above—makes a more delicate design.

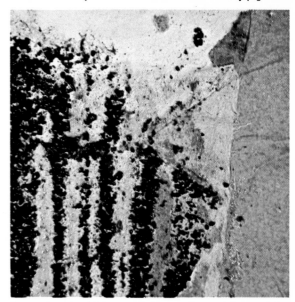

By varying the thickness of the acrylic emulsion and the amount of pigment, numerous effects can be achieved.

A single layer of irregularly-shaped Celotex glued over various grounds.

Sand and blue crushed marble solidly bound in acrylic emulsion.

Gold dust, diluted with acrylic emulsion, was brushed on glass to form a sheet.

Fine and coarse crayon shavings in acrylic emulsion over glass.

Acrylic emulsion was poured directly onto gray shirt-board and crayons were shaved onto this surface.

Several layers of tissue topped with dry pigment and acrylic emulsion.

Scraps of acrylic paint joined with acrylic emulsion.

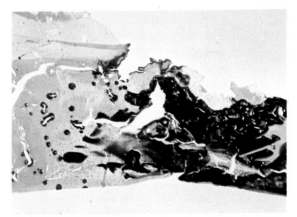

Acrylic paint run together with acrylic emulsion and emulsified ink.

47

Stitching, like drawing, gives a directional movement.

Gold spray used sparingly on acrylic color.

Cheesecloth enlivened with dry pigment and preserved in acrylic emulsion.

Acrylic color forms drawn on with black ink.

Papers that have mildewed and stuck together.

Acrylic paint brushed on stiff, crushed shelving paper. The second color was added when the first was dry.

glues discussed in the following section, except that they're sprayed on, rather than applied with a brush or a knife.

Sprays such as epoxy, on the other hand, are made in aerosol form to spare you the chore of mixing two or more elements together, as epoxy in paste form sometimes requires. If you use acrylic adhesives, it's purely a matter of personal preference whether you select an emulsion, paste, or spray. However, sprays are flammable and fumes can be somewhat noxious (the can label cautions you to keep it away from flames and to apply it near an open window), so I'd hardly recommend sprays for constant and exclusive use. Select the spray (in the *clear* color) for those materials that can't be glued with another type of adhesive, and use it for other special needs. Within this limited function, you'll find some use for the spray.

Wallpaper and paint suppliers as well as art supply stores frequently stock adhesive spray. The yellow pages of the telephone directory list many plastic products companies from whom sprays are available. The many brands on the market include 3M Spray-Ment, Krylon Spray Adhesive, Tax Spray Adhesive, and DuPont Polymer Spray.

POWDERS, PASTES, AND LIQUID GLUES

Adhesives in liquid, powder, paste, and spray form are generally made from animal and vegetable matter, as well as from synthetics. There are so many different brands and types that it would be arbitrary to name specific ones. If you prefer a non-acrylic adhesive, ask your local wallpaper dealer or art supplier for a recommendation. Any good wallpaper adhesive should be equally suitable for collage. A wheat paste is generally considered superior. Adhesive in powder form generally has to be mixed with water. The only difference between the powder and the paste is that the paste has been pre-mixed. Mucilage, another very common type, is glue in liquid form. You cannot bond non-porous material with any of these animal or vegetable glues. Any collage, whether paper or cloth, has to be framed under glass for permanency, if it's been glued with these adhesives.

RUBBER CEMENT

I'm loathe to recommend rubber cement. I do suggest its use to the beginner, but only to encourage a non-frustrating start. Rubber cement isn't a permanent product. Besides, it will show through transparent papers. It's suitable only for casual greetings, those little creations you don't intend to keep. Nevertheless, any work done with rubber cement can be kept for an indefinite period of time, provided it's framed under glass. Many companies manufacture this common product, and by consulting your local art materials store or stationery store you should find it without difficulty.

UNDERPAINTING WHITE AS ADHESIVE

The white oil underpaint used to build textures in impasto painting can also be used to glue porous and non-porous materials to a surface.

This paint, in tube form, is sold by nearly every art supply company. It dries hard overnight and grips with ease small metal, wood, stone, plastic, and other such objects.

TOOLS FOR APPLYING ADHESIVES

When you paste your collages, work at a table or easel, with your auxiliary materials and tools within easy reach. If you prefer to use brushes for pasting, you'll need at least two. Though these needn't be expensive, avoid poorly made brushes whose bristles will shed and fall into your adhesive. Look for moderately priced, flat or round brushes, in 1″ or 2″ widths (wider for large size work). If you intend to use a gel, you'll find a painting knife a very handy tool. Single edge razor blades serve many functions and are useful to have on hand. You'll need glass jars or containers to hold small amounts of emulsion poured from the original container, and as water vessels in which to immerse your brushes. Finally, be sure to have clean rags at your work table.

APPLYING ACRYLIC EMULSIONS

Pour enough emulsion from the original container into a smaller one to work with for a given period of time. Use small amounts until you become accustomed to the material. You'll notice that each time you pour off the solution, some of it remains around the mouth of the bottle. Always wipe off this excess before you close the bottle. If it remains, the emulsion will harden and make re-opening difficult the following day. Should you encounter such hardening, tap the cover with a blunt instrument until it yields. Soaking in hot water may also help.

Begin by brushing some of the emulsion over the ground where you intend to paste your first piece of paper. Place the paper over the wet area. Beginning at the center of the paper, push the glue towards the outer edges, pressing left, right, top, and bottom until the glue underneath the paper has spread evenly to all areas. A single edge razor blade is very useful to push the glue along. If there seems to be too little glue, lift the paper and repeat the process. Wipe off any excess glue that may run down in streaks. Continue to paste your other papers in the same way.

If at any time your paper should tear, it's not a calamity—in fact, it may turn out to be an asset. Use the accident in a creative way. Unwittingly, you may have added an interesting break in an otherwise unbroken form. However, if the form is very small and you don't wish the tear to remain, simply re-glue the paper and replace the edges so that they merge.

Keep your brushes in water when they're not in use. Be cautious, however: a brush that's been submerged for some time is bound to absorb enough water to dilute the glue. To avoid this, be sure to remove excess water by shaking it off, and then blotting the brush on paper toweling or on a clean rag. Another word of caution: after prolonged use, your emulsion may take on a cloudy look when it's applied *over* paper. While this cloudiness won't interfere with gluing

ability, it will affect transparency. When this happens, wash your brush thoroughly under running water; or better still, change to a fresh brush. It may be advisable to start with fresh emulsion. Don't, however, dispose of the cloudy emulsion; it has other purposes.

Never dip your brush directly into the original emulsion container for fear of discoloring its entire contents. Some colored papers (particularly tissue) bleed; your brush is apt to pick up this color and transfer it to the emulsion. Advice on how to avoid this kind of bleeding is discussed in the chapter devoted to tissues.

APPLYING WHITE GLUE

You can apply the thick white glue with a brush, with a painting knife, or with the dispenser top of the small plastic bottle in which the glue is packaged. If you prefer, this dispenser—which permits only a narrow flow of glue—can be removed. The same rules governing the application and use of other emulsions apply to white glues as well. Pour into a small container only the amount you intend to use. Wipe off the rim and the cap of the original container, and close it tightly. Never dip your brush into the original jar; and make certain not to over-dilute your glue with a water-sodden brush. Wash your brushes thoroughly after final use.

APPLYING GELS

Gels can be applied easily with a brush, a knife, or with any other device you prefer. The long blade of a palette knife or painting knife is very useful because it enables you to scoop up the gel, apply it to the ground, and then force the paper into the ground—all with the same tool. Keep the original container closed; use small amounts at a time; and don't dip into the entire contents for fear of discoloring them. Remember the added feature of gel: it can be used interchangeably with liquid emulsions because the two adhesives are compatible.

APPLYING SPRAYS

Adhesive spray is used like any other spray—by applying it to the ground or to the back of the paper itself. Read the directions carefully on spray cans which contain acrylic ingredients, and observe the warning about air flow and proximity to flame. Provided you're reasonably cautious, there's no reason why these spray cans can't be used with non-porous materials when necessary.

APPLYING POWDERS AND PASTES

A glue in powder form has to be mixed with water into a paste form. Apply the paste to the back of the paper or to the ground (sometimes to both), using a brush or a knife. Remove any excess that may possibly interfere. Press your papers into place. A glue such as mucilage is also brushed onto a surface and pressed into place.

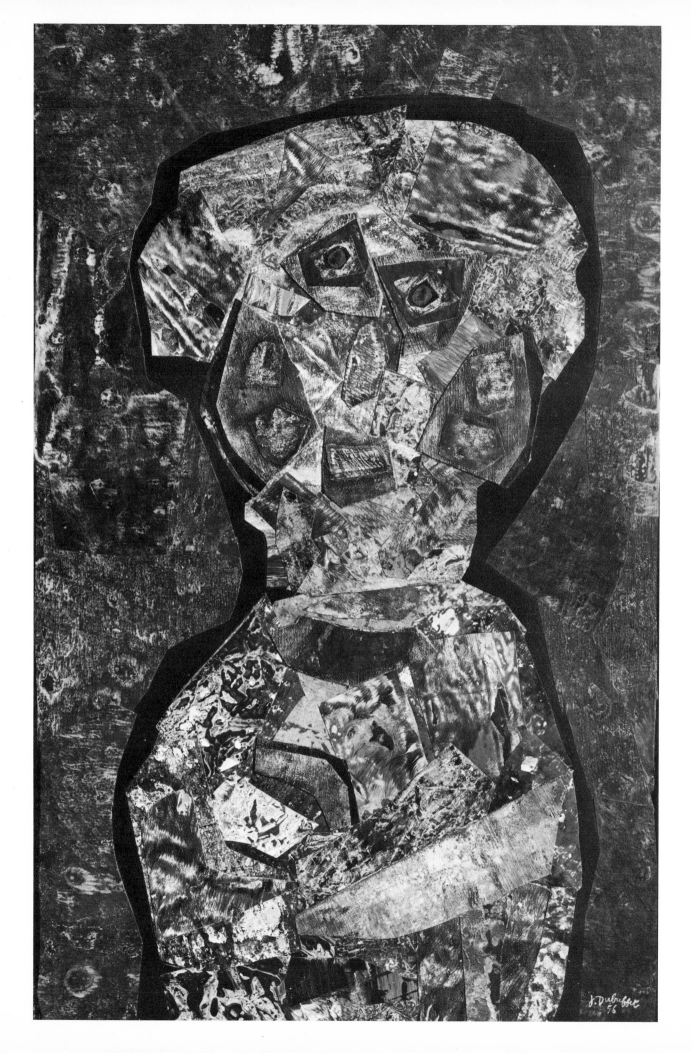

APPLYING UNDERPAINTING WHITE AS ADHESIVES

Use the underpainting white directly from the tube, squeezing the needed amount onto the ground. Work on a flat surface so that you can more easily embed the objects that you intend to lay into the paint. Use a knife to apply and spread the underpaint. Add any color over the underpaint if the natural white doesn't relate to your composition. A moderately thick layer of underpaint will harden overnight.

SOME HINTS ABOUT APPLYING ADHESIVES

Adhesives other than gels, pastes, and sprays are bound to drip onto your ground. You can encourage or discourage this merely by wiping off the excess immediately. You need only be concerned with the drips or streaks of adhesive that bear no relationship whatever to your work. Remember that, when evenly applied, each coat of transparent emulsion adds more strength to your surface.

A brayer or roller can be very helpful for applying pressure. This printmaking tool (made of rubber or hard composition) can be purchased in 2″, 4″, 6″, and 8″ sizes. Unless you work with very large pictures, a small brayer will be quite adequate. The back of an ordinary soup spoon also makes a good tool for applying pressure. Your hands and fingers, however, will unquestionably be your best devices.

Occasionally, you may be plagued by an air bubble trapped under a paper, which no amount of pressure will remove. A simple remedy is to puncture the surface with a pin, a needle, or any other fine point. Force the air from the surrounding sides toward the narrow puncture, and push the glue into any trouble spots. If this method doesn't work, you'll have to make a larger opening. Use a razor blade to make a small cut in the trouble area. Lift the paper, lay it back carefully, add glue, then replace. Again, notice if the cut in the paper adds interest to the composition. If not, merge the edges until the cut disappears.

Abrassanter by Jean Dubuffet. 31¾″ x 20″. Painted canvas has been cut into multiple shapes, arranged into the shape of a human figure, and glued to a darker canvas ground. The ground is allowed to show through to silhouette the main shape.

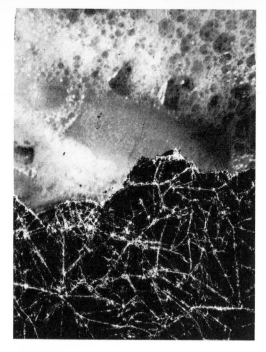

Foam from beer, shampoo, and soap advertisements lend themselves to underwater and surf effects.

Areas of hair advertisements can be used to suggest waves and clouds. Here the strands of hair suggest cloud and sky formations. Turn the illustration upside down and the hair becomes surf.

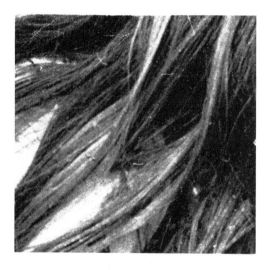

Hair grooming ads are often studies in intensities and in active or quiescent rhythms. Their textures can be used to evoke natural phenomena such as grass, earth, and water.

MAGAZINES AND NEWSPAPERS are excellent sources of exciting collage papers, offering an almost inexhaustible supply of design ideas. Before you discard them, always browse through the pages; a color, a color sequence, a motif, or a pattern may be useful in the future.

In choosing your papers, try to discipline yourself. If you're tempted to tear out every attractive page, you many find yourself with a heap of loose papers that you may eventually discard. I advise you to keep a magazine intact except for your immediate needs, noting on the cover the appropriate page number, colors, and motifs.

Even though your reactions to some pages may not be clearly defined, these may be the very papers that will set the creative process in motion and stir you into activity at a later date. It's not necessary to have a specific idea in mind in order to start a collage, because the medium permits you to change your mind repeatedly as you proceed. The urge to begin is all that's required.

Chapter Seven

MAGAZINES AND NEWSPAPERS

MAGAZINE PAPERS

Frequently, a single issue of a magazine will yield a treasure of collage papers. In most magazines you'll find a great number of pages printed in solid colors, in figures, and in patterns. Some of these colors are so luscious and intense that they'd be difficult to duplicate in paint were you to try. Moreover, colors are often repeated throughout a single issue of a periodical, so once used, a color is always easy to duplicate. Higher priced magazines provide a greater range of colors and are printed on quality paper. However, the average magazine is adequate for all purposes.

Magazine covers are printed on a heavier stock than inside pages, which vary in thickness and finish. Some papers are matte, others are glossy. These differences present no problem to the collage artist, who can gather a stockpile of beautiful papers free for the taking. Cut them, tear them, use them alone, or combine them with other papers and materials to create any number of effects.

NEWSPAPERS

While more fragile than magazine paper, newspaper has its own advantages. Its soft quality, for example, permits you to build layer on layer to create interesting textural effects. And its fragility can be circumvented by pasting it with polymer emulsions, which will make it rock hard. Newspaper ads, graphs, maps, crossword puzzles, and contour (line) drawings can contribute excellent linear and design effects to your collages. The soft grayish newspaper inks combine nicely with more dramatic materials to insure good contrast in your work. Finally, you can select from a wide range of typefaces to make repeat patterns from the printed word.

SELECTING PAPERS FOR CONTRAST

In the process of gathering your papers, strive for contrast. Find active patterns that will oppose quiet, restful ones. In choosing black and white papers, select some that are darkly inked and others that merge

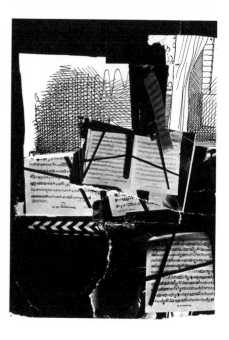

Various typefaces from newspapers and magazine papers can be used alone or superimposed as collage materials.

Drawings and illustrations can be clipped from magazines and newspapers, used whole or cut into various shapes, and glued one over the other to produce endless linear, contour, or crosshatched patterns.

In this little collage, *Musicale,* solid black newspaper is combined with newsprint and ink drawings to provide contrast between active, patterned areas and solid, quiet ones.

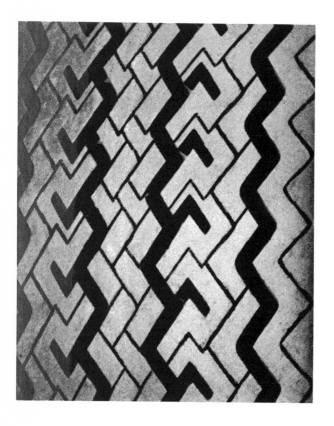

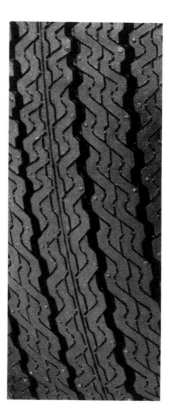

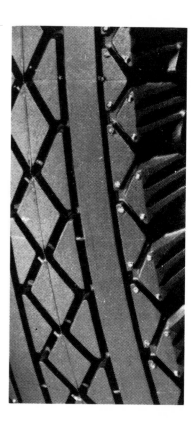

Tire advertisements are a rich source of over-all pattern which vary surprisingly from one another.

In this collage made entirely from newspapers and magazine papers, large type and a tire advertisement are set off against solid, quiet areas.

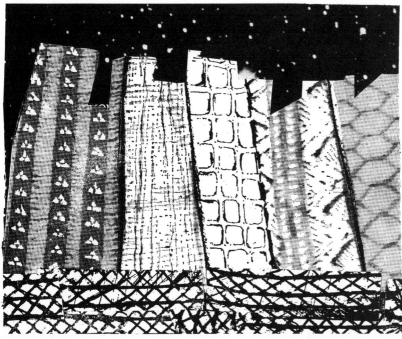

This night cityscape was created from two separate newspaper advertisements. A fashion illustration for patterned stockings was cut up and rearranged to form the foreground and the skyscrapers. A section from an advertisement for a nightclub served as the starry sky in the background.

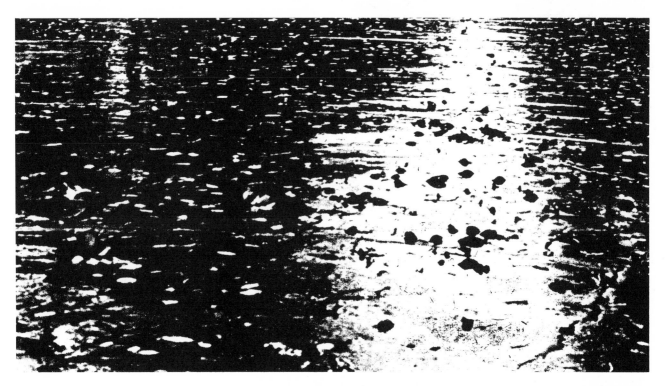

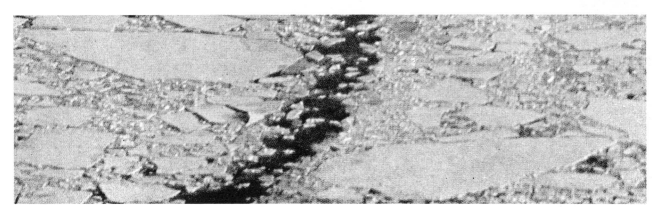

Magazines offer an incredible variety of ocean and water reproductions, in as many moods as nature can provide. Reflection from land and shore add additional color interest.

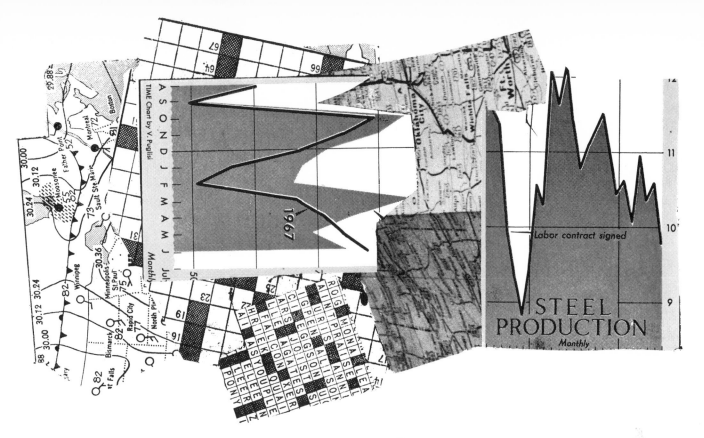

Graphs, maps, and puzzles reproduced in magazines and newspapers can offer
linear, tonal, and pattern interest in collages.

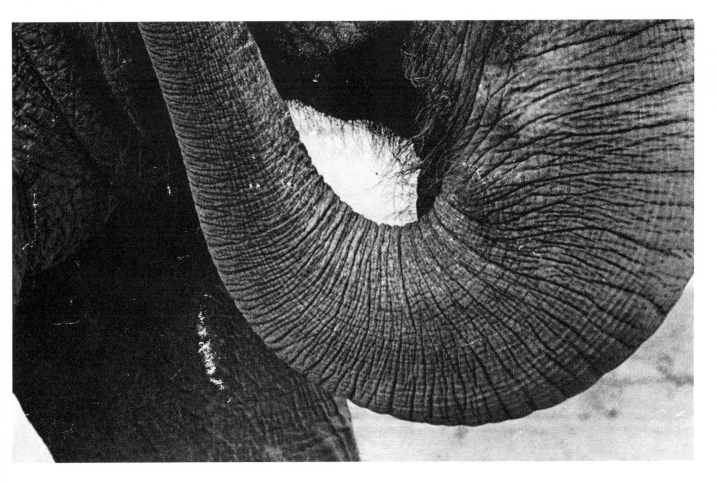

Be alert and open to unusual textural possibilities. The texture in this
reproduction of an elephant, for example, can be put to good use.

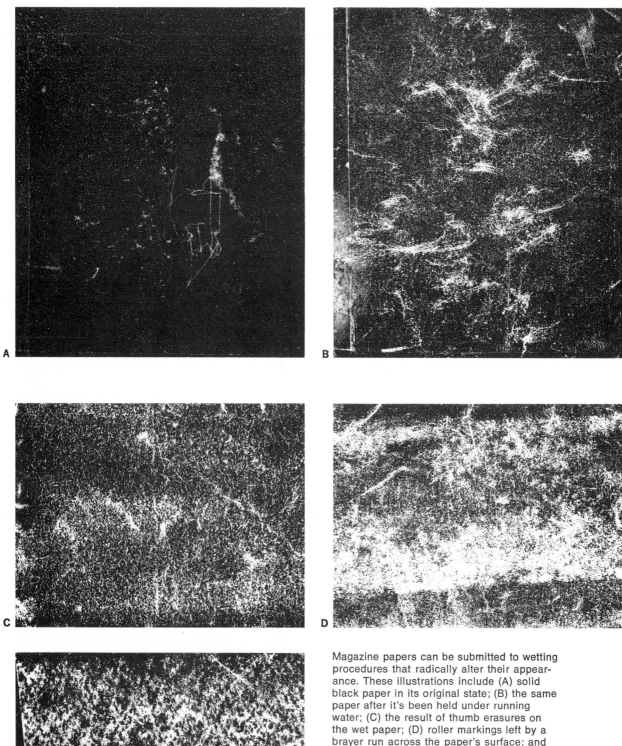

Magazine papers can be submitted to wetting procedures that radically alter their appearance. These illustrations include (A) solid black paper in its original state; (B) the same paper after it's been held under running water; (C) the result of thumb erasures on the wet paper; (D) roller markings left by a brayer run across the paper's surface; and (E) pattern produced by a single edged razor blade run at a slant across damp paper.

into grays. Collect sections of solid colors, solid blacks, and solid grays. Look for muted colors that will contrast with intense colors, hot colors that will set off cool ones. Search out variations in size, shape, texture, and pattern. Don't overlook the fact that solid colors, depending on their size, shape, and tonal values can create a feeling of activity and tension when placed in certain relationships. Get as much variation as you can.

When you find designs with lettering, take advantage of the calligraphy. Note how the lettering follows the basic rhythms of the composition in which you discovered it and let these rhythmic movements influence the composition of your own collage. Remember, too, that the amount of space surrounding a design will effect its over-all impact in your collage. A large and busy form in a small space will seem to be bursting its bounds, whereas the same form, reduced in size in the same amount of space, will, in contrast, appear to be floating in space. Placement strongly influences any given design. A form placed in one area of a composition may appear explosive while in another it may seem inactive. These are basic principles applicable to any composition.

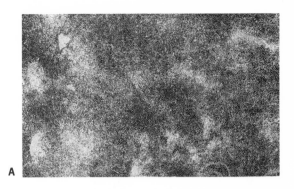

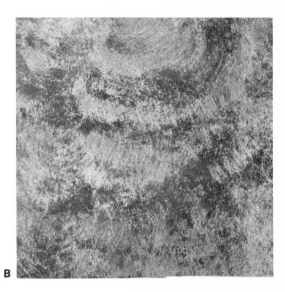

Two interesting textural effects can be made with an ordinary cellulose sponge. Ink was blotted up from the wet paper by pressing firmly on the sponge (A); the sponge was pressed into the wet surface of the paper, then twisted in a circular motion (B).

WHAT TO LOOK FOR

As you become more experienced, you'll also become more sensitive to the collage possibilities of the papers you see, and you'll hardly need suggestions to stimulate your imagination. To help you get started, however, let me mention a few subjects or recurrent themes in newspapers and magazines to give you an idea of what they might contribute to a collage.

Fashion photographs and rug or carpet advertisements can yield exciting patterns and textures, as well as close-up photographs of people and animals. Reproductions of such natural phenomena as rocks, tree bark, woods, and water can be used in whole or in part to create a mood, contribute form, or add texture. You'll find an extraordinary variety of water images, calm or stormy in mood. Photographs of the sea at sunrise, sunset, and under moonlight, as well as reflections on water, can themselves become (without alteration) vital elements in a collage.

Scenes of rubble and ruin, fire and smoke, rust and peeled paint can contribute subtle or dramatic color values. Beer, tea, and soft drink advertisements can be used to suggest foamy sea and shore effects. Food advertisements offer a rich variety of colors and textures which you can incorporate as design elements in your work. You can use to advantage reproductions of figurative and abstract paintings in whole or in part.

When cut and removed from their original contexts, enlarged photographs of human hair, in black-and-white or in color, can be very useful for collage. The finely delineated textures in "wind blown" rhythms no longer resemble strands of hair, but rather suggest land textures or sea forms. Textile designs, fake furs, textured stockings, fabrics of all kinds, make imaginative collage elements, too.

These ideas—chosen almost at random—are meant to suggest the infinite collage possibilities offered in magazines and in newspapers, at no extra cost to you.

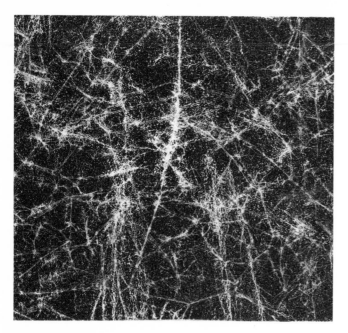

This marbleized effect was produced by dry crushing. The paper was crushed, opened flat, then held under a stream of water until the ink washed out from the creased areas and faded from its surroundings.

This paper was wet crushed—that is, held under the water tap until saturated, then crushed until almost a ball to allow the color to run freely and to produce the cracked markings. The paper was flattened, then placed on newspaper to dry.

Pattern can be imposed on magazine papers in many ways. This design was created by moistening black magazine paper, then stamping it with the end of a pencil sharpener.

Here, the eraser end of a pencil was used to stamp a design in wet newspaper. Forms resulting from the impressions of wood, metal, rubber, and plastic objects can be used to add interest to otherwise inactive areas.

MODIFYING AND ALTERING MAGAZINE PAPERS

I've been discussing what's available in magazine and newspapers for creative collages. Up to now, nothing's been done to alter the paper itself other than to cut and tear it. Here we'll consider methods of modifying magazine papers (newspapers are not suitable because they fragment and turn pulpy) by techniques such as wetting, crushing, scratching, and erasing to alter their color, design, and texture.

These procedures will radically affect the original appearance of the paper. Why, you may ask, should one wish to make such changes? Because the mysteriously faded, subtly colored, or marbleized effects you produce will make these papers appear to have been peeled from aged walls or unearthed from ancient sources. As these changes occur, they'll stimulate your imagination and enrich your collage vocabulary in unpredictable ways. Batches of papers can be prepared in advance, in the same manner that an artist prepares his palette. This approach will insure that you don't run out of materials at an inopportune moment.

Dry paper, as well as wet, can be altered to suit your purposes. Solid magazine paper was rubbed with steel wool to suggest moonlit water in this illustration.

GENERAL WETTING PROCEDURES

Many of the alteration procedures I'll describe begin with the following wetting procedure (although some are done with the dry method). Cut out several sheets of magazine paper in solid colors (including black) with dimensions no less than 3″ x 5″ and preferably larger. Hold the paper firmly in both hands and hold it under a stream of water at the sink. Let the water run directly from the tap onto your paper until white striations begin to form where the ink has washed away (black is most easily visible). If striations don't appear within a few minutes, increase the water pressure until the markings become visible. You'll note that the degree of water pressure, as well as the length of time a paper is held under water, determines the amount of ink washed away and the type of markings made. When you've finished modifying the paper, flatten it and place the wet sheet on newspaper to dry (newspaper absorbs moisture and speeds the drying process).

ALTERATION TECHNIQUES

There are many tools and techniques for altering the appearance of magazine papers. Begin by experimenting with the devices described here to get you started. If other ideas suggest themselves to you, try them out. You've nothing to lose.

To produce a star dust effect, for example, place your moist paper on a flat working surface. Press your thumb gently over the surface, then lift it to release some of the ink. Increase the pressure as you see fit, using other fingers, as well, to make the markings. Run a brayer (roller) over the wet paper to make markings of different types. Or dampen another sheet of paper until it's absorbed just enough water to make it wet, but not soggy. Then run a single-edged razor blade at a horizontal or vertical slant across the paper, working gently and slowly so that you don't tear it. Two other textural effects can be produced

Any sharp, pointed instrument can be used to scratch dry paper: a pocket knife, a pen point, a compass, or the corner of a razor blade can be used to scratch in designs and drawings.

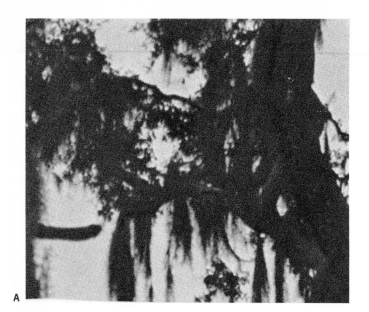

A

B

Patterned, figured, and designed magazine papers can be changed by wetting the paper, then eradicating any area of the picture that you don't wish to retain. The original designed paper is A. The same paper, wetted and rubbed out, is B.

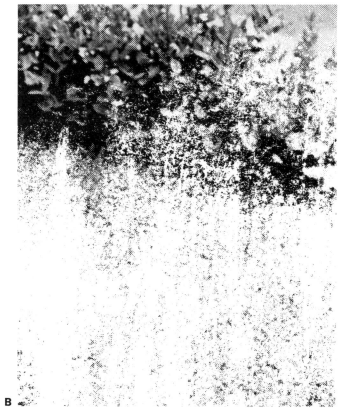

A

B

A magazine paper in its original state (A). The same paper (B) after it was moistened and erased. To eradicate unwanted areas, erase with your fingers, a cloth, or a sponge.

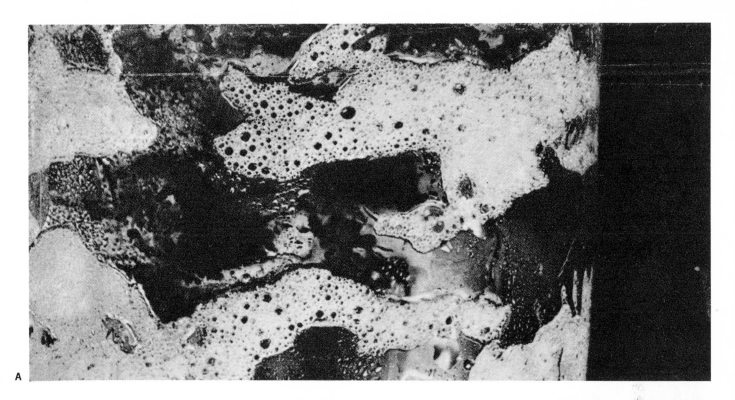

A

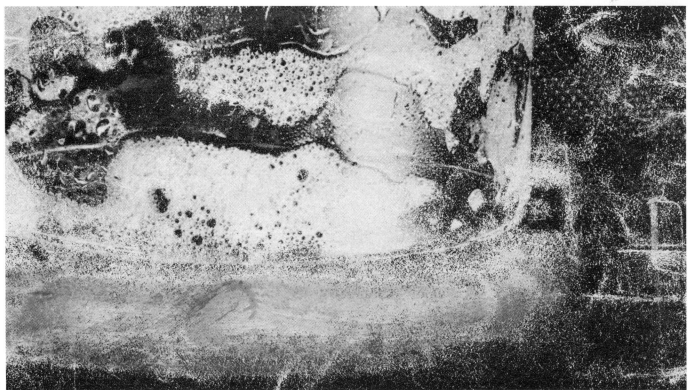

B

A beer advertisement showing foam (A) was moistened and rubbed to soften
the harsh contrast of tones and to add textural interest (B).

Wet crushing and erasing techniques can be combined. This industrial advertisement was wetted, crushed, then erased to eliminate the background color.

with an ordinary cellulose sponge. You can blot up the ink from the wet paper by pressing firmly on the sponge; and you can press the sponge into the wet surface, twisting it in a circular motion. For an all over pattern, repeat this procedure.

Any number of repeat patterns can be made in this way on moistened, solid color papers. Shapes resulting from impressions made with wood, metal, hard rubber, and plastic objects can be used. Circular repeat patterns that add interest to an otherwise inactive area can be carried out with such simple devices as the metal end of a hand-pencil sharpener or the eraser at the end of a pencil.

Although we've been referring specifically to solid color papers, it's also possible to change papers with designs, figures, and patterns, by using the same techniques. For example, the process of wetting the paper, then erasing part of the ink, permits you to eradicate any area of the picture that you don't wish to retain. Simply wipe it off with your fingers, a cloth, or a sponge. Incidentally, any altering technique can be made directly on the collage, should you wish to change the appearance of a pasted paper—*provided there's no layer of dried glue on the surface.* You need only wet the surface, then proceed to erase or modify the paper in any way you wish. Dry papers, too, can be altered. Any sharp pointed instrument—a pocket knife, a pen point, the corner of a single-edged razor blade—can be used to scratch or etch drawings onto dry paper (if you tried these methods on wet paper, they'd tear, although the blade used broadside, with caution, won't). Another interesting texture results from brushing steel wool across the surface of dry paper.

MARBLEIZED PAPERS

Earlier, I spoke of papers that can be altered to appear "as though faded, peeled, or unearthed from ancient sources." Such alterations are simple and can be successfully accomplished in a matter of minutes. For the most effective results, use intensely colored magazine papers. Black and white papers, however, can also be subtly faded. Choose papers that have a variety of strong colors on the same sheet. On papers that are designed with large areas of color relieved by smaller areas of contrasting color, the small areas may wash out completely because they don't have the intensity or scope to hold their own. This result isn't necessarily a detriment.

There are two methods for marbleizing paper: one begins by wetting the paper first; the other starts with dry paper. In the wet method, hold the paper under the water tap until it's wet all over. Then crush it, pressing until it's practically in the shape of a ball. As you crush the paper, you're producing marbleized or cracked markings. The color is running freely from one area into another, fading, merging, filling in cracks, or washing out completely. Now open the paper and place it on newspaper to dry. If your result isn't satisfactory, probably you didn't wet the paper sufficiently or use enough pressure. Try again, for you're bound to meet with success.

In the dry method, the paper is crushed first, opened flat, then held under a stream of water (you used this procedure earlier with uncrushed paper). Depending on the amount of pressure, the stream of

of water will produce the markings. Inks will wash out from the crushed areas and fade from the surrounding areas. With practice, you'll learn that the intensity of the remaining color will vary according to the amount of water and pressure it's submitted to. The striations or cracks remain fine or become wide, lighten or darken in proportion to the amount of pressure exerted. After a few attempts, you'll be able to control the degree of "fading out" that you desire from intensely inked colors.

SOME OTHER POINTERS ON ALTERING COLORS

Instead of holding a paper under the water tap, place it in a pan of water until it's faded to your satisfaction. You can blot up excess color by placing some tissue or paper toweling over any area.

For unpredictable effects, try leaving several pieces of paper in the same pan of water. These papers may be crushed or uncrushed. Combine color with black-and-white. Add a piece of strongly colored tissue paper that will bleed onto other papers. You may let these papers soak overnight, or even longer.

When you alter a sheet of colored paper, examine the reverse side to note whether it's printed in black-and-white or in color. When you process any magazine paper, you must realize that the colors printed on the reverse side will affect the final result. I mention this possibility for still another reason: if you found the same advertisement printed in a different magazine and you wanted to try for a repeat, the results in the two otherwise identical sheets might differ because the color on the reverse side differed.

An automobile advertisement clipped from a magazine was cut into sections, then altered by moistening the paper and eradicating areas with a wet sponge and with thumb pressure.

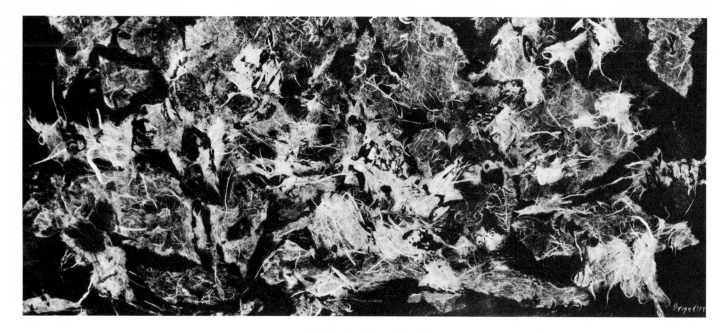

Fantasy by Anne Brigadier. Collection, Eureka College, Eureka, Illinois. Collage in various thicknesses of Natsume paper, all white against a black ground.

Low Tide by Anne Brigadier. Collection of the artist. Collage made with Chiri, charcoal, and other solid color papers.

IN THE PREVIOUS CHAPTERS, I stressed so-called "free" materials for collage—newspapers, magazine papers, wrapping papers—a supply which you must agree, is unlimited. Surely it's very satisfying to revitalize waste and it's rewarding to create something worthwhile from it. However, collagists needn't depend solely upon these free sources; they have access to countless art papers which are specifically produced for fine and graphic arts uses: printmaking, drawing, and painting.

Chapter Eight

ART PAPERS

WHY USE ART PAPERS?

Many art papers, rich in colors, textures, and finishes, combine harmoniously with other papers and serve as an enriching element in any collage. As ground colors, colored shapes, and textural additions, they're invaluable materials. These attractive papers have to be purchased, tempting us to add that you can go from rags to riches, if you choose. And you *can* choose from among hundreds of papers: printmaking, painting, charcoal, velour, origami, simulated canvas, gold and silver colored, metallic leaf, oriental, and synthetic papers.

WHERE TO PURCHASE ART PAPERS

Hundreds of art papers are manufactured in the United States, and just as many are imported from others parts of the world. Art supply stores, which stock a variety of art papers, generally print and distribute free a catalogue listing all the products offered for sale. If you were to examine several such catalogues, you'd note how very much alike they all are—even to the page sequence on which the materials are listed. Thus, any paper I recommend from one catalogue is quite likely to appear in most others.

Although your local art material dealer will have a selection of some imported papers, it will be comparatively limited. If you know the name or number of a particular imported paper not in stock, your dealer can order it for you directly from large paper merchants in the area. You, too, have access to these paper merchants and can buy your imported papers directly from them at the same price you'd pay your local dealer. See the back of the book for a list of names and addresses of paper merchants near you.

A sample booklet containing over a hundred examples of oriental papers is distributed free to art supply dealers. Your local dealer is likely to have a copy. If you wish to have a pleasurable experience, browse through this sample book at his store. You'll be thoroughly enchanted with the extraordinary variety—and unable to resist a unique purchase. By the way, this sample book of oriental papers is available to the public at large for $2.00. It's a valuable aid for reference and re-ordering. Ask your local art supply dealer or paper merchant to order a copy for you, or request it directly from Andrews/Nelson/Whitehead, 7 Laight St., New York, N.Y. 10013.

SELECTING ART PAPERS

Although color is generally the major consideration, also select your papers for color permanence, quality and durability, thickness (ply),

texture, finish, flexibility or ease of handling, absorbency, and availability. In addition to their coloristic and textural advantages, graphic arts papers must satisfy demanding printmaking requirements that make them very desirable for collage use. For example, in printmaking techniques in which a press is used, the paper is subjected to tremendous pressure. It must be able to withstand this pressure and to absorb wet color—all without tearing—conditions which make such papers ideal for collage.

However, while a printmaker will select a heavy paper for his purposes, it's in your best interests to choose lighter weight stock. To make them suitable for collage use, heavy papers have to be thinned, usually by soaking, or they require an adhesive used for three dimensional pasting. By selecting medium to light weight papers to begin with, you can avoid such needless extra expense and time consuming problems. For similar reasons, stay away from heavy weight watercolor or drawing papers. If you do choose such a paper, then use an acrylic gel or molding paste to glue it. To soak the paper, experiment with a small section, which is wiser than submerging the entire sheet in water before you know how it will react.

PRINTMAKING PAPERS

Prodigious amounts and varieties of graphic arts papers are made to meet the special needs of different printmaking techniques such as lithography, etching, engraving, woodcut, linoleum cut, silk screen, and monoprint. Domestic and imported printmaking papers are available in a wide range of colors, textures, weights (ask your dealer about suitable weights for collage), finishes, and prices. Though he'll have his personal preferences, your dealer will surely stock many of the reputable brands that have been on the art market for generations— Andrews/Nelson/Whitehead, Aquabee, Bienfang, Strathmore, Superior, Weber, and Winsor & Newton, for example, as well as many other local brands that are less well known, but equally reliable.

In addition to familiarizing yourself with domestic printmaking papers, get to know some of the imported papers, as well. Imported printmaking papers that repeatedly appear in catalogues at this writing include *Caledonian* (24″ x 36″, in four weights); *Deberasu* (20″ x 30″); *Donnasai* (20″ x 30″); *Fabriano* (20″ x 26″ and 26″ x 40″); *Holland Brown* (24″ x 36″); and *Roma Blue* (20″ x 26″). There are many other printmaking papers you might conceivably use.

DRAWING AND PAINTING PAPERS

These useful papers are produced in white, off white, cream, buff, and some spectrum colors. Of generally high quality, such papers are specially made for drawing media: pen and ink, pencil, lithographic and Conté crayons, and pastels; and for water based painting media: casein, gouache, tempera, watercolors, and acrylics. The same companies that manufacture printmaking papers also make equally fine drawing and painting papers, from which the artist can choose a wide variety at various prices. Heavy papers generally cost more than lightweight ones; fortunately, the lightweight papers are more suitable.

Charcoal papers: So that pastels, charcoals, and chalks may "grip" its surface, a paper with a grained or toothy surface is an absolute necessity for these media. This prerequisite results in papers which offer interesting textures. Many papers in brilliant or low keyed, and solid or mottled colors, are made for the various chalk media; (one company alone makes thirty appealing colors of charcoal papers). Because of their unusual features, printmakers find charcoal papers a valuable asset for certain graphic arts techniques.

In sheet or pad form, charcoal papers have much to recommend them for collage use as ready-made swatches of color, texture, and shape. The many domestic and imported papers are all attractive and modest in cost. A typical local catalogue will list Strathmore, Aquabee, Weber, and Bienfang domestic charcoal papers, as well as several brands of imported ones—many of which are 100 percent rag (the higher the rag content, the finer the paper).

Strathmore charcoal papers: Strathmore charcoal papers are available in both pads and sheets. Each pad contains twenty-four sheets—two sheets each of twelve colors—and may be purchased in three different sizes: 9″ x 12″, 12″ x 18″, and 18″ x 24″.

Single sheets are manufactured only in 19″ x 25″, in the following colors: fog blue, powder pink, pottery green, peach blow, golden yellow, minton yellow, velvet gray, storm gray, black, and white.

Aquabee charcoal papers: Aquabee papers, from the Bee Paper Company, are sold in pads only. Like the Strathmore line, they're available in 9″ x 12″, 12″ x 18″, and 18″ x 24″ sizes, and in a variety of twelve colors, with two sheets of each color, in a twenty-four page pad. Colors included are: white, ivory, sunglo yellow, tan bark, rose tan, aqua green, ice blue, lake blue, moon mist, dawn gray, skipper blue, and ebony black.

Weber charcoal papers: Some paper companies, Weber among them, market their charcoal papers in packages of one color only. A package of twenty-five Weber charcoal sheets, 19″ x 25″ each, is currently available in cool gray, cameo green, silver gray, tawny brown, azure blue, and olive green.

Bienfang charcoal papers: Bienfang manufactures pads of one color charcoal papers, 19″ x 25″, in white or solid gray. A pad contains twenty-five papers.

Fabriano charcoal papers: Fabriano, an Italian company that's been making papers for well over four hundred years, produces charcoal papers in thirty colors. In pad form, they're available in standard sizes which vary in price according to size. Single sheets are available in sizes ranging from 20″ x 26″ to 26″ x 40″.

Though some local catalogues list a few Fabriano papers, you'd have to consult import catalogues at large paper merchant houses for a complete choice. You'd see the following colors listed: cadmium yellow, mustard yellow, cadmium orange, deep orange, rust red, brick red, alizarin red, ochre red, light red, rose red, light gray, deep gray, brown gray, medium gray, purple, tan, écru, black, white, midnight blue, cobalt blue, light blue, medium blue, slate blue, cinnamon, brown, dark brown, gray brown, light green, and dark green.

Ingres charcoal papers: Imported from France, Ingres charcoal papers are available in pads and single sheets. Ingres pads, listed as *charcoal pads*, come in white only, in 9″ x 12″, 12″ x 18″, and 18″ x 24″.

An interesting two-toned paper which has a mottled effect is often listed in catalogues as Swedish paper. Tumba Ingres, the trade name for this kind of paper, is sold in 19″ x 25″ sheets in the following colors: black, white, light gray, deep gray, blue gray, sage green, cerulean blue, light brown, dark brown, medium orange, light salmon pink, and medium red.

Les Fils Montgolfier charcoal papers: Les Fils Montgolfier, a French paper company, exports charcoal papers in single sheets, white only. The standard sheet size is 19″ x 25″.

Other imported charcoal papers: In addition to a selection of brand name imported papers, most domestic catalogues also list additional charcoal papers simply as *imports*, without further identification. Though these papers come in a variety of colors and sizes, a frequent catalogue entry describes a 20″ x 26″ sheet, with the following colors offered: light tan, light gray mottled, medium gray mottled, dark gray, light salmon, dark blue, medium blue, dark brown, medium purple, and red.

Velour papers: Velour papers, so named because their surface resembles velvet cloth, were originally intended for use with pastels. However, artists have discovered their suitability for other media and have appropriated them for use with oils and acrylics as well. Collage artists incorporate velour papers into their work when they want a cloth-like effect.

Velour papers are sold in a rich range of colors, in sheets 20″ x 26″. Bienfang alone offers velour papers in yellow, white, red, pink, gray, black, brown, orange, purple, powder blue, royal blue, turquoise, light green, emerald green, burgundy, and tan.

Origami papers: These hand painted, radiantly beautiful Japanese papers were originally made to satisfy the needs of origami, the Japanese art of paper folding. Because they're inherently beautiful and also because media of all kinds can be applied over their surface before or after gluing, origami papers make wonderful collage materials. Dull coated, with color on one side only (the underside is the natural white), imported origami papers can be purchased at most Japanese import stores and from some local art supply dealers. They're packaged in various amounts and sizes, and come in twenty-two different colors. Typical package selections are: thirty-two papers, 10″ x 10″; seventy-one papers, 7″ x 7″; and forty papers, 6″ x 6″.

Aurora papers: Aurora papers, from the Bienfang Paper Company, are our domestic version of traditional Japanese origami papers. Similar in behavior and appearance to origami papers, Aurora papers are sold in packages of fifty sheets, 9″ x 12″, and are a good value. Aurora colors include: chartreuse, fuchsia, light yellow, gulf blue, rosebud, medium green, Christmas red, silver, gold, light brown, black, red, canary, lavender, green, brown, orange, ultramarine blue, white, navy blue, light blue, light green, brilliant green, maroon, gray, rust, cocoa, chocolate, and olive green.

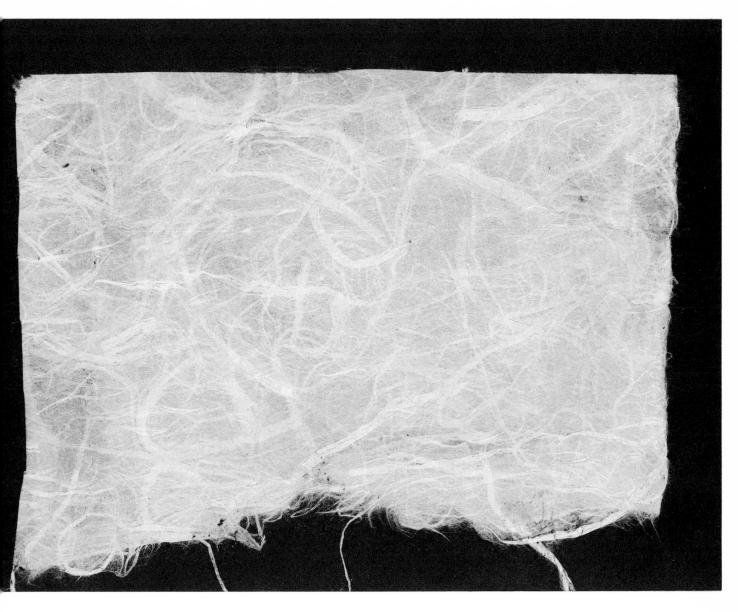

Textured Natsume papers come in thirteen varieties of colors, threads, fibers, patterns, and densities. This heavy Natsume paper offers swirling white threads against an opaque white ground. For two very different effects, the edge can either be cut with a scissors or ripped unevenly.

Shuji and Sumi papers: Both of these Japanese art papers, which differ only in trade name, are medium weight white papers used for calligraphy (either brush and ink, or pen and ink). Consequently, they're very absorbent and will take any color medium imposed over them, either before or after gluing. A package of one hundred sheets of Shuji papers, 9½" x 12", is available at most Japanese import stores, some art supply stores, and most paper merchant houses. Shuji papers are sometimes available in roll form, as well. Sumi papers can be purchased from the same sources in two sizes, 12" x 18" and 18" x 24". In addition, an American made, coarser version of Shuji and Sumi papers is carried by Woolworth's in packages of one hundred 12" x 18" sheets.

Canvas type papers: If at any time you'd like to suggest a texture in your collage akin to that of white primed canvas, you can do so with an art material that looks like canvas but is actually paper. Your local art materials dealer sells this paper in pads containing ten sheets, under the trade names of Canvas Skin (9" x 12") and Canvasette (18" x 24", 16" x 20", 12" x 16", and 9" x 12").

SILVER AND GOLD COLOR PAPERS

These papers, which are sold in sheets, offer the color of silver and various golds, but have no metallic sheen. If you use metallic foil instead of this matte paper, superimpose a transparent paper or a piece of net over it to eliminate glare and to create an interesting effect.

GOLD AND METAL LEAF

Originally used by Renaissance artists to create gold effects; today used by contemporary artists for "aged" effects, by picture framers, and by craftsmen, gold leaf also makes an effective collage paper. Genuine twenty-three karat gold leaf is available in 3½" x 3½" books of twenty-five leaves. Metal leaf, in 5½" x 5½" books of twenty-five leaves, costs considerably less than gold leaf and makes an excellent substitute. Metal leaf is available in aluminum (which looks like silver) and in pale gold (which looks like the real thing, but isn't).

TEXTURED ORIENTAL PAPERS

Handmade oriental papers are in a class by themselves. They're a visual delight and, because of their unusual textures and nuances of color, are among the most satisfying papers to work with. Some of these papers are so exquisite that it's not unusual to see a single, unaltered sheet framed, or used for Shoji screens, print grounds, drawings, or watercolors. Wherever and however they're used, oriental papers are a decided asset.

Oriental papers are excellent collage materials. Always very delicate, and frequently transparent, these handmade papers are nevertheless remarkably strong and can be cut, torn, and separated without difficulty. Moreover, they're highly absorbent and therefore adhere well to a ground. There are well over a hundred different oriental papers in

a wide variety of colors, textures, and weights. Of particular interest to the collage artist are the many textured oriental papers, in which fine threads and fibers are woven or interlaced in network effects. Some resemble milkweed hairs or dandelion gone to seed (which they probably are); others are composed of silky threads, either in white on white patterned grounds or in color on colored grounds. Some offer parchment toned ground shot through with short fibers that look like dried bits of wheat or hay.

Usually one sheet of oriental paper suffices for several collages, particularly when it's combined with other materials. Unwanted or extraneous threads in a given sheet can be easily plucked out with a tweezer. A tweezer can also be used to place single threads in position for gluing.

I won't attempt to describe individually the over one hundred different oriental papers. Instead, I'll select and describe some general groups and single types that I find valuable, hoping that you'll go on to make your own discoveries from the sample import catalogues.

Natsume papers: The textured Natsume papers come in thirteen varieties of colors, threads, fibers, patterns, and densities. Of these, only Nos. 4002, 4007, and 5019 are listed in local catalogues. The remaining ten can be selected from import catalogues, if your dealer has one. Otherwise, consult with the large paper merchants in your city for their selection of Natsume paper.

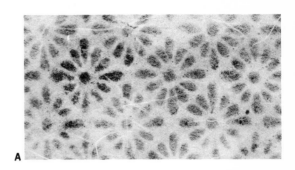

A

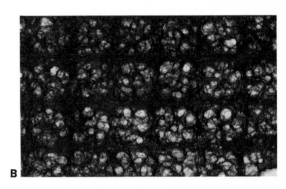

B

C

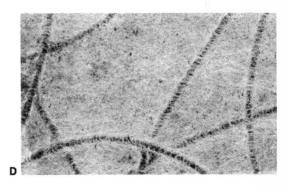

D

Examples of lace papers include (A) Hanabai, (B) black lace paper, (C) white lace paper #1, and (D) white lace paper #4. These transparent yet hardy papers come in seven patterns and colors.

Order No.	Size	Description
4002	24″ x 36″	Opaque white ground with white threads in swirling pattern
4007	24″ x 36″	Opaque white ground shot with short white fibers
5000	20″ x 26″	Medium weight white threads on a pink ground
5001	20″ x 26″	Medium weight black threads on a white ground
5002	20″ x 26″	Medium weight green threads on a white ground
5004	24″ x 36″	Medium weight white threads on a pink ground
5017	24″ x 36″	Medium weight straw fibers on a white ground
5019	20″ x 26″ 24″ x 36″	Medium weight straw fibers on a cream ground
5020	20″ x 26″ 24″ x 36″	Medium weight white fibers on a beige ground
5023	20″ x 26″	Semi-transparent white threads on a green ground
5024	20″ x 26″	Pattern variation of No. 5023
5025	24″ x 36″	Semi-transparent green fibers on a white ground
5026	24″ x 36″	Semi-transparent white threads on a blue ground

(Above) Chiri and Yamato combined with a magazine advertisement on a white ground.

(Left) Chiri paper, doubled, against a white ground. This transparent tan paper, embedded with bits of brown leaves, looks quite different over a dark ground. Contrasting tones of this versatile paper can be used to create depth in compositions. Except for its white ground, Yamato is similar to Chiri.

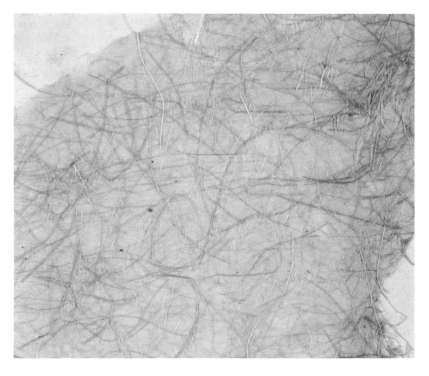

Kinwashi special paper offers small but fine straw colored fibers distributed over an ivory ground. This transparent paper tends to look white against a white ground.

Ogura paper contains long fibers of straw that form a vein-like design over a straw colored ground. Heavier than Kinwashi, Ogura is a semi-transparent paper.

Lace papers: These incredible lace papers come in seven patterns and colors. Though extremely transparent, they're hardy and can be used without trepidation. Lace papers are sold in 24″ x 36″ sheets. Hanabai lace paper, however, is available in 25″ x 37″ sheets.

ORDER NO.	DESCRIPTION
Lace paper A	Large diamond shaped patterns repeated on an umber ground
Lace paper black	Open lace patterns repeated and enclosed between solid crossed lines on a black ground
Lace paper No. 1	Variation of above, in white
Lace paper No. 2	Variation of above, in blue; has extra silk fibers scattered sparingly over surface
Lace paper No. 3	White, semi-transparent paper, with semi-opaque lines radiating from a central oval shape, also semi-opaque
Lace paper No. 4	Linear pattern on white ground, with open, freeform areas
Lace paper Hanabai	Formalized flower pattern on a white ground with a centered oval shape and small petal repeats

Chiri paper: Chiri is a transparent tan paper with different sized bits of brown leaves embedded at well spaced intervals. When superimposed, this transparent paper looks quite different over a white ground than over a dark ground. Two or more sheets of Chiri can be glued together for increasingly deeper tones. Contrasting tones of this versatile paper can be used to create depth in collage compositions. Especially useful for tidal, shore, and sand effects, Chiri sheets are 20″ x 30″.

Yamato paper: Similar to Chiri except for its white ground, Yamato can be superimposed on itself for grayish tones. Use it singly, doubly, and in combination with Chiri, magazine, and other papers. Its sheet size is 24″ x 36″.

Cloud paper: Fine but fairly dense threads of cerulean blue and sienna are dispersed on a semi-transparent, white ground to create a cloud-like effect in a 24″ x 36″ sheet.

Kinwashi special paper: Small but fine straw colored fibers are closely distributed over an ivory ground. This transparent paper, 24″ x 36″, tends to look white against a white ground.

Ogura paper: Long fibers of straw form a vein-like design over a straw colored ground. Heavier than Kinwashi, Ogura is a semi-transparent paper. Loose or raised surface fibers can be easily glued into position with any paste or emulsion.

Fantasy paper: When I mentioned a paper that's sometimes framed unaltered, I was referring in particular to Fantasy. Actually two sheets of transparent white paper with bits of dried leaves, ferns, grasses, or butterflies sandwiched in between, this group of four papers is indeed fantastic. One specimen offers the rare gingko leaf, a brown, fan shaped leaf from the temple tree, which is native to East China

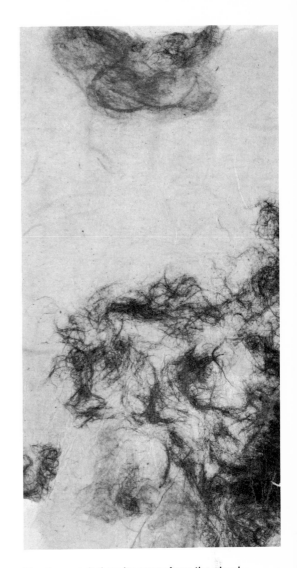

Cloud paper derives its name from the cloud-like effect produced by the cerulean blue and sienna threads dispersed in a semi-transparent white ground. Though fine, the threads are fairly dense.

and hardly ever grows wild. Fantasy papers come in 24″ x 36″ sheets. Use these ingenious examples of craftsmanship sparingly, lest you unwittingly let them dominate a composition.

ORDER NO.	DESCRIPTION
No. 1	Small green and brown leaves are clearly visible between two sheets of white paper
No. 2	Small green ferns show between transparent white papers
No. 3	The temple tree gingko leaf mentioned above, held between sheets of transparent white paper
No. 4	Butterflies of varying color and size are encased between two sheets of transparent white paper

Tosaryu paper: With their silky threads of varying lengths, these textured papers closely resemble Natsume papers. However, they're much more transparent and come in colors not found among the Natsume group. Because of the paper's silky transluscence, threads in Tosaryu are sensitive to light and tend to assume the color of the paper itself. For example, threads on a yellow ground will seem yellow in some areas and white in others, depending on how and where the light is falling on the paper. Colored sheets can be used singly for delicate effects or in two's for more intense hues. Very much like mixing your own pigments, you can produce color variations at will by gluing compatible colors of Tosaryu one over another.

Tosaryu papers can also be used as a protective device. When you're gluing delicate materials or natural objects that may protrude from your collage surface (dried leaves or grass, for example), you can assure their remaining fixed by pasting Tosaryu paper over the area. The paper is so thin that it won't conceal what's underneath, and the threads which run through the paper can be a welcome textural addition. If you object to the threads, however, you can accomplish the same ends with a threadless Tosaryu known as silk tissue. Listed in current import catalogues, silk tissue comes in 18″ x 24″ sheets, white only. Tosaryu papers, fabricated in 24″ x 38″ sheets, come in white and five colors: red, yellow, blue, green, and purple.

Tairei paper: Tairei papers are opaque textured papers in a medium weight. This paper, in 25″ x 37″ sheets, comes in six variations which are described below.

ORDER NO.	DESCRIPTION
Chinese red	A bright red paper shot with gold threads
Gray	A light gray paper with short white threads arranged in a brushstroke pattern
Brown	A light brown paper with short, white and brown threads arranged in a brushstroke pattern
Yellow	A pale yellow paper with short white threads that are barely perceptible
White	White paper with short white threads arranged in a brushstroke pattern
White and gold	Identical to above, with tiny gold dots sprinkled on the surface

Kinkami paper: Kinkami papers are textured opaque papers sold in 20″ x 26″ sheets. Kinkami, a medium weight stock, comes in three colors: red (cadmium red light), green (viridian), and blue (cobalt).

Tsuyuko paper: Tsuyuko are textured papers about the weight of strong wrapping paper. In 20″ x 26″ sheets, Tsuyuko paper is available in carmine red and in bright viridian green. Each is shot with well spaced, silky threads. These threads, though approximately the same hue as the paper itself, cast a dark shadow over it.

Unryu paper: Unryu is a white paper textured with silky white threads. This useful paper, which resembles Natsume and Tosaryu, is midway in weight between the two and comes in 24″ x 39″ sheets.

Kaji paper: This interesting paper has a unique texture somewhat different from the other oriental papers I've described. Kaji is an opaque white sheet, 21″ x 31″, with a puckered or wrinkled surface. Its weight is roughly equivalent to brown wrapping paper.

Wood veneer paper: As its name implies, wood veneer paper resembles pale wood graining. It's available in 20″ x 30″ sheets, lightweight and medium weight.

SOLID ORIENTAL PAPERS

In addition to the many textured oriental papers just discussed, I wish to call your attention to a group of solid color oriental papers which has merits of its own. Brightly colored, attractive, and as flexible as soft cloth, these seemingly untextured papers show their interesting fibers when they're held up to the light. For the most part, such fiber patterns disappear in the gluing process, leaving a smooth, matte surface which can lend contrast to textured, charcoal, shiny, or any other papers of your choosing.

There are far too many varieties of solid oriental papers to describe here. Instead, I'll choose a few of the better known and advise you to consult import catalogues for others. In addition, Japanese import shops often carry a selection of unusual solid oriental papers.

Moriki papers: Moriki papers are heavy oriental papers offered in a variety of intense colors and in white. Standard sheet size is 25″ x 36″. Colored Moriki papers are slightly higher in price than white.

ORDER NO.	DESCRIPTION
1008	Cadmium red
1009	White
1010	Dark slate
1011	Medium green
1012	Sage green
1013	Brick
1014	Dark brown
1016	Medium gray
1018	Cadmium yellow
1019	Mustard
1021	Wine

Mingei papers: Mingei papers are similar to Moriki papers except that they're lighter in weight and less expensive. The colors in each are equally intense, but the choice differs. For example, while Moriki offers sage green and medium green, Mingei has light green and dark green. Moreover, Moriki comes in gray, brown, wine, and bright red —colors you won't find in Mingei. 24″ x 36″ sheets of Mingei paper are available in blue, brick, dark green, light green, mustard, cadmium orange, and cadmium yellow and are listed in catalogues by their color.

Other solid color oriental papers: Among other good examples, *Kizuki* (24″ x 36″) is a transparent umber paper of medium weight. *Kitakata* (16″ x 20″) is a semi-transparent ivory paper, also medium weight. *Okawara* (12″ x 16″, 14″ x 35″, and 36″ x 72″) is an opaque cream or ivory paper, medium weight. A student grade of Okawara is also sold in 18″ x 25″ sheets. *Sekishu Natural* (24″ x 39″) can be purchased in two varieties: light ivory and white. Though both are medium weight papers, the light ivory is semitransparent, while the white is almost transparent. *Troya* (24″ x 36″) is a lightweight, opaque paper in white. Finally, *Toyogami* (20″ x 26″) is a paper about the weight and strength of manila wrapping paper. This opaque paper comes in three brilliant colors: cadmium red light, billiard green, and cobalt blue.

I can almost predict that once you've experienced working with these uncommonly beautiful papers, particularly the oriental ones, they'll become major elements in the collages you create.

Fragmented Figure by Anne Brigadier. Private collection. This collage combines Chiri papers with Moriki, a heavy oriental paper.

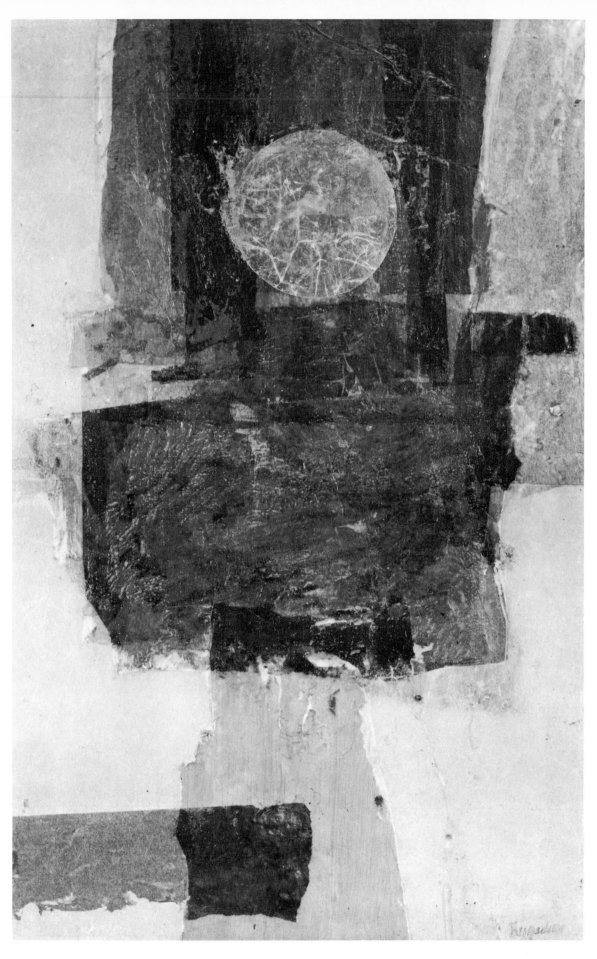

Homage to Hans Hofmann by Anne Brigadier. Tissue collage. Private collection, New York.

IF ASKED to describe tissue papers, you'd say unhesitatingly that they're papers generally used for regular or gift wrapping; and you might further add that they're thin, transparent papers found in white and in many colors. This would be an adequate description. However, what you might not know or particularly care about is that tissues are manufactured from rags, sulphite, and soda—a combination which makes them extremely absorbent, and thus able to soak up many dyes to produce a great profusion of colors.

GENERAL USES OF TISSUES

Most of us daily use tissues in one form or another: as wrapping paper, facial tissue, or toweling; for cigarette papers; and in carbon copies of manuscripts and letters. The favors that decorate our party tables and the artificial flowers that brighten our homes are made of tissue paper. Large tissue sheets commonly cover our new clothing to protect it against soilage. When crushed, these seemingly fragile papers can cushion and thereby safeguard even the most delicate and breakable objects.

Since tissues are neither costly nor esteemed, they're considered disposable. Facial tissues and toweling, in fact, are *meant* to be discarded. We tend to throw out tissue wrappings as fast as we can unpack them, only saving sheets whose colors strike us as particularly appealing. Even our language expresses our contempt for this paper. When describing a fabric as being "thin as tissue," we're really making a derogatory remark about its inferiority as a material.

WHY USE TISSUE IN COLLAGE?

So fragile, gossamer-like, and light that a sheet will take off like a kite in the breeze and tear if handled roughly, this flimsy paper is nevertheless easy to apply and wonderfully adaptable to innumerable collage techniques. When used with acrylic polymer gluing emulsions (which contain hardening agents and preservatives), tissues become quite strong and will retain their brilliant colors while still preserving their transparency.

Here, then, is a ready-made collage material in incredible colors whose range is even more varied than those found in artist's pigments. Yellows, for example, run the gamut from the lightest tints to the deepest tones—a spectral range equally available in blues, greens, reds, oranges, and violets. Moreover, tissue papers adhere well to any kind of ground. When used alone, they make elegant collages. On the other hand, they combine handsomely with cloth, string, and every type of paper.

HOW AND WHERE TO BUY TISSUES

Tissue papers are such a joy to have around for their color lift alone (as many as thirty different colors are listed in local art material catalogues), that you'll find it hard to restrain yourself when making a selection. Happily, there's no need to try. Tissue papers are so inexpensive that you can afford to indulge yourself.

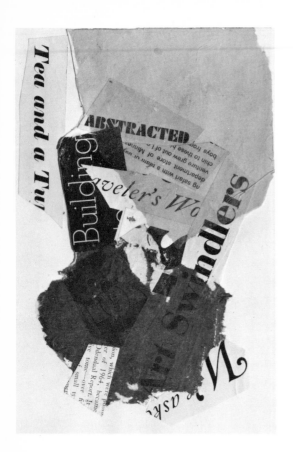

A single layer of tissue has the same effect as a color wash, but is easier to apply. Not all tissues, however, have the same degree of transparency. The newsprint in the upper right, for example, shows clearly through the overlying red tissue, while it almost disappears in the lower half of the collage, where blue tissue has been superimposed.

When purchased wholesale in large quantities, tissues currently cost less than one cent a sheet. Their retail price is slightly, but not significantly, higher. For under one dollar you can buy a quire (twenty-four sheets) of one color, in a standard 20″ x 30″ size (folded to 10″ x 15″). You can also purchase tissue papers in variety packs, in 12″ x 15″ and 15″ x 20″ sizes, containing from fifty to one hundred sheets in twenty-nine or more colors per package. Sold for as little as one dollar under the brand names of *Tissue Craft* and *Craft Tissue*, these papers are somewhat heavier than regular tissue, but are nevertheless transparent.

Regular tissues are available at art supply stores, Japanese import shops, large paper companies, five and ten cent stores, stationery stores, and from Party Bazaar, 390 Fifth Avenue, New York, N.Y.

In addition, large paper companies import a Japanese tissue called *Hakone* which is available in twenty-eight colors. Finally, *Madras* papers—tissues that have bands of multiple colors on the same sheet—can usually be found for well under a dollar in dime stores and Japanese import stores.

GLUING TISSUES

Tissues may be glued directly to your ground or prepared in advance in sizes suited to your needs. An acrylic emulsion glue is most desirable for tissues, but any thick glue thinned with water will serve— provided it has a water or acrylic base. As I've previously mentioned, acrylic emulsion strengthens tissues. When coated with this adhesive, even a single layer of tissue no longer seems fragile; yet it remains extremely transparent. Although four or more tissue layers glued together with acrylic emulsion may assume a rubbery texture and may be hard to pull apart, they will still remain transparent (some colors more so than others). Red, for example, is more transparent than blue, and light colors are more transparent than dark ones. Take advantage of this variation in transparency.

Furthermore, the color values of layered tissues change. If you want to counteract tonal darkening, alternate your color sheets with layers of plain white tissue. You should also keep in mind that when several layers of different colored tissues are glued together, the papers in the lighter colors will reflect the underlying colors better than darker colors will. For example, emerald green light, and pink will reveal more underlying color than dark blue.

MIXING COLORS TO MAKE A TISSUE PALETTE

Assuming that you have papers in only the three primary colors—red, yellow, and blue—you can at once double your color range to include orange, green, and purple. The procedure for doing this is so simple and elementary that it's known by every schoolchild. If you can mix crayons and other pigments to produce these colors, you can also "mix" tissues. To make secondary colors from primary colors, simply glue together the two appropriate tissues: yellow and red for orange; yellow and blue for green; and blue and red for purple. Thus, you'll extend your color range to six hues.

CREATING TONES WITH TISSUES

Again using just primary color tissues, you can increase your color range still further. By gluing several layers of the *same color* one over another to intensify or deepen the hue, you can change the tonal value of that color. This variation of value, while permitting you to remain within the same tonal range, helps create depth, or shadows, in a composition. Such darks against lights can be used to emphasize a line, an edge, a mass, or a form, thereby adding contrast to any picture.

SEQUENCE OF COLORS

By adding only one extra color to your primary, it's possible to produce a still greater variety of tones. The outcome, however, will largely depend upon the order in which you superimpose the colors. That is, the sequence with which you mix tissue colors will affect the resulting color.

Let's note what happens, for instance, when a red and a blue paper are glued in different sequences. When a cadmium red tissue is glued to a white ground, and a cerulean blue tissue imposed over it, the resulting color is purple. If you reverse the order, placing the blue first over the white ground, you'll get a color close to maroon. The order in which you paste the same four colors of tissue—red, blue, yellow, and emerald green light—will produce many different colors and as many as four variations of one color alone. Yellow, for example, will range from light to mustard, depending on the sequence of colors you use.

TESTING FOR COLOR EFFECTS

You can test color effects with tissues much as you would with pigments: by making small samplings until you're satisfied. In pigment mixing, the ratio of one color to another determines the result. To a degree, the same is true of tissue mixing.

To test for color effects, place small pieces of tissue one over another and hold them against a strong light or up to the window. If you prefer, glue small samplings together with thin adhesive (you needn't wait for it to dry). To see approximately how a tissue will look after it's been covered with a layer of acrylic emulsion and allowed to dry, just wet your thumb and make a mark on the paper with it. Any pasted paper that proves unsatisfactory on the actual ground can be removed while it's still wet. Just be sure to clean the newly exposed area before proceeding.

DRAWING AND DESIGNING OVER TISSUE

Designs can be drawn on tissue with pens, markers, brushes, rubber stamps, sprays, etc. If your tissue isn't yet pasted onto the collage ground, be sure to work on a firm surface to prevent the paper from tearing—possibly doubling it to prevent this from happening. Inks will adhere well to tissue, even when emulsion has dried over the surface of the paper.

Black Japanese lace paper is superimposed over yellow and black tissues. The openwork of the lace allows the underlying color of the paper, as well as the white of the exposed ground, to show through.

Tissues can be cut or torn into desired shapes. In cutting, hold the tissue against a piece of cardboard and cut the two materials together.

Tissue shapes can be used as separate design elements or can be laminated between layers of tissue to add pattern interest.

Pastels, charcoal, chalks, and crayons will adhere to any tissue whose surface is free of dried acrylic emulsion. However, you must spray pastel, charcoal, or chalk with fixative to prevent these media from smudging and dusting off.

If you decide to add another layer of tissue over one which has a design drawn on it in one of the above media, proceed in the following way: first, add acrylic emulsion to the underside of the papers to be glued. Don't place any acrylic emulsion directly over an area drawn with pastel, charcoal, or chalk. Then position the paper immediately and cleanly, avoiding shifting it once placed, to prevent smudging. Instead of using the usual broad pasting method, gently *tap* the glue into place around the drawn area.

Pencil markings can be an effective design medium on tissues. Just be sure to use a soft lead rather than a hard one to avoid tearing the tissue. Pencil, like ink, is another medium that will adhere to tissues which have acrylic emulsion dried on their surfaces. Moreover, because acrylic paints have the same acrylic polymer base as emulsion, they can be brushed onto tissues—whether the tissues are in their original state or covered with a coat of acrylic emulsion. Apply acrylic paints with a palette knife, a brush, or squeezed directly from the tube as thickly or as thinly as you wish. Acrylic emulsion can't be applied over oil paints. However, oil paints can be applied over acrylic emulsion. Oil based and water based spray paints can be used over tissue within the limits described.

PREPARING YOUR PAPERS IN ADVANCE

For the most part, you'll probably be gluing single pieces of tissue of one color directly to your collage ground. However, you can prepare sheets of tissues in multi-colors and many shapes in advance, then apply them to the ground as you need them. The advantage of advance preparation is that it allows you to choose immediately from a selection of colors and shapes just waiting to be picked.

To prepare your papers in sheet form in advance, all you need are tissues, acrylic emulsion, single edge razor blades, ordinary wax paper, and a brush for gluing. You'll also need a glass palette or one or more pieces of ordinary framing glass, 9″ x 12″, or larger. Tape the sharp edges of the glass with masking tape to avoid accidentally cutting yourself.

LAMINATING TISSUES WITH ACRYLIC EMULSION

Place a sheet of white paper under the glass (the white will reflect your colors best). Use a semi-fluid gluing emulsion rather than a paste. If your glue is very thick, thin it with water. Make sure the glass is clean, then brush a light layer of acrylic emulsion directly on the glass. Now position a sheet of tissue on the wet surface. Next, brush a coat of acrylic emulsion over the paper itself. Let the paper dry on the glass.

If you like the effect of a single tissue embedded between two layers of acrylic emulsion, then let the paper dry as is. If you wish to continue laminating, position a second layer of tissue over the first

Crushed paper effects are created by rolling tissue into a ball, opening it only partially, and brushing acrylic emulsion over and under the crushed areas.

and brush a new coat of acrylic emulsion over it. Repeat this procedure, if you like, until you've pasted four—but no more—layers of tissue. Later on, you can experiment with additional layers, but let four be your maximum now. If you decide to alternate your colors, remember to wash your brush after each color is used to prevent discoloring the acrylic emulsion. Even if you use only one color, you should still wash out your brush for the same reason—but you need do so less frequently.

DRYING AND REMOVING EMULSIFIED TISSUES

When all four layers are completed, allow your emulsified papers to dry for at least an hour on the glass. Drying time, of course, always depends on the number of layers you've laminated and on the thickness of the acrylic emulsion you've used.

Removing dried papers from the glass is a simple procedure, but one that should be carefully followed to avoid tearing your papers. When the tissues are dry, saturate their surface with cold water, using a brush and allowing the water to soak in for several minutes. The water won't affect the color of the tissue because the color's been sealed in with acrylic emulsion. Pry off one end of the tissue with a razor blade. If it doesn't yield, add more water. Once you've released a small section of paper, continue to add water to the underside as you direct your blade downward toward the glass, *but not toward the papers.* As soon as a section of the paper is released, and as soon as enough water has penetrated to the undersurface, the papers will peel off as you lift them by their ends.

If your papers tear during this procedure, it may be due to one of the following causes. Perhaps you didn't wait long enough for the papers to dry; or, you forced your blade against the paper instead of the glass. Possibly, you didn't allow enough water to saturate the underside of the paper. In any event, if you've torn a paper, start again, making certain that your glass is clean. The procedure itself is so simple that after a few tries you'll become expert at executing it. Have more than one good sized piece of glass available so that you can prepare more than one paper at a time.

When you've removed your papers from the glass, they'll be somewhat damp and tacky. To dry them, place them on a glass surface or on a sheet of wax paper or tin foil (unless they're to be used immediately). During the drying process, the papers have to be lifted repeatedly and replaced on dry areas to prevent them from sticking. If the glue-coated paper is permitted to dry undisturbed, the wax paper will adhere to the laminated papers and will interfere with the transparency of your tissues. When dry, store the tissues between fresh sheets of wax paper until you're ready to use them.

PREPARING TISSUES ON WAX PAPER OR TIN FOIL

Wax paper or tin foil can be used instead of glass to laminate papers. However, there are some differences in procedure which must be carefully observed. You can't brush a layer of acrylic emulsion onto the wax paper or foil as you did with glass because the tissues will

adhere to either material (though not as quickly to the foil). Instead, begin by laying out an ample piece of wax paper on a firmer working ground. Proceed just as you did when you worked on glass, with one exception—eliminate the first coat of acrylic emulsion. Alternate layers of paper and acrylic emulsion until you've laminated no more than four tissues. After ten minutes, lift the tissues from the wax paper and replace them on a fresh sheet of wax paper. Repeat this lifting and replacing procedure every ten minutes until you're certain that the tissue will no longer stick to the wax paper.

It's to your advantage to use glass rather than wax paper. You might conceivably have to leave papers glued to the drying surface for some length of time before removing them. With glass, you could do so for an hour, a day, a week, a month—even a year or more—without any ill effects to the papers or their colors. They've been sealed in with acrylic emulsion and are thus preserved.

To remove papers which have been left on glass for a prolonged period simply requires more soaking, more prodding, and a bit more patience. Papers that I left for over a year were easily removed by completely immersing the entire glass in a basin of water. Heavily layered papers, too, will lift easily if first immersed in a basin of water for at least an hour, and possibly overnight. To be sure, such papers will be quite wet and will take longer to dry, but with no ill effects on the paper.

EXPERIMENTING WITH TISSUE AND ACRYLIC EMULSION

Once you understand the technique of laminating tissues with acrylic emulsion, you can apply your skill in many ways to create an unlimited number of effects. For example, instead of laminating single sheets that are all the same size, you can glue as many *strips* of tissue as your glass can accommodate—all different lengths, widths, and colors. As a first experiment, cut several strips of various colored tissues —at least six strips, in a minimum of four colors. For the sake of simplicity, cut them in 6″ to 8″ lengths and 2″ to 3″ widths for your first try. Until you're more proficient, *cut* rather than *tear* the tissues. Using acrylic emulsion, glue these papers side by side, by lengths or widths and in one or more layers, until you've no more room on your glass. Let dry, then remove as instructed.

Try this experiment again, but this time use irregularly shaped and torn strips of tissues (rather than the evenly cut ones that I previously recommended). The results are certain to prove even more interesting.

Has it occurred to you that you can glue an entire collage onto your glass surface with acrylic emulsion? A collage so constructed can then be removed and replaced on a sturdy ground after it's dry. It will solidly adhere, provided that you've applied enough acrylic emulsion to that ground. If the entire collage won't lift off the glass easily, remove it in sections and glue these pieces to the ground one at a time, matching the sections. Small collages are most easily done in this manner. If you're working with thickly layered papers, use a heavy paste, preferably a gel.

As you work, other possibilities with tissue papers may occur to you. If you take the time to try whatever comes to mind, you'll make

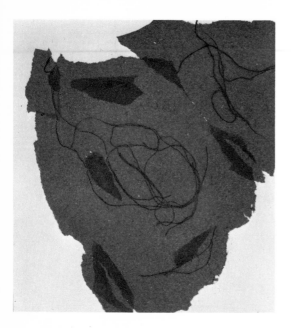

Pattern interest can be added to tissue by gluing it over thread or string. In addition, tissue superimposed over string holds the string securely in place and helps intensify its linear patterns.

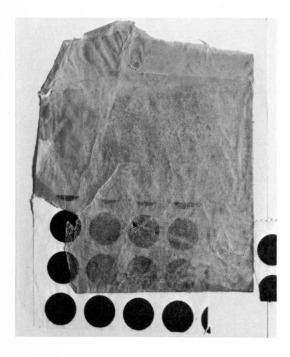

In gluing tissues over other materials, remember that tissues in lighter hues permit more transparency than those in darker hues and that a single layer of tissue is more transparent than two or more layers.

many unexpected and interesting discoveries, each one leading to the next. Many of the techniques I've described here resulted from my willingness to try *anything*; others have been sheer accidents.

ADDING PATTERN INTEREST

It's entirely possible to add pattern in one form or another between layers of tissue or to introduce contrasts that will remain clear and harmonious. As an experiment in pattern, select sheets of red, yellow, and black tissue, as well as some ordinary newspaper. In the usual manner, spread a layer of acrylic emulsion directly on the glass. Over this, position a layer of red tissue and coat its surface with acrylic emulsion. Cut out some shapes from black tissue and place them over the emulsified red sheet in whatever pre-arranged order you choose. Brush acrylic emulsion over these shapes, then enclose them under a second layer of red tissue. Add a new coat of emulsion and let dry.

Try the same experiment again, but instead of arranging the inner papers in advance, let them fall at random. Actually cut them out over the tissue surface, making sure that you've applied enough acrylic emulsion so that the papers will adhere where they fall.

For a third experiment, use the yellow tissues as layers. Repeat the previous experiment; but in addition to incorporating pieces of black tissue as pattern elements, also snip in bits of newspaper for contrast, letting them fall where they may. From now on, why not improvise other possible combinations?

String and thread are useful materials for adding pattern interest. Moreover, they adhere easily to collage grounds, provided that generous amounts of acrylic emulsion are used. A good way to fix string and thread even more securely in place is to paste tissue—which is transparent—over the area where the string and thread are glued. Not only does the tissue add security, it also intensifies the linear pattern made by the string, thus adding interest and contrast to the area.

STAINED GLASS EFFECTS

If you were to glue four or more layers of tissues of the same color or of colors that blend well, you'd find them quite strong because of the acrylic emulsion, which dries hard. Try to use this principle to simulate tiles for stained glass window effects or as strips or areas of color.

Teachers working with young children can suggest that the students cut out several simple shapes from a sheet of heavy paper. Behind these cut-out "windows," the children can tape (scotch or masking) the tissue. When completed and held up to a real window or against artificial light, the colors of the stained glass tissue will become beautifully illuminated. Older children, with more advanced manual skill, can use illustration board instead of paper to cut out geometric or other shapes. Ideas for cut-outs include using names—your own or someone else's—or short words. Or, cut simple contour outlines of flowers, sea life, or animals, and build up your emulsified tissues within them. Black illustration board (use a minimum size of 9″ x 12″) in a medium weight makes a dramatic contrast to the tissue tiles. These stained glass

cut-outs can be made into free standing pieces of art by butting panels of illustration board to either side of the central board and securing them with scotch or masking tape. Place the finished panel on a table near a lamp or a natural light source.

Another idea for using the stained glass concept is to place the emulsified tissue shapes between two pieces of medium weight acetate or glass or Plexiglas and to tape the edges. If you use glass, make a stand from a block of wood, carve out a thin but fairly deep groove, and insert the glass in it. To make mobiles from these "stained glass" tissues, build them up in four or more layers, cut them into whatever shape you choose, and suspend them from wire or string.

VEINED EFFECTS

In your work, you've probably noticed that a wet tissue wrinkles, puckers, and becomes marked with striations that resemble veins. When you were gluing, perhaps you were even forced to smooth out your tissue to remove these "defects." Now I'll show you how to encourage wrinkling or veining in tissues to produce unusual effects.

Papers with veined effects can be prepared directly on the ground after you've learned to control the procedure. For the moment, you'll do better to work out this technique on glass. (Wax paper isn't suitable for this procedure.) Crush a piece of tissue into a small ball, then smooth it open. Brush a coat of acrylic emulsion on your glass and put the paper over it; then let it rest for a few moments to permit the veining action to set in. With an emulsion-charged brush, encourage the veining in the direction you wish it to go. After a few attempts, you'll be able to control the results almost as though you're drawing. You'll note that the veining begins to suggest objects such as trees, leaves, stained glass windows, and many other shore and land patterns. As the veining sets in, keep brushing on acrylic emulsion so that the pattern will remain in place and become hard when dry.

For crushed paper effects, again roll your paper into a ball and open it, but only *partially*. Brush acrylic emulsion over the tissue, being sure to spread it both over and under the crushed areas. If you crush the paper directly on your collage ground, use a piece of tissue larger than the area to be covered to make allowance for the diminished size after crushing.

TISSUES AS COLOR WASHES

Tissues can be used quite effectively in conjunction with acrylic emulsion as color washes over numerous collage materials. A single layer of tissue so used has the advantage of being easier to apply than a wash of actual paint. Over newsprint, for example, a layer of emulsified tissue adds color, but doesn't affect the transparency of the underlying newspaper print. Tissues glued in single layers over magazine papers also permit maximum transparency and won't cause underlying inks to run. Colored magazine papers, in their original state or altered by crushing, wetting, scratching, etc., combine with tissues and acrylic emulsion without difficulty. Tissues can be used as color grounds or as superimposed washes of color over billboard papers or posters.

The natural tendency of wet tissue to wrinkle or "vein" can produce unusual effects, like this shore and land pattern.

Papers with veined effects can be prepared in advance on glass or, once you've become adept, directly on the collage ground.

Veining can be encouraged to go in a particular direction with an acrylic emulsion-charged brush—so that the results can be controlled almost as though you were drawing.

Bleeding tissues imprinted on newsprint add depth and color.

BLEEDING AND HOW TO TAKE ADVANTAGE OF IT

Strongly colored tissues have a tendency to bleed, or run, when wet. The tendency of tissue paper to bleed shouldn't be considered a drawback because it can be controlled and put to practical use. Moreover, any undesirable color stain on a white ground can be removed (if done so at once) with a wet cloth, and, if necessary, soap—provided that the ground is firm. It's wise to have facial tissue or cloth rags at hand as you work to absorb any running color. However, running color should sometimes be permitted to merge with an adjacent color if it will produce a harmonious effect.

IMPRINTING WITH BLED COLORS

While at work, I accidentally discovered a practical use for running color. A wet tissue fell, unobserved, onto a white paper. It dried, then lifted of its own accord, revealing an imprint of good color. This triggered an idea: why not try to use tissues in several colors, overlap them in some areas, then press *dry* colored tissues onto *wet* white paper? First, I dampened (with water only) a sheet of absorbent, medium weight, white drawing paper. Then I placed the dry tissues on the paper. To get out as much color as I could, I pressed down on the paper surfaces with a rag (a dry brush works, too). The papers were left to dry for an hour or more. The result? Many clear colors, as well as some attractively merged ones emerged on the white paper as a result of this technique.

In turn, this experiment suggested a use for tissue papers other than as pieces of color for collage. Tissue bled colors, imprinted on white paper, make beautiful and colorful backgrounds for superimposed drawings done in any number of media. The results of such an approach bring to mind wash drawings of such artists as Raoul Dufy, Paul Klee, Joan Miro, and Fernand Leger. This isn't to suggest that these distinguished artists themselves worked in so superficial a manner, but rather that many artists develop the inner structure of a painting in color and depth while simultaneously integrating contour drawings over the background. Once you've tasted the possibilities inherent in imprinting with bled colors, your reluctance to toss out waste tissue may lead you into the habit of keeping white paper close by as you work and casually adding tissue scraps to it as you go along. Or, you may prefer to let these scraps accumulate and then prepare them all at once, at the close of a studio day.

OTHER EXPERIMENTS WITH TISSUE

Recalling that I used tissue as a color wash (glued with acrylic emulsion directly over newsprint and other papers), I was curious to test how much bled color would adhere to the newsprint itself and to see whether or not the wet newspaper would remain intact. When I dampened the newspaper and placed dry tissues over it, the color washed on easily enough, with no ill effects. While the color it produced was less intense than usual, it was also perhaps more subtle.

Wondering what might happen if I dampened white paper with

acrylic emulsion instead of water to bleed tissues, I discovered that a change in procedure was called for. After leaving the tissues on the emulsified paper for ten minutes, I tried to see how the color was taking. It was impossible to lift the tissues because they'd become strongly bonded to the white paper. Nevertheless, I didn't consider this mishap a total failure, realizing that the bonded tissue could be used in future collages or employed as backgrounds for drawings. I then repeated the experiment and found it necessary to remove the tissues after three or four minutes. The resulting imprint was deeper than those made with water because the acrylic emulsion, being denser, diluted the dye less.

TISSUES AND OTHER PAPERS

Being quite compatible, origami and tissue papers make attractive combinations and entail no gluing problems when they're bonded with acrylic emulsion. These highly colored papers and tissues can be used sequentially to create any number of interesting color effects. Japanese papers such as Chiri, Ogura, Fantasy, and lace make ideal materials to combine with tissues, since they're similar in weight and transparency. Japanese papers can be used in any sequence or in any combination with tissues, and they can be superimposed to create interesting design and color effects.

Silver, gold, and aluminum foil papers can be modified in fascinating ways by combining them with tissue papers. When various colored tissues are glued over such surfaces (and this is done easily with acrylic emulsion), they create quite subtle effects. Tissue removes the glare from metallic foils, producing an effect similar to light shimmering under water. Naturally, tissue colors respond differently to silver and aluminum papers than they do to gold, since the former are cool colors, while the latter is a warm color. For example, a cerulean blue tissue pasted over gold foil produces an antique green-gold effect. The same tissue pasted over silver or aluminum foil allows the metallic shimmer to come through, but preserves the hue of the cerulean blue. Red tissue over gold foil creates a warm gold tone. Over silver or aluminum foil, however, the red color will predominate. Most tissues in deep colors will react in a like manner when placed over foil.

Fine and coarse sandpapers also make suitable collage materials in conjunction with tissues. Because sandpaper can be purchased in colors, as well as in tan, be prepared to expect tissues over a sandpaper ground to react according to the same color rules that apply to canvas or any other toned ground.

TISSUES AND CANVAS OR CLOTH

Canvas, primed and unprimed, makes an excellent collage ground for most materials. Tissues will adhere easily to a canvas ground with acrylic emulsion. While a primed canvas is generally white, the color of an unprimed canvas varies according to the type of linen or cotton from which it's woven—from tan to off white.

Just as the color of a pigment is modified by the color of the ground over which it's been applied, so will the color of a tissue vary

A carnival advertisement cut out of a newspaper is dramatized by a single layer of red tissue, which acts as a color wash.

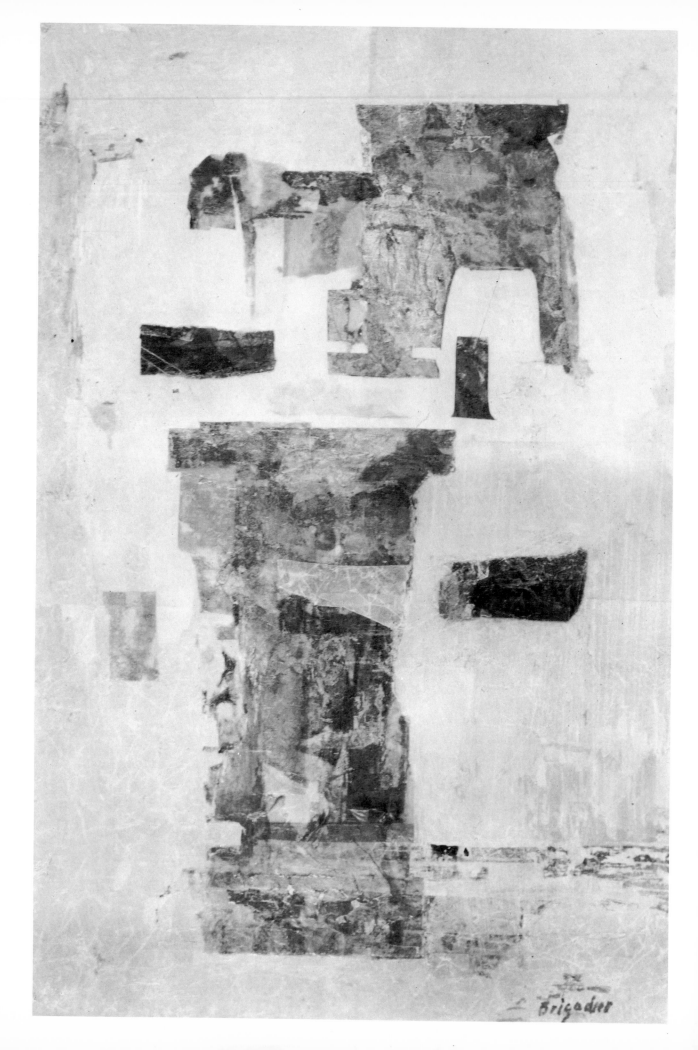

according to the ground over which it sits. Therefore, you must take into consideration the color of your canvas ground, in order to judge the effect it will have on the color of the tissue glued over it. For example, a yellow tissue laid over a white canvas will remain clearly yellow. Over an unprimed linen canvas, on the other hand, the tissue will look considerably different. (Naturally, you can tone your canvas any color you like, with paint or other media.)

When you're making color tests, pieces of tissue will appear one way when held up against the light, but quite another way when placed against an opaque ground. Stay alert to the possibilities of similar color variations—particularly to avoid unwanted results and to understand why, for example, the same color reacts one way on one ground and another way when repeated on a different ground.

TISSUES AND OTHER PAPER CUT-OUTS

To cut a tissue into a desired shape, hold it against a firmer paper or against a piece of cardboard and cut the two materials together. Dry tissues may also be cut against glass with a sharp blade or a cutting knife. Don't try to cut wet tissues on glass because they'll gather and tear unevenly. Tissues that have been coated with acrylic emulsion and allowed to dry are rigid enough to be cut satisfactorily without any additional support.

Overlays or cut-outs can be used over various colored tissues for unusual effects. For example, cut out a shape with varied inner openings from any paper that will adhere easily to tissue (charcoal, origami, wrapping paper, lightweight illustration board, or drawing and watercolor papers). Place this cut-out over the tissue areas and move it about until you get the best color effect. Then glue it in place with acrylic emulsion. There are times when this procedure can perceptibly change the context of a collage—particularly when you're in some difficulty with composition. Overlays and cut-outs can be a "way out."

I know you'll enjoy working with these colorful tissues. If you react to them as my students usually do, you'll find it next to impossible to set tissues aside in favor of other materials.

Triumphal Column by Anne Brigadier. Tissue collage. Collection of the artist.

A black oil in water print done on white mimeograph paper. The smooth and shiny finish of this common paper creates results quite different from the effects achieved on a more absorbent, dull surfaced paper.

An example of a second oil in water print made on absorbent, matte finish paper. No two prints made by this method are ever identical. Disturbance of the water and the decreasing amount of paint are the two variables that prevent duplication.

(Left) This oil in water print is made in black on absorbent white Japanese paper, which has a matte finish. The effect is very graphic.

A CONSIDERABLE NUMBER of papers that vary in type, color, pattern, and texture have been suggested for your use thus far. If no other sources were available, these papers alone would be more than adequate materials for an endless number of interesting collages. Were I to classify the papers dealt with up to now, I'd call them found materials because their colors, patterns, and textures are an integral part of the original papers—regardless of how we manipulate them or in what contexts we place them.

Now we'll explore still another source of collage papers as I introduce you to techniques that will permit you, quickly and easily, to control the color, pattern, and texture of your collage materials. These techniques include monoprints, multiple prints, and procedures for using color left over from palettes or brush wipings (which may be applied to paper). I'll show you how to work with oils, spray paints, acrylics, drawing media, and inks; and how to apply wax and oil crayons directly or indirectly onto paper and cloth. With these varied media, you'll be able to apply color to art papers, tissues, cardboard, canvas board, newspapers, and magazine paper. (Bright color brushed against the black print of newspaper and magazine papers can be a decided advantage.) The techniques I'll cover are not only quick and easy, they also have the advantage of being fast drying. I don't intend to delve into complicated printing techniques, wishing simply to show how color and pattern may be added to papers for almost immediate use.

OIL IN WATER PRINTS

Oil in water prints are one-of-a-kind prints made by adding oil paints to water. They're so simple to do and the process is so immediate that you need wait only for the paper to dry before using them. Very little equipment is required to make these monoprints. You'll need a tin or enamel pan, 2" to 3" deep and approximately 12" to 14" long. Unless you intend to print very large papers, this size will suffice. You'll also need the following materials: brush; oil colors; rectified turpentine; glass jars to mix and store colors; papers of any type in white and in color; water; newspaper on which to dry the papers after printing; and disposable gloves if you wish to avoid stains.

Have all your materials close by, for this type of printing must be done quickly. Arrange your papers near you, in single sheets rather than in piles (especially if you intend to wear gloves), because when oil paint is added to the surface of the water, it makes a pattern which may change with the slightest movement. You'll have to work quickly if you wish to capture a pattern before it changes. In a glass jar, mix your oil color (one color only, whether pure or mixed to obtain a particular shade) with enough turpentine to make the paint runny, but not thin. Thin color prints poorly. Carry out this mixing procedure thoroughly, for blobs of unmixed color will sink to the bottom of the pan and be useless. (For your first attempt at an oil in water monoprint, try using black oil paint on white paper to insure a sharp effect.)

Fill your pan with water until it's no more than one third or one half full, to prevent it from splashing and spilling when you shake or move the pan about to change a color pattern. Pour some of the oil

PREPARING YOUR OWN PAPERS

Another example of a second oil in water print made on absorbent, matte paper. Subsequent sheets immersed in the same bath will print different patterns, each of which will be successively lighter in color. If you wish a second printing to have greater intensity, add more oil of the same color.

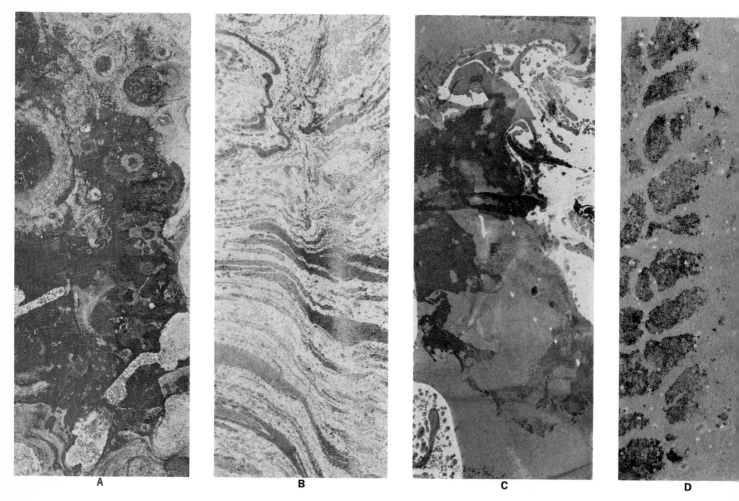

A B C D

Each type of paper reacts differently to immersion in an oil in water bath. Here are four different effects (A, B, C, D) produced on four different stocks.

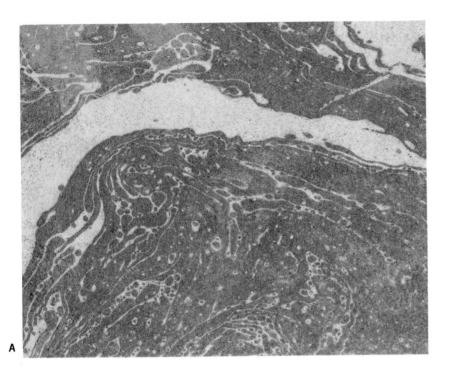

A

These oil in water prints (A, B) were done in cadmium red on very absorbent white paper.

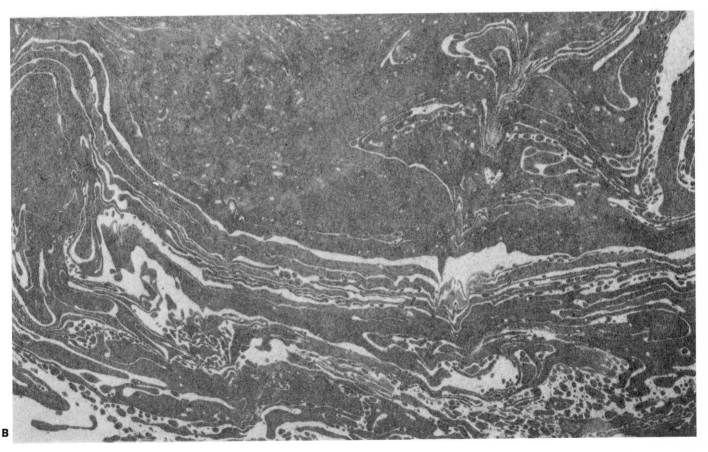

B

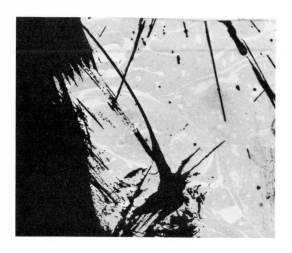

Oil in water prints can be made on found papers. This print, for example, was created from a section of an exhibition notice immersed in a single blue bath.

This soft effect was achieved as a result of a third printing.

Black and white oil in water print combined with Natsume paper.

color from the jar directly over the water so that it covers an area about the size of the paper on which you intend to print. Instead of letting the thinned paint *flow* out of the jar, *toss* or *thrust* the color into the water. This technique helps produce a pattern. However, if a solid form is made which you wish to change, simply break into the form with a brush, knife, stick, or any other suitable instrument until you produce some desirable pattern variations. Another method for adding oil paint to the water is to fill a brush with paint and, with a snap of the wrist, to toss the color into the water. Continue until you've created a pattern you wish to print.

To make the first monoprint, hold your paper securely at both ends, directly over the pattern you intend to print. When the paper's correctly placed, drop it completely into the water, or hold the paper without releasing the ends so that it just touches the surface of the water. The print will be produced in a matter of seconds, particularly if the paper is very absorbent. If you release the paper, it will sink below the surface of the water, creating a second—and different— design on the topside of the paper. Whether you submerge the paper in the water for two distinct designs (choose the one you prefer), or else remove it at once, dry the print flat on newspaper, design side up. If you prefer, clip it to a clothes line to dry.

If you don't get much of a print on your first try, you may not have had enough oil paint in the water, or you may have used a poor grade of turpentine. If an area didn't print, return it to the bath.

No two prints made by this method will be identical. Because of water disturbance and a decreasing amount of paint, subsequent sheets immersed in the same bath will print different patterns which will be lighter in color. If you wish a second printing to have greater intensity, add more oil paint of the same color. For experimental purposes, try a second print in the remaining color to note the different effect. If you want your colors to remain pure, don't change the color of the oil paint until you've first thoroughly cleaned the pan. Have more than one pan available for separate colors so that you can avoid frequent cleaning. Try this oil and water technique on different types of paper—matte, smooth, and textured surfaces of varying absorbencies. Here's another suggestion. Crush the paper first, flatten it, and *then* make your print.

Oil in water prints should be allowed to dry overnight before you use them. Even then, it's wise to test them for dryness. Prints made with paints other than oil are usually ready for use within a half hour.

MULTICOLORED OIL IN WATER PRINTS

Oil in water prints in multiple colors can be made in two ways. In one method, you print with only one color, wait for the paper to dry, then add a second or even a third color. The second method is to mix more than one color in the water bath, making certain that the colors don't negate each other, and end up as mud. Colors will merge differently, according to the method you use.

For an exciting variation of multicolored prints, use a single color on an already colored ground such as wrapping paper or charcoal paper. Make sure that the color in the paper will be visible (a yellow

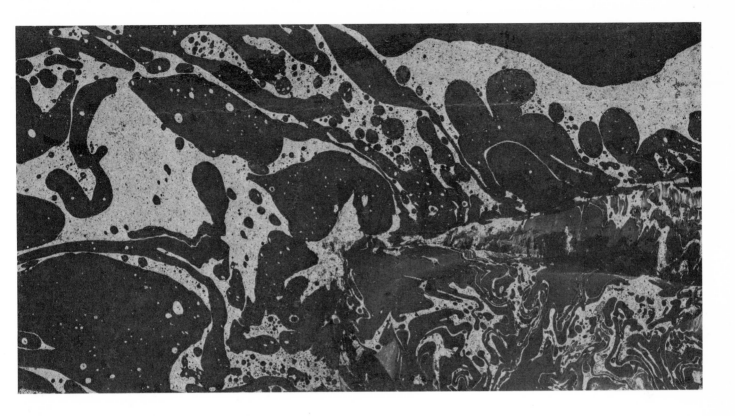

(Above) This apparently two color print is
actually a one color oil in water print:
black oil paint on brown wrapping paper.

(Left) Black oil on yellow ochre charcoal
paper creates a two color effect in a one
color operation.

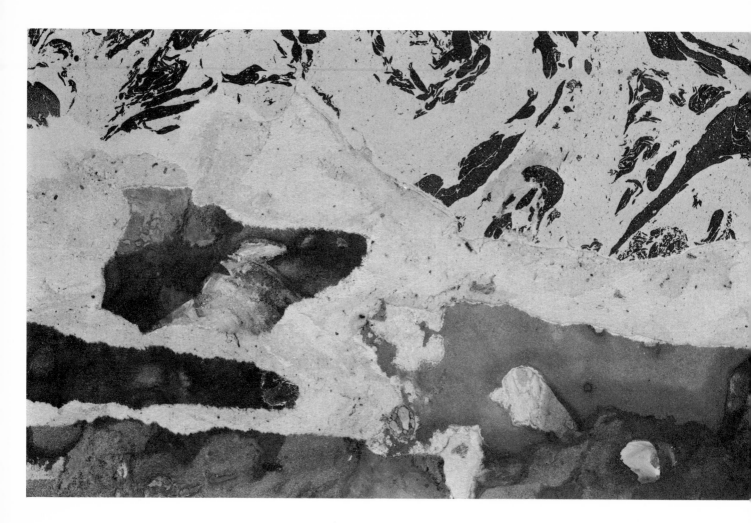

Sections of two oil in water prints combined with Chiri paper.

paper printed with a yellow paint would barely show up, for example). When submerged in a print bath, black and white exhibition notices or posters cut to size can be quite useful. Furthermore, Japanese textured papers make interesting grounds for prints; since these papers are very absorbent, oil colors will print almost immediately on both sides of the Japanese paper. One side will show the texture of the threads more clearly than the other, but both sides are desirable for use. Another good idea for multicolored prints is to take a sheet of white drawing paper which has already been colored by bled tissues (see Chapter Eight) and to immerse this sheet in a print bath.

Whatever way you decide to make your monoprints, once dried, they can be cut into pieces or used in their entirety, both with one another and in combination with other collage papers.

MONOPRINTS ON GLASS

The forms, designs, and textures produced by the oil in water process are unique and cannot be duplicated. However, other one-of-a-kind prints, either monochrome or multicolored, can be made on any glass surface. Though the patterns produced on glass differ somewhat from oil in water prints, they, too, are attractive and useful. Furthermore, while oil in water prints are limited to the medium of oil paint (acrylics in water print poorly), glass prints can be successfully made with a number of media, including oils (thinned with turpentine), acrylics (thinned with polymer emulsions or water), printmaking colors (diluted with thinner), and dry pigments including gold and silver powder (mixed with turpentine or polymer emulsions).

There are two methods of making glass prints. In the first, the paint—whether oil, acrylic, casein, gouache, or tempera—must be applied to the glass in moderate amounts. If thickly applied it won't respond well to rubbing and may spread out into uninteresting blobs of paint. In such cases, you may have to remove the excess color. To avoid the problem altogether, be sure to dilute your color somewhat with the appropriate thinner, such I've just described. Printing inks that have a thick and paste-like consistency should be similarly dealt with. Except for oil colors, glass prints so prepared dry quickly and can be used within a half hour. Using a brush or a painting knife, make definite strokes or marks as you apply the paint to the glass. Work at first on a small section, no larger than about 6″. To make a first print, place a sheet of paper directly over the painted area and rub with your fingers, a flat instrument, a spoon, a roller, or any other suitable device. If you've used a lightweight, absorbent paper, you won't need to apply much pressure to print your design. Consequently, the rhythms, strokes, and marks made by the movement of your brush or knife against the glass will reproduce on the rubbing. A rubbing made over your regular painting palette will also pick up these markings, which will be visible in the final print. Lift the print and lay it flat, design side up, on newspaper to dry.

To make a second print, place another paper over the remaining paint and repeat the process. Though more pressure will be required and the second print will differ in pattern and color intensity, the original strokes of the brush or painting knife should still be visible.

One of a kind prints can be made on glass, and in any number of media. This one color glass print is done in black on a white ground.

Subsequent prints can be made on glass. Like oil in water prints, an effect will never duplicate itself. This illustration is of a second print taken from the same glass as the preceding illustration.

This section of a first print made on glass was achieved with thinned, flowing oil color.

A second print made from the same glass "plate" as the preceding picture shows a lightening in intensity, the appearance of tone, and, around the edges, the beginning of texture.

A third glass print, again taken from the same plate as the two preceding pictures, is highly textured. The textural quality is due to decreased amount of pigment left on the glass.

Variations in pressure, the instrument you use to apply that pressure, and the type of paper you're printing on will all affect the result. You can continue to make subsequent monoprints until no more color remains on the glass.

In the second method of making glass prints, the printmaking color, paint, or ink must be thinned so that it flows somewhat freely. Also, the glass you're working on should be easy to lift (14″ x 18″ is a comfortable size). Pour a small amount of color onto the glass, then lift and tip it in all directions until the paint or ink flows into an area approximately equal to the size of the paper to be printed. With a little patience, you can learn to control the shapes that are formed; if more than one color is used, you can still control the color mergings, but to a lesser degree. Select a fairly absorbent paper to make your first print, and follow the same procedure as before. Don't consider yourself a failure if your first print turns out like a big smudge. Your mix may have been too runny. If this is the case, your "failure" has probably served to absorb much of the excess thinner in your color. Make a new print and consider it your first.

To make subsequent glass prints with this method, continue to print as before, varying the amount of pressure and the instruments you apply. Make as many prints as the paint permits.

To make glass prints with dry pigments (including silver and gold powders), simply mix them in turpentine or polymer emulsion and apply the resulting liquid to glass. Another way of handling dry pigments is to arrange the powdered colors directly on the glass in any order you choose, add polymer emulsion or turpentine over them, and tip the glass. The colors will run slowly into one another, so be careful to use compatible hues.

A rubbing made of wood grain is simple to do, and makes a dramatic collage paper.

WIPINGS

At the end of a working day, there's generally a good deal of paint left in brushes, on knives, or on the palette. This residue is commonly removed by scraping or wiping the color on rags, which are then discarded. Instead of throwing out good color that may be useful for collage, brush the excess colors on paper, then hang them up to dry. Almost any type of paper can be used for wipings—from common brown wrapping paper to the most costly watercolor or drawing paper —and including newspaper, magazine paper, ordinary sketching and watercolor papers, typewriter and mimeograph paper, and even very soft, absorbent Japanese sketching paper (which produces a particularly quick result). These papers may be just what you'll want on some later occasion. Color left over on the palette can be used by following the same procedure as you used in glass printing. If the palette contains thick oil paint, dilute with turpentine; if acrylic, dilute with emulsion and water.

RUBBINGS

Rubbings can be made over almost any textured or raised surface. All of us, at some time or another, have made coin rubbings with soft pencil and paper. Many of us are acquainted with the exquisite Chi-

Rubbings can be taken of any surface that's textured or raised. This rubbing was made over a metal flower stand.

Metal and wire objects can be rubbed for unusual textural effects. Looking for all the world like canvas or burlap, this texture was actually produced by rubbing a window screen.

Multiple rubbings can be made one over the other. This rich paper combines rubbings made from a hardtop roadway, a metal table top, and a screen.

nese rubbings made from stone carvings. Rubbings for collage may be made easily from wood (which leave impressions of grains, knots, and burls), stone, metal, glass, shingles, straw and cane objects, and heavy textured boards. Simply place a sheet of drawing paper over the object whose impression you want to transfer to the paper and rub the paper with any of the following media: soft pencils in all colors; wax, oil, and Conté crayons; pastels and charcoal; felt, fiber, or nylon marking pens; or any other drawing media that come to mind. A very wet medium will not print well because the paper will become too moist for rubbing. However, a drybrush method can be used.

To carry out the drybrush technique, dip the tip of a dry, small, soft brush into dry pigment, scraped chalks or pastels, or charcoal dust. Rub off excess color before you make your rubbing to avoid unwanted solid streaks. Place the paper over the pattern you wish to rub, then move your brush lightly and repeatedly over this pattern until it begins to emerge on the paper. You can also use this procedure with liquid paints as long as you're careful to charge your brush very sparingly so that it's hardly wet.

Newsprint rubbings can be made over any waxed surface on paper, cloth, or directly on a collage. The wax is rubbed very vigorously so that it leaves a surface (see Chapter Thirteen for types of wax) when used in solid form. Paste or liquid wax can be used for the same purpose. Place the newsprint over the waxed area and rub firmly from the rear of the paper with your fingers or any flat instrument (the side of a pencil will do). A mirror image will be produced. Good quality wax crayon in bright colors (so that print becomes visible) can also be used.

Prints can be made from pieces of cheesecloth, cut and pulled to create any form. This illustration shows the cheesecloth from which the print will be made.

CHEESECLOTH PRINTS

Surprisingly enough, interesting prints can be made quickly with ordinary cheesecloth. Unlike monoprints, cheesecloth prints can be repeated for as long as the fabric holds out—and it does for a considerably long time. You can make such prints separately on any type of paper, or, for added interest, you can print them directly onto your collage ground over previously pasted papers.

Cut a 4″ piece of cheesecloth for a trial run and flatten it on any hard surface. Using a brush, saturate the cloth with any paint or ink that dries quickly after printing. Diluted oil, acrylic, ink, printing colors, and dry pigments, including gold and silver powder, are all suitable for cheesecloth prints. Lift the cloth carefully at both ends after it's been saturated with color, and position it on the paper you wish to print. Place another sheet of paper directly over the cloth and rub in the pattern. You should have two prints, one a mirror image. If the print is blurry, you used too much pigment. Repeat the printing process; the next images will be sharper. Continue to print as long as color remains in the cheesecloth, adding more when needed.

Another example of the cloth itself from which the cheesecloth print will be made. The threads have been pulled and bunched together to open up the form in some places, add thickness and weight in others.

Try the same experiment again, but this time remove a few threads from the cheesecloth to change its form. You can vary your cheesecloth prints in as many ways as your imagination suggests. For example, instead of using a symmetrical piece of cheesecloth, cut out an irregular shape and print that. Cheesecloth cut-outs can be printed in one

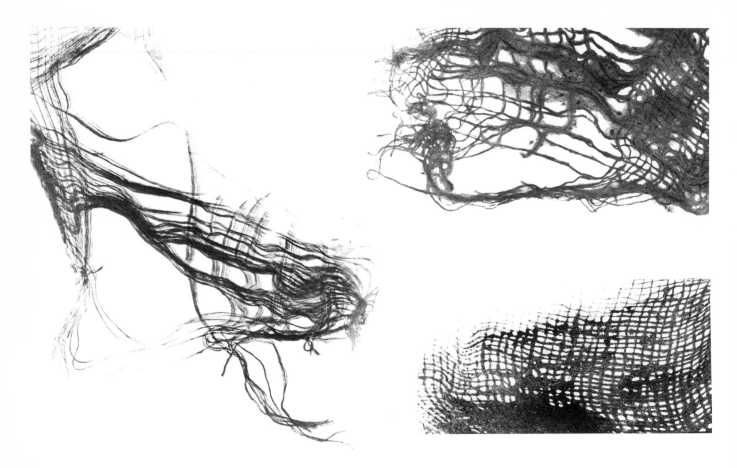

Three examples of cheesecloth prints show a wide range of effects—from wispy to boldly graphic.

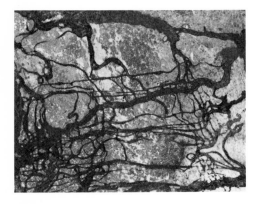

(Above) Another cheesecloth print made over an oil in water print. Unlike monoprints, cheesecloth prints can be repeated for as long as the fabric holds out.

(Right) Like rubbings, cheesecloth prints can be combined with other prepared papers for striking effects. Here, cheesecloth is printed over an oil in water print.

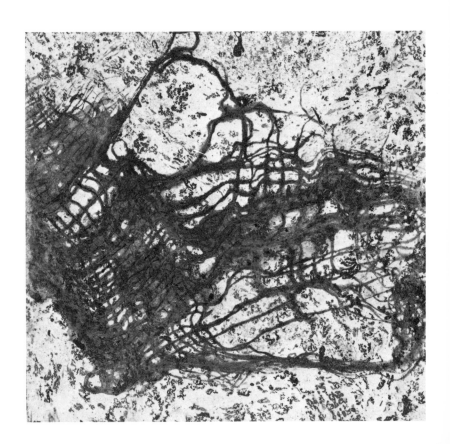

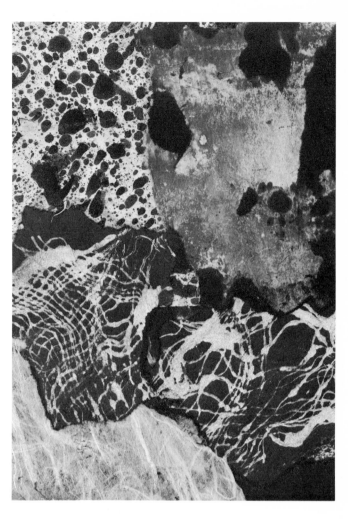

Zinc white oil paint is used on a black charcoal paper for a dramatic cheesecloth print.

A cheesecloth print is combined with Natsume papers and an oil in water print.

The pen-and-ink quality of this print was achieved by "pulling" a piece of cheesecloth, wet with paint, across the paper.

Foam rubber sponges offer a quick way to add color and create texture. The variation in the orifices of a sponge—from small to large—contribute pattern and design interest. This sponge print is black on a white ground.

Sponge print, flecked with gold dust, combined with Chiri paper.

or more colors. For a two color print, let the first color dry on the paper while you remove all extra color from the cheesecloth cut-out by blotting it between sheets of waste paper. Select a second color that will be compatible with the first, saturate your cut-out, and print this second color over the first. In all likelihood, the second impression won't be an identical duplication of the first. Nevertheless, the slight variation can prove quite interesting. If you want to improvise further, use a different form, cut from a fresh piece of cheesecloth, to print your second color. Another variation is to cut a cheesecloth form, leaving uneven lengths of thread along the ends. Saturate the cloth well—particularly the thread ends; then, holding it by both ends, pull it across the length of the paper. This technique will produce fine line markings, as well as patterns in heavier lines.

As you work with cheesecloth prints, vary both the colors you print with and the color of the ground you're printing on. Don't overlook the possibilities of colored charcoal papers as grounds for cheesecloth prints. Black charcoal paper, in particular, makes a dramatic ground for high intensity colors such as pure yellow, white, red, and green. Experiment with combinations, too. Try combining cheesecloth prints with Natsume or tissue paper, and with other types of prints. For instance, you can make a cheesecloth print over a dry oil in water print; or, in the reverse order, make an oil in water print over a dry cheesecloth print.

SPONGE PRINTS

Another quick way to apply color and create texture is to use a foam rubber sponge. Soft, pliable, porous, and able to hold pigment well, sponges can be used to apply all the paint media suggested for other prints. If you examine a sponge, you'll note how its orifices vary: some are small, while others are quite large. This variation in the size of perforations interests us for the patterns it produces.

Before using the sponge, rinse it well—in water if you intend to print with water based colors, in turpentine if you intend to use oils. Pour some of your color into a shallow pan that's large enough for the entire sponge. Practice dipping just a small section of the sponge in the liquid color, then pressing it against your paper. The amount of color the sponge absorbs and the amount of pressure you apply to the sponge will determine the result of your print. Continue to practice this technique until you're able to effect variations in color intensity and in shape.

It's possible to superimpose one color over another in sponge prints, provided that the colors don't cancel each other out. Print light colors first and allow them to dry before adding darks. Be sure to vary your ground colors. And, of course, try combining your sponge prints with various papers and with other prints.

SPRAY PAINT PRINTS

One can't imagine any painting process that's faster or more immediate than working with spray paints. Though a paint roller will cover a fairly large area quite quickly, spraying is carried out even more

Spray paint offers a fast and attractive method of making prints. This print shows the wide range of effects possible with the spray, which can be controlled to produce a pure and solid color or a fine mist.

Spray paint, used in conjunction with stencils or cut-outs made from masking tape, can be used to create any number of realistic or abstract patterns. The black stencils in this illustration (left) were cut out of masking tape and stuck on the paper, which was then sprayed. When the paint dried, the tape was lifted off to expose the patterned white ground (right).

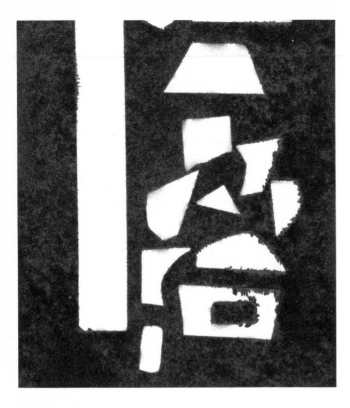

The edges produced by stenciling can be hard or soft. The masking tape in this paper was lightly placed so that color could overlap and run a bit. For a clean edge, the tape should be tightly secured.

A cardboard shape was placed against a white ground and sprayed with black paint. The gradation in tone was achieved by spraying some areas—particularly those directly surrounding the stencil—more heavily than others.

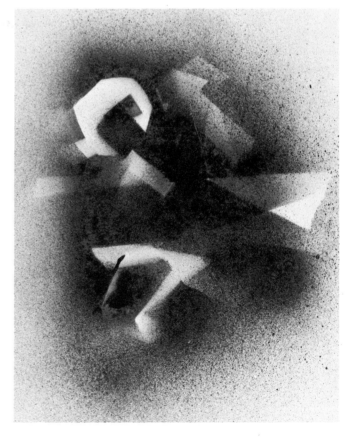

Spray print using leaves as a stencil. Almost any natural form or man-made object can be used as a basis for a spray print.

Another way to vary spray prints is to shift the forms about as you spray.

quickly. For this reason, artists often use spray paints as a ground color over canvas or board. If you've had any experience with sprays, you know that they permit effects which vary from fine mists to deep and solid intensities. Spray paints are available with both oil and water bases, so they can be used on any type of paper or collage ground. The oil will take longer to dry than the water based spray. However, if you apply oil based spray as a mist, it will dry very fast, usually permitting you to use it within a half hour. Use whichever spray you prefer, bearing in mind these differences.

You can spray several colors on the same paper for very attractive effects. Or, for pattern variations cover an area of the paper with cut-outs (stencils) or masking tape, then spray. When the stencil or tape is removed, the original paper will be untouched. For a clean edge, make sure that your stencil or masking tape (which is self-sticking) is securely fastened. On the other hand, if you wish the spray paint to run a bit, try for some unpredictable effects by not pasting down the stencils. When sprayed, the stencils will shift about in response to the air released from the spray can, creating unique effects. If your cut-outs are so lightweight that they shift undesirably, glue them in place with rubber cement. After spraying the paper, simply lift off the cut-out and remove the remaining rubber cement with a pick-up eraser (specially made for this adhesive), or with a ball of previously dried rubber cement; or rub off by hand.

You can vary your spray technique in endless ways. At times, it's interesting to shift your cut-outs as you spray. Overlap your forms for still other effects. Use metal, wood, and aluminum foil shapes for spray designs. Textured candy wrappers, corrugated board, colored tissues, and colored magazine papers—as well as oil in water prints or glass prints—are all suitable grounds for spray patterns. Spray paint prints, of course, can be combined with any other collage material. For surfaces that have been treated with an oil based medium, use a gel as your adhesive; for surfaces that have been treated with a water based medium, use an emulsion as your adhesive.

ADDING COLOR TO PAPER WITH PAINT

When Matisse was bedridden at the end of his life, he derived great pleasure from his last form of expression: cut-outs, or paste-ups. He would color papers in brilliant hues with gouache and watercolor, cut out forms from this paper, and then paste them onto a ground. The Museum of Modern Art in New York has one of these collages, *Maquette pour Nuit de Noel*, in its collection. His enchanting little book, *Jazz*, reproduces examples of this technique.

You, too, can prepare papers à la Matisse—and with all types of paint, including those that may be needlessly drying on your palette. Any type of paper is suitable for this technique, including one I haven't previously mentioned: you can paint strong colors on ordinary tracing paper of good quality. The transparency of the paper allows the color to show through onto the reverse side. Therefore, you can use either (or both) sides of painted tracing paper, since they offer two intensities of exactly the same color. Try this technique with high quality tracing paper.

For still other effects, the techniques of overlapping and shifting can be combined in the same spray print.

Metal objects, including paperclips, razor blades, washers, wood joiners, and other odds and ends, are used for pattern in a spray print carried out on an ordinary file card.

ADDING COLOR TO PAPER WITH CRAYONS

Wax and oil crayons provide an easy way of preparing sheets of collage papers in colors. Wax crayons are available in round, flat, and semi-flat shapes. All three can be used. However, to speed the preparation of papers, the broad, flat shapes seem to work the fastest.

To carry out this technique, remove the wrapper from your wax crayon, splitting the paper down the middle. Simply rub with the wax crayon until the paper is covered with a solid color or with any combination of colors and shapes you choose. Hold your crayon broadside as you work to cover a large area in a short time. I refer to this technique as the cold method, to distinguish it from a second procedure which involves heat and is even speedier.

In the hot method, an ordinary laundry or traveling iron is used. Heat the iron until it's warm, but not hot enough to scorch your paper. Working on any wood, board, or heavy cloth surface, run the iron over the section of paper on which you intend to add color. Apply the wax crayon over the heated area; you'll find that the color almost flows on, evenly and quickly.

Oil crayons, which are very rich in pigment, can be applied directly to papers by the cold direct method only. However, an alternate procedure is to dip the oil crayon in turpentine, damar varnish, or any oil medium, and then rub it on the paper.

Papers prepared with wax and oil crayons can be combined with all other collage materials, with no pasting problems. However, I advise you to glue overlapping forms of unusually thick pieces with epoxy (either tube or spray form). You can use acrylic emulsion or gel on thinly waxed papers as long as you apply a weight over the collage to insure adhesion while it dries. Always remember to insert wax paper or tin foil between the collage and the weight to prevent unwanted sticking from glue leakage. Leave the weights on overnight and test the dryness of your collage before you remove them.

The various techniques I've suggested in this chapter for preparing your own papers will provide you with a wide selection of materials which are no longer "found" or "ready made." Your personal imprint on these papers should spur you on your way, eager to use your now unique materials creatively.

Forms were laid over ordinary corrugated board and then sprayed. Textured candy box paper is another found material which makes a good ground for spray prints.

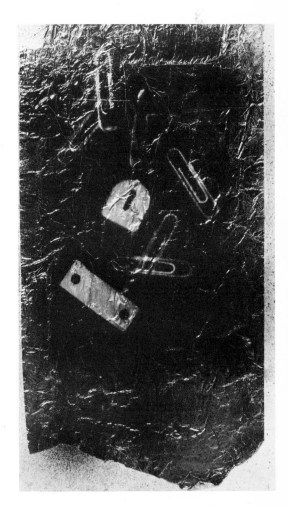

Aluminum foil makes an unusual material for spray prints. Colored aluminum foil could be used as well.

D-1957 by Esteban Vicente. 27⅞" x 20". Collection, Whitney Museum of American Art, New York. Gift of the Friends of the Whitney Museum of American Art. Paper has been torn into geometric shapes, overlapped, and pasted to a support of corrugated paper.

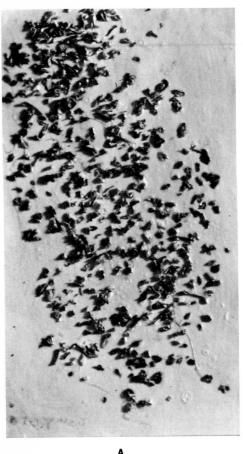

A

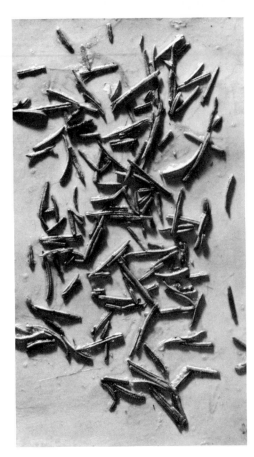

B

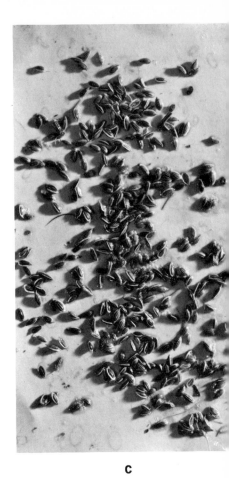

C

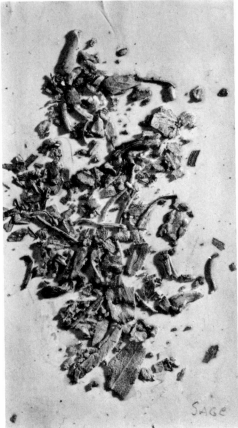

D

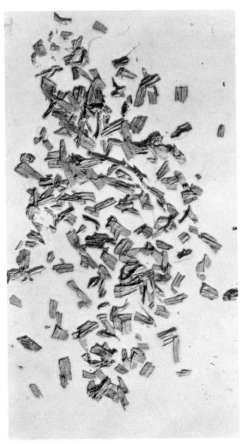

E

Five herbs—clockwise from upper left: oregano (A), rosemary (B), dill (C), sage (D), and tarragon (E)—are glued to a ground and used for texture.

IN TRADITIONAL OR CLASSIC PAINTING, objects are painted to create the illusion of being "real." The mind's eye translates the illusion so that it "seems like," but doesn't "feel like," what the image is meant to portray. In *trompe l'oeil* painting (*trompe l'oeil* means *deceive the eye*), the illusion of reality is carried to the maximum. Thus, texture doesn't necessarily have to be raised, in relief, to be "felt."

It's worth noting once again that collage as an art expression originated at the very moment when, instead of imitating textures in their paintings, Braque and Picasso used the actual material. Things no longer "seemed like"; they actually "were." When newsprint, wallpaper, patterned cloth, and the like replaced the imitations, a new art medium, destined to have a strong impact on the entire art world, was born.

THE PURPOSE OF TEXTURE

All matter on land, in the sea, and in the sky has its characteristic tactile quality which we call texture. Matter may be hard, soft, rough, smooth, ridged, raised, flat, sharp, blunt, coarse, fine, and so on. From early childhood, we begin to recognize how most materials feel, so that recognition of texture—originally revealed to us by touch—becomes an almost automatic process, mainly determined by observation alone.

If the world about us offered our senses no variety, it would be a dismal, monotonous, and confusing environment in which to live. As in nature, painting, sculpture, music—in fact, every art form—requires sensual variation. Texture is just one of many essential elements; as such, it must relate in proportion to the other elements required in the resolution of a creative work. Too much texture for the sake of texture alone can be a bore, just as unvarying repetition of any one element at the expense of others is the antithesis of excitement.

THE USE OF TEXTURE

In selecting texture, you must consider its type, color, weight, suitability, and relationship to the basic structural or directional movement of a composition. Since texture is just one element which mustn't be exploited at the expense of other elements, factors like theme, color relationships, mass, volumes, tensions, balance, and contrast must enter into the creative decision-making process, taking their place alongside that of texture. However, in composing a collage, you may encounter what are sometimes referred to as *dead areas*, areas that seem unable to function. It's possible, at times, to make such areas come alive by the mere addition of textural interest. What will concern us here is how to produce such textures and use them in a manner that will enrich your work.

If you've experimented with any of the materials suggested in previous chapters, you've already produced some types of textures. For example, when you used two or more unlike papers in relationship to one another, you created textural interest. Perhaps you combined a smooth, matte paper with a rough, grainy one. If your papers wrinkled or veined when you were gluing them, you inadvertently or deliberately produced textural effects. If you crushed papers, made rubbings,

Chapter Eleven

TEXTURES FOR COLLAGE

prints, and drawings, added pigments, or combined paper with cloth and string, you introduced still more textural interest.

GENERAL METHODS FOR PRODUCING TEXTURES

You're certainly no stranger, by now, to texture in collage. Now that you've worked with texture as a kind of by-product, let's approach the subject systematically.

Basically, textures can be convex (raised), concave (recessed), and flat. For raised effects, you can use materials of many types, including some not generally considered legitimate artists' materials. Coffee grounds, herbs, seeds, grass, leaves, sand, gravel, crushed glass, crushed plastic, crushed marble, marble dust, plaster, cement, paint pigments, papers, string, and cloth are all suitable materials to use for raised effects. For additional off-beat materials, re-read the chapter on found objects. Moreover, you can modify many paper and cloth collage materials by combining them with other media, by superimposing other materials over them, and by crushing, folding, fading, scorching, and otherwise changing their appearance. The acrylic emulsions you use for gluing can be used as a textural material for surprising effects. Later, I'll introduce you to an encaustic (wax) method that at once provides interesting textural possibilities and also serves as a preservative for collages framed without glass. A method of building up layers of materials one over another and then ripping, cutting, or tearing out sections is yet another means of producing attractive textures. These are a few techniques that I'll take up, one at a time, in the following chapters.

FOOD FOR THOUGHT—AND TEXTURE

It might interest you to learn how much material suitable for introducing texture is in your home at this very moment. If you had the immediate urge to experiment with texture, you'd need nothing more than some glue, and paper or cardboard. In other words, you wouldn't have to purchase any "art materials" to begin.

You probably have dried herbs and some kind of coffee in your kitchen right now. Select some herbs from your shelf that vary in size, shape, and consistency. Because they're so varied in length, shape, and consistency, the following herbs might make a good combination: tarragon, dill, sage, rosemary, oregano, paprika (for its attractive color), and cinnamon. Now look over your grocery shelf. Do you have any powdered instant coffee, freeze dried coffee, ground coffee, or grounds left over from your breakfast coffee? Use any or all of them. Any cocoa in your cupboard? Take it out. Do you have a pet? Then requisition its bird seed, meal, or any other suitable food. In craft techniques, the use of beans, grains, and other foods is not at all uncommon. Why not, then, use them for collage as well?

GLUING FOODS

To glue herbs, coffee grounds, and like material is a simple operation, but one that might be worth testing out before committing yourself to

Dry and used coffee grounds can produce
effects varying from sparse to dense .

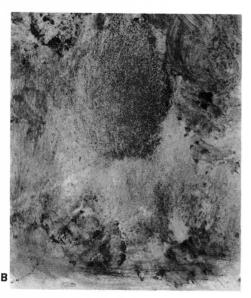

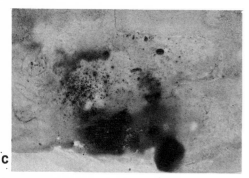

Instant coffee (A, B) is open to a wide range of textural effects, whether you use the powdered or the freeze dried variety. Powdered cocoa (C) reacts similarly, but in a different color.

a formal collage ground. With whatever adhesive and type of brush you're accustomed to using, spread an area of glue or emulsion on paper or board. Don't apply your adhesive so thickly that it makes a pool, causing your materials to go swimming about; use it moderately so that it won't stream off. Keep your work flat as you glue. Have a waste basket or newspaper handy to receive excess material after gluing.

If you're aiming for a solidly covered effect, concentrate the glue within one solid area. For broken areas or for sparser effects, distribute your adhesive more broadly. Now immediately add your texture. Material with some body can be sprinkled over the glue by hand or with a spoon or knife. Powdered coffee, paprika, cinnamon, cocoa, and other finely powdered substances can be shaken directly from their containers, provided that they have small openings, or they may be added like dry pigments. For this method, use a pliable palette knife to scoop up the material so that it rests on the tip of the knife blade. Holding the knife in one hand, gently tap the blade at a point directly behind the material, guiding it over the areas covered with wet glue. Be careful: if you tap too vigorously, your material will all fall into a single area. A few trial runs with this technique will make you a veteran.

However you choose to apply your herbs and coffee, use enough to insure covering the area you wish. After drying, the excess can be removed and used at a later time. Allow the material to remain on the glue for at least three to four minutes. To remove the excess, lift the ground, hold it over newspaper, and let the excess slide off. Tap the ground from the rear and the sides to dislodge other loose material. If you've shaken off more than you wish, simply repeat the gluing procedure. When you've finished, brush a thin coat of acrylic emulsion over the surface of your glued material to insure drying and preservation. For this operation, a soft, inexpensive brush (of the Japanese type) will serve.

When you're reassured about the simplicity of this technique, try it directly on your collage ground, experimenting on various types of paper, cloth, and other material. If you wish to work with coffee grounds, find a textured paper or cloth that's related in color, so that the coffee "echoes" the color in the papers. For example, oriental papers like Chiri and Yamato are textured with brown flecks—one on a white ground, the other on a tan ground. Either or both papers can be combined with a golden brown tissue (itself an untextured paper) for an attractive collage.

TECHNIQUES WITH SAND AND OTHER GRANULAR MATERIALS

Sand and materials like marble dust, crushed marble, crushed glass, crushed plastics, plaster, spackle, and cement have been used for some time as textural aids in paintings. Easy to embed in oils (if the paint's thick enough), they'll adhere directly to the canvas. Moreover, any painting medium that contains a dryer (damar or other) can be used as well as oil paint for this purpose. Sand can be purchased at pet stores, garden supply stores, and hardware stores; craft shops stock crushed marble, glass, and plastics; and cement and plaster are available in hardware stores and in many art supply stores.

(Above) For an irregularly shaped area such as this one, paint your glue on the ground with a brush—as though you were actually drawing the form you had in mind—then sprinkle on the sand.

(Left) Fine line and dot effects are best carried out with a small, round brush charged with glue. Work as though you were painting with color instead of adhesive. Use the tip of the brush to make pinpoint dots. Then apply sand.

For calligraphic effects with sand, apply glue with a brush that's related in size to the width of the intended writing. Or pour acrylic emulsion into a small plastic container that has a dispenser top with a narrow opening, turn the container upside down, and "write" with it. Then apply sand to the wet glue.

As a textural aid, sand, in particular, has many advantages, one of which is that pigment of any color can be applied over it. Many effects are possible with sand and collage glues. You can build up solid masses to any thickness, create shapes that are irregular in form, make fine lines and dots, and work out spattered, calligraphic, and striated effects. Crushed glass, crushed marble, and crushed plastics can be purchased in colors. These materials can be used singly or mixed with each other and glued to the same grounds as sand.

For irregularly shaped areas, paint your glue on the ground with a brush, as though you were actually drawing the form you had in mind, then apply your sand. Any extra glue that interferes with your conception may be wiped off with a damp cloth before you add the sand. Fine line effects are best carried out with a small round brush, as though you were painting with color instead of adhesive. Use the tip of the brush to make pinpoint dots. For spattered effects, charge your brush fully with glue, then tap the brush or use a wrist movement to spatter its contents. For calligraphic effects, add your glue with a brush that's related in size to the width of the intended writing. Another method is to pour some acrylic emulsion into a small plastic container that has a dispenser top. The top should have a narrow opening so that you can control the flow of adhesive. Turn the container upside down and "write" with it. Before you add sand, wipe off excess emulsion with a damp cloth. A nail brush or toothbrush is a suitable tool for creating striated effects. Saturate the tip of the brush with emulsion, but don't completely submerge it. This striated technique works well with coffee grounds, as well as with sand. Sand and coffee, by the way, combine well to suggest shore effects like sand flats and reflections at low tide.

COMBINING SAND WITH PAPER AND CLOTH

Sand can be combined with, or glued over, any number of papers and cloths. For example, sprinkle sand over newspaper lightly enough so that some of the print remains partly visible (a more subtle effect than covering it over in a solid mass). Use this technique with magazine papers, both colored and black-and-white. For interesting effects, combine sand with newspaper, tissue, and sprayed paper. Rubbings of all types can be used in conjunction with other papers and sand for rewarding compositions. Oriental papers, including those that you've made monoprints from, combine well with sand. Natsume paper, in particular, shot through with threads, adds textural interest when it's combined with sand and other papers.

You can achieve very striking effects by sanding colored tissues, then spraying the sand with paint in a hue that complements the colors of the tissues. For example, sand applied over red and yellow tissue and subsequently sprayed with black enamel paint will make a very attractive collage or area in a collage. For unlimited possibilities, try using sand on any of the following papers and cloths and combine them with each other or with other types of materials suggested in the chapter on found objects; billboard, charcoal, wrapping, oriental, origami, and aurora papers, canvas, metal foil, prepared monoprints, rubbings, cotton, cheesecloth, linen, silk, string. These can all be used

A nailbrush or toothbrush is suitable for creating striated effects. Saturate the tip of the brush with acrylic emulsion, but don't completely submerge it, then apply sand.

This striated technique works well with coffee grounds, too.

Sand and coffee grounds are combined on the same ground to suggest sand flats and reflections of water at low tide.

Sand can be combined with, or glued over, any number of papers and cloths. Sand sprinkled over newspaper, lightly enough to permit the lettering to show through, can contribute subtlety.

This landscape abstraction was created by combining a rubbing, a torn black tissue, sprayed papers, and sand.

Sand can be easily glued over cheesecloth. The cloth itself, of course, can also be varied by pulling, removing, or bunching its threads.

in conjunction with sand. I might mention, too, that sand can be easily glued over cheesecloth, string, and tissue; and that these materials, in turn, can as easily be glued over sand. Finally, sand can be added over wood and metal if you use an epoxy cement as your adhesive.

CHANGING THE COLOR OF SAND

In its natural color, sand is quite attractive and useful. On the other hand, should you wish to change the color of sand, it's a simple matter. Acrylic and oil colors, drawing and printing inks in all colors, oil and wax crayons, enamel or water based casein sprays, and dry pigments will cover sand. Use a brush or palette knife to apply black acrylic paint over an area of sand glued to a white ground. Now try the same experiment again over a black ground or a colored ground and note the difference. Use oil paints in the same way. Sand absorbs India ink as easily as it does printer's ink. Try gluing sand over brown wrapping paper and then darkening the sand with black India ink for an attractive effect with good contrast.

To add wax or oil crayons, brush the sand surface with an extra coat of acrylic emulsion, let it dry, then gently rub in the crayon, holding it broadside. If you use a spray enamel, hold it at a safe distance from the ground. This procedure will prevent blobs and streaks of paint from forming. Make a few practice tries before you spray your actual collage. You can create many attractive effects by spraying white paint over sand that's been used in combination with papers or cloth. To color sand with dry pigment, generously coat acrylic emulsion over the areas where you expect the pigment to fall. Tap the pigment onto the sand from a pliable palette knife, following the same procedure explained in the section on gluing foods. The pigment will dry in the sand. Instead of pigment, you can also use charcoal and pastel, scraping the dry material from the sides of the stick with a single edge razor blade.

TEXTURING WITH THREAD, STRING, AND ROPE

In Chapter Nine on tissues, I briefly mentioned that tissue, because it's transparent, can be glued over string and thread to secure it more firmly to the ground. At this point, I'd like to explore with you in greater detail how to use thread, string, and rope as textural elements in your collage.

String, rope, and either cotton, silk, or nylon thread can be used in collages for making contour and linear "drawings." Undoubtedly, it's much simpler to draw directly on your ground with a graphic medium, but such means won't produce the raised effects possible with these fibers. When you use thread, you'll note that it will tend to curl as you unwind the spool. If they serve a creative purpose, take advantage of these easy curves. If, on the other hand, you want to overcome the curl, dampen the thread and run your fingers the full length of it, pulling tightly to straighten it.

Try a free form exercise with thread. Using a pair of scissors, snip threads of any length directly over an area well saturated with acrylic

Two areas of sand are combined. The sand, with its natural multi-colored granules, is left untouched (above). Most of the sand mass has been brushed with black acrylic paint (below).

Black wax crayon has been rubbed on sand glued to a black ground and sealed with an extra coat of acrylic emulsion.

Spray enamel is a convenient material to color sand. In this collage, sand glued to a white ground has been sprayed with black enamel. The spray is allowed to carry over to areas of the white ground. To prevent streaking and the formation of blobs, hold the spray can at a safe distance from the ground.

Charcoal dust over sand. Charcoal, pastel, and dry pigments work well on sand glued down with acrylic emulsion. Tap the pigment onto the sand from a palette knife, or scrape the sides of the pastel or charcoal stick over the sand. The colored powder will dry into the sand.

In addition to sand, other textural materials like crushed glass, crushed marble, and crushed plastics are suitable for collage work. An added advantage is that they can be purchased in colors. This example shows blue crushed marble glued to a white ground. Crushed plastics are less granular.

emulsion, allowing the threads to fall where they may. This method gives you more control than you might imagine, since you can determine the direction in which the threads fall and can place the threads approximately where you wish. White threads against a black ground, or black threads against a white ground, can liven up areas in a collage that call for activity. This idea applies equally to colored threads on colored grounds. For linear contrast, try alternating thread (which is thin) with string (which is comparatively thick).

Either alone or combined, thread and string can be used to create contour drawings in your collages. Use straight pins to hold the thread or string in place as you develop your drawing, then remove the pins one at a time, gluing as you go along. Any rigidity in the line that's been caused by the pins can be eased out with your gluing brush. If you're using a hardboard ground like Masonite, the pins won't function unless there's a layer of paper or cloth on the board. Otherwise, you'll have to glue your contour as you develop it, using generous amounts of acrylic emulsion to keep the string or thread anchored. As an exercise, try combining string with sand, coffee grounds, herbs, crushed marble, or any of the other textural materials mentioned in this chapter. Brush an extra coat of emulsion over the completed work.

GLUES FOR ROPE AND OTHER THREE DIMENSIONAL OBJECTS

Rope was among the first collage materials Picasso selected, using it as a frame for his collage, *Still Life with Chair Caning*. Since then, rope has been frequently used both in collages and constructions. None of the glues and emulsions that you've used thus far, however, will hold rope securely. Instead, epoxy in spray or paste form such as 3M, Du Pont, and Borden's are required to adhere rope and other three dimensional objects to a ground. You also have the option of stapling or nailing the rope (if you're working on a wood ground).

Moreover, other hard drying products known as fillers, molding pastes, modeling pastes, and underpaints, though essentially not glues, can be used as such to embed three dimensional materials of all kinds into any type of ground. These products are intended as fillers meant for building up textures as underpaintings on canvases or other grounds. When the filler is dry, color is applied over its surface. Because these fillers dry quickly to a hard finish that's matte and opaque, they're ideal for pasting three dimensional collage materials.

There are various kinds of fillers on the market. A product called acrylic molding paste or modeling paste, manufactured for use with acrylic paints, can be mixed with acrylic gel or used alone for this purpose. An underpainting white, meant for use with oil paints, is sold by most art materials manufacturers. Finally, acrylic gesso white, ordinarily a primer for canvas or Masonite, can be used to embed three dimensional materials in collage work. Traditional gesso, however, doesn't dry as quickly as the others when it's heaped on; and when dry, its surface has a bit of a shine (this is also true of acrylic gesso). The consistency of both acrylic and traditional gesso, which is looser than the consistency of other fillers, can be stiffened by mixing them with modeling paste or gels in a one-to-one proportion.

Cement, plaster, and spackle (a powdery white, refined version of

White threads glued sparsely to black ground.

White threads applied densely to black ground.

Black thread and string combined on a white ground for linear and textural variety.

Black string and coffee grounds add texture, pattern, and color to a plain white ground.

Black string in two thicknesses used in conjunction with coffee grounds and sand against a white ground.

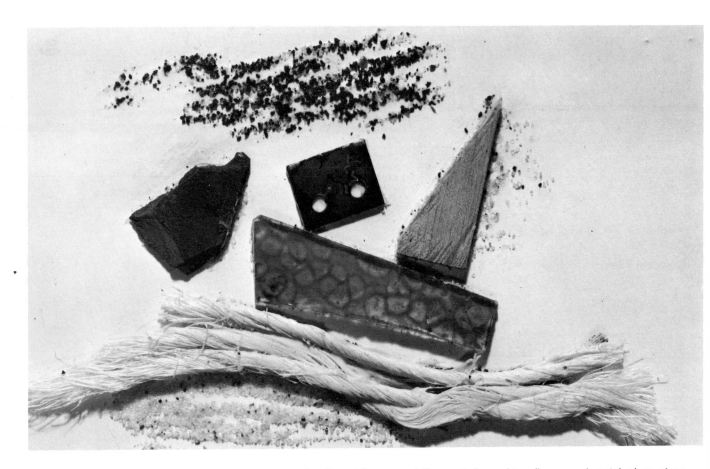

Acrylic molding or modeling paste is used to adhere wood, metal, glass, stone, rope, or any other raised object to a collage ground. Underpainting medium is also a suitable adhesive. Apply the paste with a palette knife, position the three dimensional object in the paste, and scrape off any excess adhesive.

In addition to their use as glues for raised objects, acrylic modeling pastes alone are interesting textural materials. Here paste is applied with a palette knife.

Acrylic modeling paste has been applied opaquely, then given a fine line effect with a stiff bristle brush. Such pastes can be used to produce flat or impasto surfaces. The material can be colored simply by mixing it with acrylic colors before applying it to the collage surface.

White acrylic gesso primer can be used for texturing.

Blue acrylic color is mixed with underpainting medium and applied as an impasto for texture.

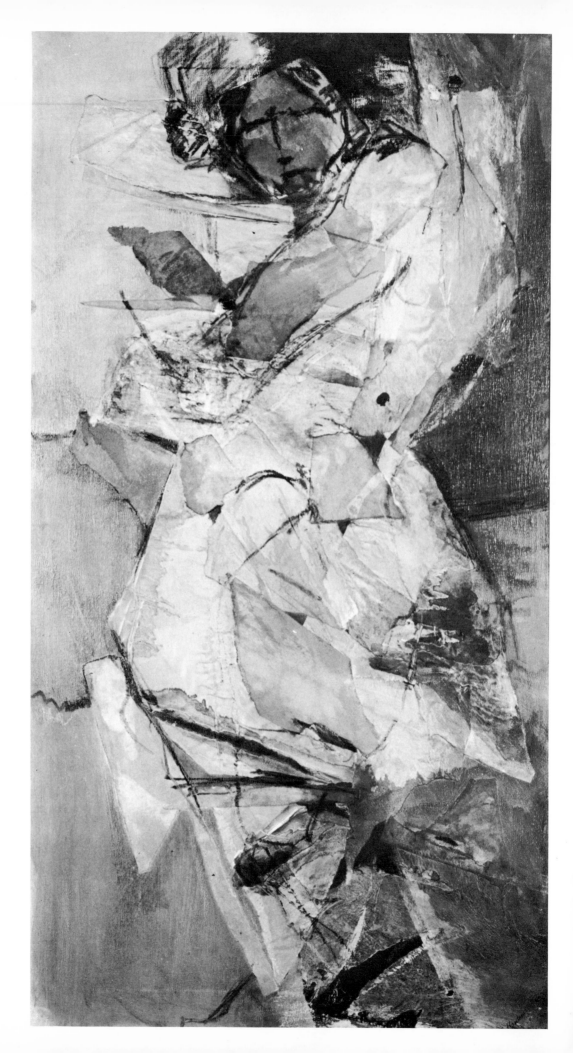

cement that dries slowly) can be used to receive three dimensional objects. Since spackle dries more slowly than the other materials, it's easier to work with. These products are all hardware store items. They should be mixed and applied with a scraper or trowel.

To glue rope or to embed three dimensional objects such as glass, leather, metal, heavy paper, plastics, powdered or granulated substances, stone, and wood, simply apply your filler with a palette knife and position the object in the filler. Scrape off any filler you don't wish to be visible. If the material is undesirable as white, paint it to match your ground color.

UNDERPAINTS, PASTES, GESSO, AND GEL AS TEXTURES

In addition to their function as glues, all the fillers just described can be used to build up textures on any collage ground. You can color fillers by mixing them with tube colors in proportions suited to your needs, and in whatever intensity you wish. Apply them with an instrument whose size suits the area you want to texture: a brush, painting knife, palette knife, or wood stick for small areas; and a roller, spatula, or trowel for larger areas.

Use these fillers for flat effects, or build them up into heavy masses or impastos. For a grained texture, capitalize on Braque's and Picasso's idea: apply your pigment quite thickly with a brush or a knife, or squeeze it directly from the tube. Using a wire brush or a steel comb, scratch into the paint surface. For an unbroken line, run the implement horizontally or vertically over the full length of the area to be textured. To produce a veined effect in as thick or as thin a pattern as you wish, press the tip of your palette knife against the pigment on the ground. This will produce small textured effects. For longer or larger effects, press with the full length of the knife blade. You can also make repeat patterns by applying a layer of filler, pressing any desired object into it, and then removing the object so that only its impression remains.

Though I've suggested many possibilities for textures, the most rewarding will be those you discover on your own. However, bear in mind my caution to use texture selectively and subtly, so that you create a work of art, not a decoration.

Raw umber acrylic color mixed with acrylic molding paste and applied in various thicknesses that graduate from impasto to transparently thin.

Figure by Jane Brigadier Howland. 36" x 20". Collection of the artist. Brown wrapping paper, silver and gold papers, and tinfoil have been glued with acrylic emulsion over a support of stretched canvas and then partly torn in selected areas. Volumes and textures have been developed with washes of oil and turps, and, lastly, with contour drawings in charcoal.

Fabrics provide a pleasant and durable collage material which can be altered with many of the same techniques that apply to paper. This white bed sheeting has been scattered with small metal objects, then sprayed lightly with black oil paint.

To heighten the individuality of your collage materials, try the oil in water technique on already patterned fabrics. Here, black has been printed in oil over a black and white striped cotton.

THE QUALITY AND COST OF PAPER are determined by its rag, or cloth, content. Papers that contain a high proportion of linen, cotton, or silk are considered top quality and therefore cost more than papers with a lower rag content. Quality papers are very desirable for use in collage (in conjunction with any paint medium) because they're the most permanent of papers. Although greater cost may be involved, quality papers are unique.

If cloth content adds to the quality of paper, why not use cloth itself for collage? Picasso probably had this thought in mind—in addition to the design element—when he chose to use cloth that resembled chair caning in his first collage, *Still Life with Chair Caning*.

Chapter Twelve

CLOTH FOR COLLAGE

WHY USE CLOTH?

Any doubts you may have about the durability of fabric as a collage material will be quickly dispelled if you recall the innumerable examples of well preserved cloth—some centuries old—on display in museum collections. If kept dust free, in fact, a fabric collage framed without glass or preservative can have a greater life expectancy than a paper collage framed without glass. This is one very good reason to experiment with cloth collages.

Not only is cloth durable, it's also a pleasant material to work with. It looks and feels different from paper; it's sometimes more flexible than paper; and in terms of the colors, patterns, and textures available, it far surpasses some papers. Moreover, cloth, like paper, can be preserved with any of the acrylic emulsions I discussed earlier. Attractive and subtle collages can be made entirely of cloth, or constructed from cloth combined with many other materials. All materials that adhere to paper can also be glued to cloth, both before and after it's been fixed to the ground.

TYPES OF CLOTH TO USE

A glance at the lists of cloths used by the early collagists proves that they overlooked nothing. The only materials missing from their work are the synthetic fabrics that have been developed since their time. The varieties of cloth that these early collagists appropriated ranged from the coarsest and most commonplace to the most luxurious and elegant. Picasso, for example, included a soiled floor rag in his collage, *Guitar*. Arthur Dove used needlepoint and combined it with shingles in his work, *My Grandmother*.

The contemporary artist has a vast choice of fabrics available to him: coarse and fine, brilliant and muted, solid and patterned. Patterns and textures simulate all of nature herself: earth, sky, sea, insect, fish, bird, animal, flora, fauna, and all agricultural products. Fabrics are manufactured in rough, smooth, ribbed, pebbly, nubby, fleecy, tufted, quilted, and loosely or closely knit weaves and textures. Fabrics, then, are readymades which you can use as inventively as your artistic intuition prompts. The more you work with cloths, the more you will see the possible variations you can achieve.

Canvas makes an excellent candidate for adaptation. This piece of primed canvas has been printed in black oil.

Primed as well as unprimed canvas responds to an oil in water bath. This piece of tan unprimed canvas has been submitted to a black oil bath.

Though the list is far from complete, here are some fabrics I've found adaptable for collage:·

Bed sheeting, cotton or percale	Pellon
Broadcloth	Plastic leather
Burlap	Poplin
Canvas, primed or unprimed	Rayon
Cheesecloth	Ribbed hose
Corduroy	Ribbon
Dacron	Rope
Denim	Sackcloth
Drill cloth	Sateen
Duck cloth	Satin
Felt	Silk
Flannel	String
Gingham	Terry cloth
Hopsacking	Thread
Lace	Toweling
Linen	Tweed
Monk's cloth	Underwear knits
Muslin, bleached or unbleached	Velvet
Netting	Woolens
Nylon	

PASTING CLOTH TO A GROUND

Though cloth will adhere easily to any ground, it's best to select the type of firm ground recommended for papers. If you plan to use a hardboard ground, but don't want to prime it in white or color, brush on a coat of acrylic emulsion to insure a good gripping surface. Allow the emulsion to dry thoroughly before you begin your collage.

It's not necessary to cover the entire ground with cloth in order to start your collage. However, you may wish to do so if the color or pattern of your fabric is expected to play an integral part in your entire composition. Before you paste any piece of fabric, always examine its reverse side. You'll often find it more interesting than the "right" side. To paste cloth, use the same adhesives you'd use for paper. Like heavy paper, heavy cloth requires a gel or an epoxy glue. If your acrylic emulsion seems too glossy, add water to dull it or use the matte type of acrylic emulsion instead. You can paste cloth over cloth as easily as paper over paper. As with paper, too, use a roller, the back of a spoon, or the pressure of your hand for a flat effect.

MODIFYING CLOTH TO SUIT YOUR NEEDS

If you're lucky enough to find a fabric in precisely the color, pattern, and texture you need, there's no problem. But what if you can't find what you're looking for? Or what if you want to control the color and texture of a fabric to individualize your work more precisely? Such problems can be solved in a number of ways by modifying the cloth to suit your particular needs. Some of these techniques require advance preparation; others can be carried out directly on the collage ground.

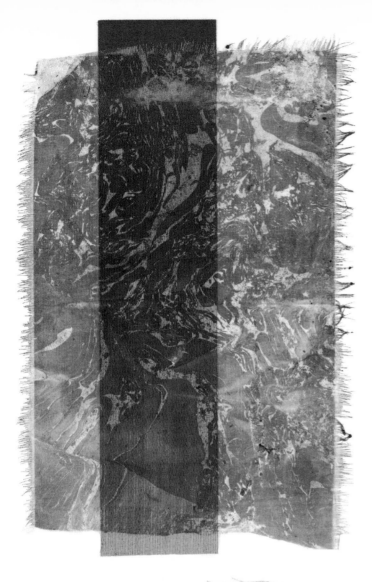

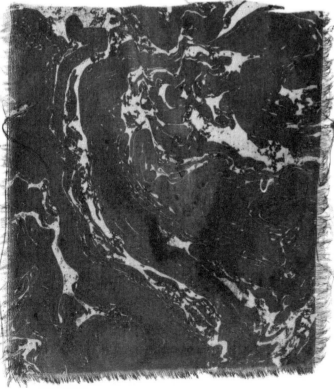

(Above left) Sheer fabrics make excellent grounds for oil in water prints. The transparency of the material has the added advantage of permitting the underlying ground to show through. Here white nylon printed in black oil is shown against both a white ground and a black ground to illustrate the different effects.

(Above right) Cloth, like paper, can be printed in two or more colors. This two color print (cadmium orange and black) was made on very sheer white cotton.

(Left) Colored nylon, as well as white, can be printed. This effect was achieved by submerging blue nylon in a black oil in water bath. Sheer fabrics can be used to produce changes in tonal values or colors. Doubled, the color of a sheer fabric will intensify. Like tissues, sheer fabrics will change or modify in color when placed over another color.

Black sponge print on white broadcloth. Single color or multicolor sponge prints can be made on white, colored, or patterned fabrics. Prepare them in advance or directly on the ground.

Rubbings can be made on cloth as easily as on paper. This pencil rubbing has been carried out on white cotton cloth.

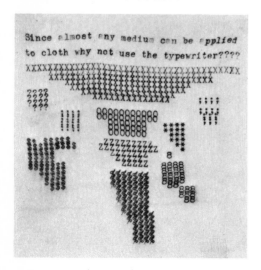

One way of adding pattern to cloth is by typing on it. The material, naturally, must be thin enough to fit into the carriage roller of the typewriter. Fabrics like percale and broadcloth are suitable. Handkerchiefs provide a ready made material.

ADDING COLOR TO CLOTH

There are several ways you can add or modify color on any fabric you purchase. For example, you can quickly and easily dye your own fabrics with aniline dyes. Directions for use are clearly explained on the package of these generally fade-proof dyes. If your fabric isn't unwieldy and can be completely immersed, it can be dyed in oil colors diluted with turpentine—which means you can mix your own colors. Just make sure that cloth dyed in oil paint is thoroughly dry before you use it.

You can also add color with a brush, a roller, or a painting knife *after* the cloth has been glued to the ground. Furthermore, color can be as easily applied with spray paint on cloth as on paper, both before and after gluing. Any fabric you wish to spray evenly in advance should be stretched on a flat working surface and held in place with tacks or tape. Brush wipings on ordinary rags can sometimes be useful as pieces of color, so check them before you throw them away. You can also cut up unresolved canvases or add color to pieces of canvas as other fine collage materials. Color from a bleeding tissue can be applied directly to cloth. Simply wet the tissue, crush it, and rub in the flowing color over the desired area.

If you want to create an interesting pattern on a light weight, absorbent fabric, try a tie dyeing technique. Tie dyeing is done by folding or crushing a piece of cloth, then tightly tying string around the areas you choose to leave undyed, and immersing the bundle in dye. If you tie the string tightly enough, the pattern made by the string will be reproduced in the original color of the cloth where no dye has been permitted to penetrate.

BLEACHING AND FADING CLOTH

If you want more subtlety in the color of a fabric, you can always bleach or fade it. I've used ordinary household bleach on blue denim and on some patterned fabrics. However, you'll come across some cloth that simply won't bleach—a tribute to textile manufacturers. When I left such hardy fabrics in bleach for a few hours or overnight, some fell apart, but never lost their original colors. Other fabrics such as denim, on the other hand, will fade in a matter of minutes; therefore, it's wise to watch the bleaching process carefully.

ADDING PATTERN TO CLOTH

Just as you can modify the colors of a fabric at will, so can you add pattern to any cloth you buy. A quick and easy way is to place objects (I've often used small metal items like paper clips and washers) over those areas you wish to outline, spray paint around them, and lift off the objects when the paint has dried.

Many other methods of adding pattern to cloth are also available to you. The printmaking techniques I described in the previous chapter are as simple to carry out on cloth as they are on paper. Oil in water prints, either monochrome or multicolor, are particularly suitable for this purpose. Prints can be made on solid, white, colored,

and even patterned or striped fabrics, and on primed or unprimed canvas. Oil in water prints carried out on sheer fabrics, such as nylon and cotton, will print almost immediately. Such sheer fabrics have the added advantage of tissue-like transparency but, unlike tissue paper, needn't be fortified with acrylic emulsion. Moreover, like tissue, very sheer fabrics can be doubled to darken their value or imposed over other colors to intensify or change their shade or tone.

Sponge prints on fabric can be prepared in advance or created directly on the ground. Rubbings, too, can be carried out on glass or your palette to take advantage of left-over color. Like paper, cloth lends itself to experimentation. For example, since I know that almost any medium that's suitable for paper can also be used in conjunction with cloth, I decided to try typing on a piece of fabric as a way of adding pattern. Naturally, the material had to be thin enough to fit into the carriage of the typewriter. Hence, I chose handkerchiefs and other fabrics about the thickness of percale and broadcloth for my experiment. I was pleased with the effect; if you have the patience to work out some interesting typing patterns, try out this idea.

Other media usually associated with paper are also equally suitable for adding pattern or color to cloth. Inks of all kinds, marking pens, pencils, oil and water based paints, pastels, and both wax and oil crayons allow you to draw or paint your own unique patterns.

ADDING TEXTURE TO CLOTH

You can add other textural interest to any flat fabric, from light to medium weight, by folding or pleating, gathering or crushing, wrinkling or rippling, or by removing some of the threads. Some types of cloth respond to such treatment as easily as paper (some fabrics even more so than paper). Other cloths, because of their coarseness or heaviness, are more difficult to manipulate. Even so, if they're first wetted, they'll be easier to handle.

You can gather cloth by pulling its threads. If you pull them at irregular intervals, you'll create more interesting textural variations. I use the corner of a single edge razor blade to force ripples into place while pasting. Small wooden sticks (used for stirring), brushes, painting knives, and your fingers are all devices that will help you implement these texturing techniques.

Whenever possible, tear your cloth to take advantage of uneven threads, which can then be used inventively along the edges of the fabric for linear interest. If, on the other hand, your subject calls for a straight edge, cut the cloth with a scissors.

Texture can also be introduced into your collages by gluing down thread, string, and rope, which will adhere to cloth as easily as to paper. (When artists use heavy rope on a wood board, they sometimes nail or staple it; others glue it with epoxy; others embed the cord or other three dimensional object into a molding paste or the paste mixed with acrylic gel or underpaint white. Such a paste will dry hard.)

COMBINING CLOTH AND PAPER

Ordinary cheesecloth is about the most commonplace material you can buy. Thus far, I've discussed it as a device in printmaking. Now

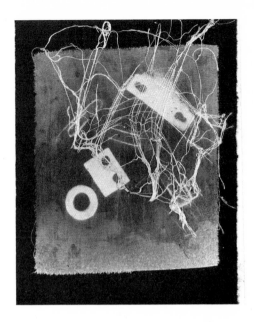

Ordinary cheesecloth is about the most commonplace material you can buy. It is also enormously versatile. Here cheesecloth adds texture and linear interest to a sprayed print on cloth.

Bleaching out or fading color can make an ordinary fabric much more interesting. This illustration shows a piece of ordinary blue denim which has been faded with a liquid chlorine bleach.

Not only pattern and color, but also texture can be added to fabric. Lightweight or medium weight cloth can be folded, pleated, gathered, puckered, crushed, wrinkled, or modified in any number of ways, then glued down.

This cloth has been torn instead of cut to create linear interest at the edges. Color was added to the folds for extra emphasis. Whenever possible, tear your cloth to take advantage of the threads.

I'd like to recommend it to you for use with cloth (or paper) because it serves several functions and contributes a character all its own. Though sheer and filmy, its threads are surprisingly strong. These threads can be pulled apart or removed entirely to open up areas in the cheesecloth and thereby create an irregular design. Moreover, it can be used in its original state or changed by adding color to it either before or after gluing. In its original white color, cheesecloth, when glued over a too-intense color, will function as a glaze to tone down that color, and will add textural interest as well. As a collage material, cheesecloth, in short, is a flexible material which lends itself to numerous techniques.

When superimposed over cloth, transparent oriental and tissue papers produce interesting effects which enable you to change the color of a fabric, yet keep its pattern visible and unchanged. If the area of cloth to be covered is well saturated with acrylic emulsion, the paper will remain transparent. Papers of all types can be glued to cloth. From time to time, review the list of suggested fabrics, papers, and found objects. Refreshing your memory may reveal solutions to compositional problems.

An oil in water print carried out on white cotton cloth. Oil in water techniques, in monochrome or several colors, are particularly suitable for adding pattern to cloth.

To make puckering easier, this moderately heavy cloth was first dampened.

Cycle by Henry Botkin. (Left) 10" x 7½". Collection of the artist. Canvas, paper, and black fabric have been painted with watercolor, oil, and crayon in contrasting hues of pale blues, deep grays, and dusty black. The fabric, mounted on heavy cardboard, is glued to the Masonite support.

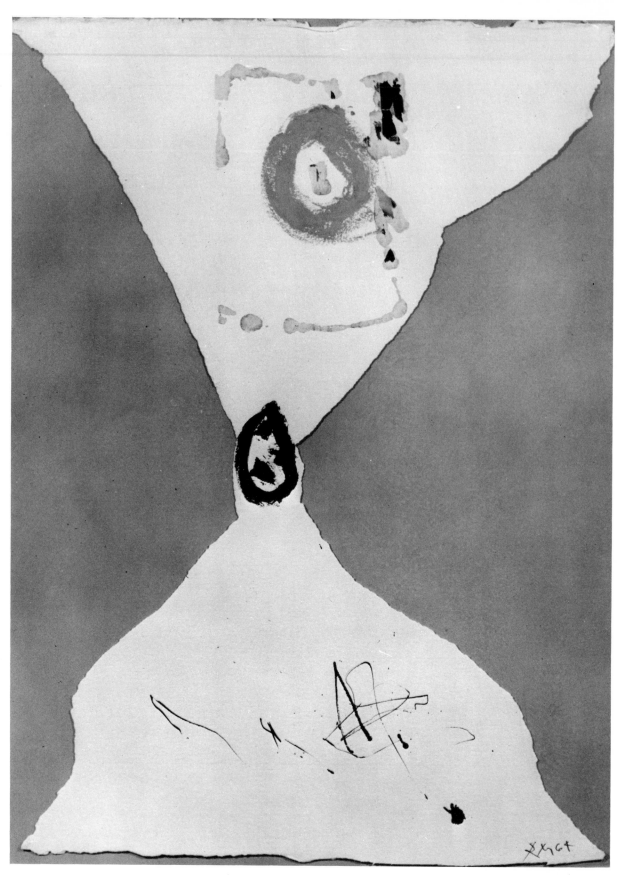

In White with Pink and Black Rings by Robert Motherwell. 29¾" x 27⅞".
Courtesy, Marlborough-Gerson Gallery, New York. Torn paper shapes, against
a paper ground, are enlivened with oil colors. Note the delicate calligraphic
effect near the bottom, achieved with either brush or pen.

APPROXIMATELY FIFTEEN YEARS AGO, I became involved with collage, anticipating its possibilities for expansion beyond the casual treatment it was being accorded by many artists at that time. Acrylic polymer products, with their hardening agents, had not yet been perfected to the point where they could be used both as a glue and as a preservative; thus, most collages were usually framed under glass. It was my personal annoyance with the glare and reflections of glass frames which led me on a search for a product that could preserve a surface and yet remain transparent. The varnishes, sprays, shellacs, and other available products were not meeting my needs.

REDISCOVERING AN ANCIENT TECHNIQUE

After considerable investigating and testing, it occurred to me that I had overlooked an obvious and old technique—one which might offer the solution. Encaustic (hot and cold wax) painting, one of the most ancient techniques, dates back over two thousand years. It was used by the Egyptians, the Greeks, and the Romans for mummification, portrait painting, ship building, mosaic, fresco, for the famous tiles in the Roman baths, for illuminations, and on slate and jewelry. Julius Caesar is said to have paid the equivalent of $350,000 for an encaustic wall painting. The method was later introduced into Russia, where it was employed for painting icons.

Pliny, the Roman biographer (A.D. 23–79) and Plutarch, the Greek biographer (A.D. 46–120), describe encaustic painting, stating that ". . . even time cannot efface it . . ." (Plutarch); and that "action of sun, waves, or wind cannot corrupt it . . ." (Pliny). Apparently the method was highly regarded.

Encaustic paintings completed between the first and fourth centuries, and excavated in the Fayyum district of Egypt in the 1880's, were found to be in fine condition. Some of the works may be seen in the Metropolitan Museum of Art in New York and in the Fogg Museum in Boston.

WAXES FOR ENCAUSTIC TECHNIQUES

When my need for a transparent and protective product arose, a number of artists were rediscovering and experimenting with encaustic painting methods. As a result, art materials stores began to stock the required materials.

Different types of wax are used for each of the two major encaustic processes. Hot encaustic techniques, which are carried out with melted wax, required tablets or discs of purified beeswax. Cold encaustic procedures, on the other hand, do not involve heating or melting and thereby require a form of wax that is already in a soft or liquid state. Many art materials manufacturers put out a wax medium (Dorland's is one), available in jars and tubes, that has the consistency of paste. Bocour's wax emulsion, a second type of cold wax, is, as its name implies, a liquid wax the consistency of heavy cream. This emulsion, a highly concentrated form of wax, will only darken the paper approximately one tint when it has dried. Winsor & Newton makes a wax varnish that looks like cloudy water and contains wax, modern

Color can be added to white beeswax in a number of ways. Here, wax crayons have been shaved into hot wax, then applied to white Tosaryu paper.

synthetics, and other ingredients. When dry, the color remains close to the original. However, the wax does not leave a heavy coat. If several coats are applied, this, too, will cause some darkening.

HOT AND COLD ENCAUSTIC METHODS

In the hot method, a small metal box called a *hot palette* is used to melt the wax. It contains two electric bulbs and a removable metal top with wells. These compartments hold the melted wax, solvents, and pigment in a fluid state. This fluid mixture is brushed onto the painting ground, on which it dries almost immediately. The brushes must be washed in turpentine to avoid destruction.

Another ancient (and contemporary) method is to use a cold wax in emulsion or paste form, which is mixed with pigments and solvents such as turpentine and damar varnish. Upon completion, a picture painted in encaustic was traditionally heated from behind to deepen the colors to a rich intensity (provided it was made on a canvas or other ground that permitted the heat to penetrate). In both the hot and cold wax techniques, colors remain pure and luminous. Both ancient and contemporary encaustic techniques for painting are somewhat complex and require in-depth study. The techniques presented here, which developed from my own collage needs, deal only with the wax itself, rather than with the traditional methods.

Since it was the wax that acted chiefly as the preserving agent, it occurred to me to use it as a protective and transparent surface for my collages so that I could do away with the glass. I was on my way— and to other discoveries as well.

COATING COMPLETED COLLAGES WITH COLD WAX

I tried coating collages with cold wax emulsion and wax paste. Both were simple to apply with a brush or with a clean cloth. Drying time was rather short—a bit longer with the liquid wax than with paste wax. However, three or four coats were needed for a satisfactory effect with both types of wax. I allowed each coat to dry before applying the next. Since hardboard such as Masonite was the ground I chiefly used I couldn't treat the board with heat from behind. However, I did note that the cold wax (either liquid or paste) did not substantially change the colors of the pigments—a point I kept in mind for the future.

COATING COLLAGES WITH HOT WAX AND A BURNISHING IRON

I was then interested in the effect of hot (melted) wax on papers. The solid types of waxes (which required heat to liquefy them) varied in color, density, and melting points—important factors for the encaustic painter. My concern as a collagist was to choose a wax that would remain transparent, wouldn't discolor, and would have a high melting point—which meant that it wouldn't soften or turn gray in high temperatures. Therefore, I chose white, clear beeswax, which is sold by the pound or in small discs that are 3″ to 4″ in diameter, and ¼″ thick. One melted disc covers an area approximately 16″ x 20″.

142

After finding the right type, my next problem was to learn how to apply the hot wax directly to the collage surface, without using the hot box and brush, and to devise a way to keep the wax fluid, I decided to try a burnishing iron, the type generally sold with children's wood-burning sets and sometimes available separately at hardware, craft, and electrical supply shops. A burnishing iron is much like a soldering iron, except that it has several removable nibs of various sizes. The widest nib, which is the best of the three for my purposes, is satisfactory for medium sized collages.

In addition to the burnishing iron, the following tools and materials were also essential: razor blades to scrape off excess wax from the surface; an extension cord when the outlet was out of reach; a plate, pan, ashtray, or asbestos pad to rest the hot iron on when it was not in use (and to avoid furniture burns); and several discs of beeswax.

I would suggest the following procedure. Place the collage on a flat working area that's near an outlet; plug in the iron and break off a piece of wax (about a third of a disc) for easier handling. Though burnishing irons usually have no multiple heat controls, you'll readily be able to determine how soon the heat will melt the wax. When heated to its maximum, however, the iron can scorch an unprotected surface. If the iron becomes too hot for your personal comfort, unplug it and continue to use it until it's too cool to melt the wax and must be reheated. Hold the wax against the warmed iron until it melts. It will become soft and pliable and will spread easily. As the melting begins, immediately move along the iron to the next area so that the wax doesn't accumulate in one spot. After covering a small area, temporarily put aside the wax disc and use the warm iron to spread more evenly the wax that's already been applied, moving it into unwaxed areas. Use the blade to scrape off excess wax wherever necessary. Even out the wax surfaces by continuing to spread the wax with the iron and by scraping with the blade. You can go over the waxed areas repeatedly, with no ill effects to the collage.

Occasionally, the edge of the nib will make a visible ridge of wax, which can be removed with heat or by scraping with a razor blade. As a final treatment, however, use soft steel wool, rubbing it very gently over the surface to eliminate unevenness and to make the surface perfectly smooth. At times your iron may smoke because wax has accumulated on it. If this happens, unplug the iron, let it cool, and then clean off the excess wax with a cloth or steel wool.

In working with this method of applying hot wax, I've observed that the technique deepens colors so that they become richer. A very thick coat of wax isn't required; in fact, a thinner, more moderate coat is actually preferable and will preserve the collage surface just as well. A small collage that I made over fifteen years ago from the cover of *Life* magazine, coated with a medium layer of wax, is as permanent today as when it was first completed.

Another effective way to add color to hot wax is by sprinkling in dry pigment. This paper was coated with hot beeswax combined with black pigment.

COATING COLLAGES WITH HOT WAX AND A LAUNDRY IRON

Trying to cover large collage areas with the nib of a burnishing iron was such a time-consuming and tedious task that I decided to seek

Waxed papers of all kinds (except newspaper) can be crushed to create marbleized effects. Make sure that the wax is dry and cool before you crush it. Half of this charcoal paper was waxed and crushed, while the other half was left untouched. Charcoal paper, which is somewhat stiff, must be crushed between the thumbs.

other tools. I anticipated—and correctly so—that the nib of the burnishing iron would be useful later. It became an aid for merging colors, for adding wax color to the edges of forms prepared in advance, and for leveling ridged and uneven areas.

In my quest for another device, I was told that any toolmaker could easily and inexpensively construct a broader copper nib to fit the burnishing iron. Then I discovered that an ordinary laundry or travel iron proved quite satisfactory for waxing larger collage areas. If you choose to use such an iron, work with this appliance just as you would with the nib—by melting the wax against the front of the iron and then carefully spreading it. Because laundry and travel irons have a higher heat potential than a burnishing iron, it's necessary to control and reduce the heat. If touched accidentally by the iron, unwaxed pasted papers may scorch and lift when excessive heat is applied.

PREPARING PAPERS IN ADVANCE WITH WAX

In my experiments, I found that laundry and travel irons worked very well to apply wax to the surface of collages that were already complete. Then I wished to coat my papers with wax *before* gluing them because I sensed that something interesting might develop. How to coat collage papers with hot wax was the next problem I had to tackle. With this end in mind, I purchased the largest shallow iron pan that I could find (iron retains heat best). I decided to use a small electric burner with three controls—low, medium, and high—which I preferred to a gas flame, which might accidentally ignite the papers.

Here's how I proceeded. I chose ordinary white drawing paper and some mimeograph paper (because I'd inherited packages of it), placing it conveniently near the iron pan; several discs of beeswax; and a pair of tongs (a helpful device to lift and shift papers in and out of the hot wax). I placed the iron pan on a high heat so that it would warm quickly, then reduced the power to medium or even low. Into the pan I dropped a chunk of wax, which dissolved and spread over the base of the pan.

Holding the 8½″ x 11″ paper firmly by one end, I slid the narrow end into the wax. As soon as it was coated (in a matter of seconds), I lifted the paper out with the tongs, turned it around, and submerged the other narrow end. In a very few moments the coated end that had been lifted out had cooled, so that I could grip both ends of the paper in my hands and feed it into the pan without using the tongs. As I proceeded, more wax had to be added from time to time, and the heat raised and lowered as required.

I observed that unless I worked quickly, the wax became unnecessarily thick in some areas. However, I found a simple and fast means of removing the excess, which is explained a little later. The hot waxed papers were allowed to cool on tin foil or glass (*not* wax paper, which becomes sticky when hot) while I waxed other papers.

INFLUENCE OF WAX ON PAPERS

I experimented with all kinds of papers—and my hunch about unusual results proved accurate. Papers that were a clear white became

somewhat gray in tone when coated, while those with a slightly yellow cast turned a parchment color. All the papers that were coated became transparent. Having noticed that the colors of papers darkened when I waxed a completed collage, I anticipated the same effect on all charcoal papers. As expected, they became even deeper and richer in tone when I coated them with wax in advance. Common wrapping papers (colored or patterned), as well as ordinary brown paper bags took on coloristic depth and generally became translucent when coated with wax (except for very heavy papers). Newspaper, including faded and yellow ones, became darker and considerably stronger as a result of their wax bath. Origami papers, originally opaque, became transparent, while metal foil papers lost some of their glare.

When coated with wax, the color of tissues changed less dramatically than other papers (in some instances their color lightened somewhat). Tissues gained strength from this procedure which differed from the emulsion coat. Solid color Japanese papers like Shuji, Moriki, and Mingei reacted like charcoal papers to the coating: they intensified and became semi-transparent. Transparent Japanese papers such as Cloud, Chiri, and Yamato took the coating extremely well, remaining transparent and deepening in tone.

Japanese papers such as Chiri, Yamato, Cloud, and Moriki respond extraordinarily well to waxing and crushing. The effects of these procedures on delicate Chiri, Yamato, and Cloud papers are so subtle that they elude reproduction. The somewhat sturdier Moriki is illustrated here.

A NEW TECHNIQUE: DIRECT RUBBING

It occurred to me that I could wax papers that were small enough to fit into the pan in a simpler manner: by moving the wax along over the paper as it melted. I cut my wax disc evenly in half to get a straight edge; then, holding it at right angles to the paper (which absorbed enough heat to make the wax melt), I rubbed the disc over its surface. The wax melted quickly and easily. When excess wax accumulated in the pan, I reverted to the dipping technique. Instead of using discs, the pound size wax proved even better for this purpose because of its oblong shape, which one could firmly grip.

CRUSHING WAXED PAPERS

Thinking of the marbleized effects that I'd produced with colored magazine papers, I decided to try the crushing technique on all types of waxed papers: charcoal papers, wrapping papers, common white note paper that comes in pads, inexpensive drawing paper, oriental papers in solid colors and in textured transparencies, prints, magazine paper, tissue—and anything else I could think of—were appropriate for this experiment.

The results were rewarding and effective with every variety except newspaper. Though newspaper coated well and took on strength, it fell apart when crushed. In crushing waxed papers, the only caution I had to observe was that the wax be dry and cool so that the marbleizing would show. Soft papers crushed easily between the palms of the hands, whereas stiffer paper had to be crushed more slowly between both thumbs. Tissue papers produced markings finer than the other papers, yet remained intact when gently crushed. Magazine papers which were wet first, crushed, and thoroughly dried *before* *waxing* were then re-crushed when cool. The colors darkened percep-

An absorbent, lightweight paper has been crushed, then selected areas have been dipped in colored wax. A variety of effects can be achieved by dipping lightly and quickly, by using varying amounts of pressure, and by twisting the crushed paper.

tibly, and the marbleized effect was quite unusual. When dry magazine papers were waxed, *then* crushed, they also darkened; some of the colors loosened and merged as a result of the heat, but not as freely as when wetted first.

REMOVING EXCESS WAX AND MARBLEIZED MARKINGS

For paper that's been too heavily coated with wax and requires thinning out, I devised a simple method which, in turn, gave me an idea for waxing larger sheets of paper (24″ x 36″). To remove the extra wax from small papers, I place the sheet between at least three layers of other papers like heavy wrap or newspaper. Using Masonite as a support, I iron over these disposable papers until the heat penetrates through to the underlying papers and melts the wax, which is then absorbed by the newspapers or wrap. The disposable papers, now coated with wax, become usable materials—a fact that can be kept in mind and taken advtantage of by substituting papers that can be used in the future.

Crushed papers in which excessive markings may interfere with compositional intent can be erased by melting them out with a burnishing iron. When heated, any of the lines can be eradicated. It's even possible to erase the markings of an entire sheet with the larger iron and to re-crush the paper when it has cooled. This procedure can be done repeatedly, with no ill effects.

GLUING WAXED PAPERS

At the time I developed the foregoing techniques (well over fifteen years ago), the acrylic products hadn't yet been completely perfected. Collagists used Sobo and sometimes Elmer's glue—neither of which then contained the hardening agents and preservatives they and many other similar products have today. These glues worked well for pasting paper, cloth, and string; but waxed papers were a problem. I tried to circumvent the difficulty by scraping some wax from the rear of the papers before applying paste. Though this was a nuisance, I could nevertheless manage. Then I discovered that by placing heavy weights over pasted waxed papers and leaving them on overnight or longer (depending on their size), the papers would adhere to a ground. Large collages (such as 2′ x 4′) I placed on the floor, evenly distributing weights over the entire area.

I now find acrylic gels to be the best adhesive for pre-waxed papers. White glues can also be used, but unlike gels, they require weights, though for shorter periods of time than formerly.

PREPARING PAPERS WITH PIGMENTS AND HOT WAX

Color can be added to white beeswax by combining it with one of several materials. If you're using the hot wax method, you can shave in good grade wax crayons until the colors deepen the beeswax, and then you can coat the papers as before. I've also tested dry pigment, casein paint, oil crayon, and oil paint. The most successful of these were wax crayons first, and dry pigments second. Casein paint sputtered, then set-

tled and merged; oil crayons were unpredictable (some merged easily, while others didn't).

To maintain color purity, the pan must be thoroughly and regularly cleaned unless you use more than one pan. More pigment of any type produces thicker and denser color. The ratio of wax to pigment, the intensity of the heat, and how you shift the paper as color flows over it are all factors that lead to different effects.

Provided that they're compatible, colors can be mixed. Results are more satisfying when the mixed colors are of the same medium (blue wax crayon with yellow wax crayon, for example). Anyone interested in using waxes other than beeswax might investigate the following varieties, which range in color from white to honey to tan and are made from plants and minerals.

Unbleached wax: honey colored
Bleached wax: pure white
Candellila: brown
Carnauba: cream, tan, white
Ceresin: white to yellow
Montan: white to yellow

These waxes are used primarily for encaustic painting because they all have high melting points. Art materials stores and chemical firms carry a supply. Some people use ordinary canning wax (paraffin) because it's less expensive. This is an example of foolish economy. Since paraffin has a lower melting point than most waxes, it will soften and turn gray in even moderately warm temperatures.

SUPERIMPOSING DIFFERENT COLORS OF WAX

Many colors can be added to the same sheet by dipping and re-dipping unwaxed or already waxed papers. On paper that's been coated with a solid color of wax, it's possible to superimpose still another color, provided that the heat applied is moderate, but not intense. If the wax bath is too hot, the wax coating already on the paper will melt and its colors will become muddy. The procedure is to touch such papers lightly to the color in the pan, lift, and repeat the procedure over other areas.

If you intend to crush any of these prepared papers, be certain they're not the same quality as newspaper, which will fall apart when crushed. It's wise to test small samples before you crush larger pieces. With experience, you'll automatically know the behavior of the papers you use.

QUICK HEAT METHOD FOR ADDING TEXTURE AND COLOR

I found the following shortcut for melting crayons directly on a paper surface without placing it in melted wax. Place the paper in a clean, heated pan and "write" with your crayon in fine line or with broad strokes, and in any thickness. On contact, wax crayons will immediately melt; oil crayons will bubble a bit. When dry, however, oil crayons produce an interesting thick texture. This method supplements, but doesn't replace the procedure suggested earlier, in which you heat

Pan wiping on disposable paper. Instead of throwing out left-over wax when you clean your pan, crush any kind of paper and wipe it over the pan. The remnants of colored wax will penetrate and fill the cracks in the crushed areas.

your paper with a laundry iron, then add crayons. The ironing technique melts the crayon on smoothly, but not thickly. Thick textures have to be created subsequently with a burnishing or laundry iron. Nor does this writing technique replace the emulsion method, which has several advantages—one of which is that it allows you to view your color mix before coating the paper.

DARKENING MARBLEIZED AREAS FOR CONTRAST

Waxed papers that have been crushed to make marbleized effects can be given contrast by darkening the striations with any of several types of pigment. For example, black oil paint (or any other dark color) that's thinned with turpentine will penetrate the cracks. Apply the paint with a brush or with a cloth and immediately wipe away the excess from the solid areas. If the solid areas darken, use clear turpentine to wipe off excess color, or gently rub soft steel wool over the solid surface. Any water soluble medium can also be used to darken the marbleized areas. Inks (particularly black) work better when they're diluted and when in excess ink, is removed with water.

CHANGING THE COLOR OF PASTED WAXED PAPERS

When you wish to change the color of a waxed paper that's already pasted to a collage ground, you can do so with many mediums. Pure oil paint can be added directly with a palette knife or with a brush. Oil can also be mixed with liquid or paste wax—as can dry pigments, casein paints, and other water based media—and then applied with a knife or brush. Both wax and oil crayons can be added directly, but only wax crayons can be melted onto the surface with a burnishing iron.

PAN WIPINGS AND CRUSHED PAPER

One day, as I was cleaning my pan before preparing a fresh color of wax, an accident occurred which I learned to use to advantage. The moderately warm pan was being cleaned with a wad of paper that I had crushed. Out of curiosity, I opened the paper and was surprised to note the manner in which remnants of color had penetrated and filled the crushed areas. This discovery led to further experimentation of crushing and dipping papers by various procedures. By dipping lightly and quickly, by using pressure on a crushed area, and by twisting the crushed paper, I achieved a variety of effects. I found that I could control the area I wished imprinted by crushing and re-opening a single sheet of paper repeatedly. The amount of color and wax in the pan, as well as the width of the crushed area placed in the color were also controlling factors. I discovered that it's also possible to repeat this procedure on the same sheet of paper with more than one color when I crushed ordinary mimeograph paper and dipped it successively into three colors of melted wax crayon. Not all my attempts, however, met with equal success. Many required a bit of practice. Hence, don't be disappointed if your first try fails.

PREPARING COLLAGE PAPERS WITH COLD WAX AND PIGMENT

Cold waxes, whether in emulsion or paste form, mix evenly and spread easily when they're combined with oil or casein colors. A small amount of oil or casein in wax can cover a sizable area of paper. However, when dry pigment is mixed into a cold wax, ample amounts of pigment are required in order to create strong colors. Dry pigment in wax mixes and spreads easily when brushed on to papers.

I must emphasize that what I'm describing are highly simplified variations of traditional encaustic techniques, methods devised simply to produce papers, quickly and attractively, using a medium that remains transparent. Pigments mixed with cold wax, let me say again, won't change much in color, but will remain pure and luminous; heat will deepen their tones. Papers so prepared can be very useful for your work.

When wax crayon shavings are added to cold wax, they remain separated unless you force their merger with a stiff brush, palette knife, or your fingers. However, the scattered crayon shavings themselves create an interesting effect, one that can be prepared either in advance or directly on a collage ground. The shavings from oil crayons, on the other hand, soften and mix in both types of cold wax —paste and liquid; when a bit of pressure is applied, they brush and spread easily on paper.

WAX WITH DRAWING INKS

The urge to experiment led me to mix drawing ink with hot and cold wax, even though I knew in advance that this idea might not work. First, I added drawing ink to hot wax, which sputtered and settled. Then I coated the paper; the effect was unexpected, but interesting. When I combined ink with paste wax, the mixture produced another type of effect, darkening the mix in proportion to the amount of ink added. Wax emulsion reacts with ink in the same way it does to paste.

USING WAX TO DULL SHINY SURFACES

In addition to the many uses of wax already discussed, waxes have yet another contribution to make to collage: any surface that is undesirably glossy can be dulled or matted simply by rubbing a piece of solid wax over it. The effect is immediate. Though you can use either wax paste or wax emulsion, solid discs of bees wax are preferable because they don't involve any drying time. For example, you can eliminate excess sheen on a pasted collage whose surface has been preserved with acrylic emulsion or shiny paste by rubbing wax over the dried surface. Or you can also apply a coat of melted wax, without fearing that it will change the ground color, since the acrylic has sealed in the color.

At this point, it's essential that you remember the following rule for waxes when used in conjunction with acrylic products: *you can apply wax over acrylics, but you can't apply acrylics over wax.* This rule is crucial to your work.

Paste and emulsion waxes mix evenly and spread easily when they're combined with oil, casein colors, or dry pigment. This illustration shows the effect of oil paint in cold wax. The textural effect is arbitrary; the mixture could as easily be brushed on for a smooth effect. A small amount of oil or casein covers a sizable paper area.

Dry black pigment mixed into emulsion wax and brushed on white paper. When combined with emulsion or paste wax, dry pigment requires ample amounts to create strong colors. Regardless of how much or how little you use, the pigments won't change color, but will remain pure and luminous.

The shavings from oil crayons, in contrast to wax crayons, soften and mix in both paste and emulsion types of cold wax. With a bit of pressure, the mixture brushes and spreads easily on paper. Here, oil crayons have been mixed with emulsion (left) and with paste wax (right).

Hot wax combined with wax crayon has been brushed on nylon cloth. The dark horizontal band at the top is actually a dark ground, placed to show how it affects the transparent nylon.

WAXES ON CLOTH

The ancients used the encaustic technique on many surfaces, including cloth. As easy to carry out on cloth as on paper—and with the same tools—wax techniques work on all types of cloth, including nylon and other synthetics. Care must be taken, however, in using hot wax methods on synthetic fabrics, which may melt or dissolve when subjected to high temperatures. To be safe, it's wise to test a swatch before committing the entire piece of fabric to possible disintegration. Whether applied with or without heat, waxes adhere well to cloth according to the same rules for coating as you follow for paper. Moreover, you can expect similar results. For example, pure white wax applied hot to unprimed canvas or to any other cloth deepens the color of the cloth, just as it did on paper. An interesting idea is to strew wax crayon shavings between bedsheeting and then to iron the folded sheet. The crayon shavings sandwiched between the sheet will melt and create a double mirror image on the fabric.

The many suggestions regarding encaustic that I've made can enrich your collage vocabulary if you're willing to use the extra bit of effort required to carry out these varied techniques. Probably you'll make exciting discoveries of your own which will be even more satisfying.

Drawing ink added to hot wax will sputter, then settle. A paper coated in this wax-ink mixture produces an effect like this one.

Ink added to cold wax (paste or emulsion) darkens the mixture in proportion to the amount of ink it contains.

This ordinary white paper has been smoked by passing the candle over it in a straight motion.

A circular movement was used to smoke this paper. Moving the material against the flame, and moving the flame itself, will produce patterns.

FLAME AND HEAT, to which you can subject practically all collage materials, provide a technical avenue to texture, color, and ambiance that you haven't thus far experienced. With the following techniques, you'll be able to produce—in a matter of seconds—color effects that range from light gray to charcoal black, and from light brown to dark sienna. Most materials—white, solid colored, and patterned—can be subtly altered to give them an aged, mysterious appearance: art paper, newspaper, magazine paper, wrapping paper, tin foil, kitchen aluminum wrap, cardboard, and other similar materials respond well to flame and heat. Cloth, primed and unprimed canvas, sand, marble dust, crushed marble, glass, paint, and objects embedded in pastes can also be subjected to the following procedures. Though you'll find it simpler to prepare your unpasted materials in advance, you can nevertheless process any pasted collage that's light enough to lift and hold over a burning candle.

Chapter Fourteen

SMOKING, SCORCHING, AND BURNING

TOOLS AND PROCEDURES FOR SMOKING

Before you experiment with smoking procedures, read these words of caution carefully and take them to heart: *whenever you're using any kind of flame, always work directly at the sink, with the water running.* If any material ignites beyond control, immediately drop it into the basin. If this is your first experience with procedures that entail flame or fire, use a material that isn't easily flammable—such as kitchen aluminum foil, moderately heavy cardboard or shirt board, or mounting board. Avoid any material thinner than file cards. Don't work with light weight materials until you've gained experience with heavier materials, so that you know how quickly an effect can be produced on a material without igniting it.

To carry out the smoking technique, you'll need a candle secured in a holder, that can be rested when not in use, the material to be scorched, and pastel spray fixative. I generally place a candle in a small jar or glass so that the candle extends an inch or more above the rim. A plumber's candle or any decorative candle can be used. Any holder or candlestick will do. Turn on the faucet, light the candle, and place it on the ledge of your sink. If you want to use aluminum foil for your first effort, double or triple it to make it firmer (try a piece 5″ x 8″ folded) as you move it over the flame. Holding the foil by one corner, direct it over the candle so that the tip of the flame merely licks the surface of the foil. Move the foil quickly from one end to the other, then lift it to study the effect. (Though it may get uncomfortably warm, aluminum foil can be held closer to the flame for longer periods of time than most other materials. It won't flare up easily.)

If the foil has turned a pearly gray and you prefer a darker tone, repeat the process over the same area one or more times, or pass the foil more slowly over the flame. After a few attempts, you'll automatically be able to determine how long your surface may be held safely against the flame. Naturally, the amount of time will depend on the thickness, density, and general properties of the material you're altering. The color effect you produce will be determined by the length of time you expose the material to the flame.

Both primed (A) and unprimed (B) canvas respond well to smoking.

Primed canvas, textured with sand, has been smoked.

When you've achieved the effect you're seeking, spray the surface of your material with pastel fixative, holding the spray can at least 12″ to 16″ away so that you don't wash off the color.

TECHNIQUES AND USES FOR SMOKED MATERIALS

In addition to coloristic changes, the flame technique also produces patterns. The act of moving the material against the flame and the movement of the flame itself create these patterns. Hence, to some degree you can control the type and amount of patterning produced by the flame. For example, instead of passing the material over the flame in a straight line, you can use a circular motion; or you can alternate your movements, making them as large or small, as open or closed, and as rhythmic as you like.

There are several variations with tin foil that you may want to try. Not only can you process a flat piece of foil, you can as easily smoke "veined" tin foil by first crushing and flattening it, and then submitting the veined foil to the flame. Or, you can crumple a piece of foil and smoke it without smoothing it out. Use any of these techniques on colored or patterned foil, as is, or with some other material (such as sand) glued over it. Try this smoking technique on primed or unprimed canvas; it will work equally well on canvas that's been combined with sand, paint, or other material.

In fact, any collage ground, covered with almost any paper or cloth, will respond to smoking. If, for example, you've embedded a three dimensional object in adhesive, molding paste, underpaint, or gesso; or if you've used these materials for texturing, they can be submitted to the candle flame. A collage surface covered by a layer of dry acrylic emulsion can be smoked, as well. Lightweight papers, otherwise quite flammable, can be treated with a flame technique when their surfaces have been coated with a layer of emulsion. Covered with sand and emulsion and then smoked, light weight papers make an interesting combination for collage. If its surface has been coated with emulsion, newspaper, too, can be smoked with ease. Untreated newspaper can also be submitted to the flame technique, but the process is tricky unless you're experienced. For intriguing collage materials, paste several layers of smoked newspaper or magazine paper together, reversing the print patterns and varying the sizes and shapes of the paper. For still another effect, wet a light weight board or a sheet of very heavy paper, shake off the excess water, then subject the board or paper to the flame. Water that still clings to the surface of the material will create unusual patterns and textures as the flame causes it to move about. Be sure to let the material dry thoroughly before you spray it with fixative.

A FEW POINTERS ABOUT SMOKED MATERIALS

If you intend to add a preservative over the fixative sprayed onto smoked materials (it's not essential to do so), use only the paste types such as gels, or wax in paste form. Evenly apply a thin coat. If you use a liquid preservative, you risk losing your smoked color. I've had success with liquid emulsions over material already sprayed with fixa-

Kitchen aluminum foil, laid flat, has been smoked to create tones that range from pearly gray to charcoal black (left). Veined tin foil, created by crushing and flattening the material, is submitted to the flame (right).

This textured effect was produced by smoking crumpled tin foil. Colored and designed tin foil is also amenable to the smoking technique. Smoked foil must be protected with fixative to prevent smudging.

Adhesive, acrylic molding paste, underpainting white, and gesso—whether they've been used as grounds, to embed objects, or to add texture—can be smoked. Here, molding paste, used for texture against a black ground, has been submitted to the flame.

Objects in white acrylic gesso are smoked a light gray.

Gesso and molding paste combined for an impasto effect take on intensity and contrast by smoking them.

Black paper has been sprinkled with sand, sprayed with white acrylic paint, then submitted to flame.

tive only when I've proceeded with utmost caution applying an extremely thin coat. After it dried, I added a second thin coat.

It's next to impossible to use the smoking technique on a collage that's lying horizontally or that's positioned vertically on an easel. If you try to do so, you won't be able to direct the flame and you'll end up with candle drippings all over your work. You also risk starting a fire, should your material accidentally ignite. Therefore, it's entirely preferable from all points of view to smoke your material as I suggested earlier—by preparing your materials in advance at the sink, or by smoking an already pasted collage at the basin, provided it's light enough to lift and hold comfortably. Instead of placing your candle on a flat surface and holding the material in both hands as you pass it over the flame, see if you can comfortably hold the candle in one hand and the material in the other. This procedure will enable you to see what you're doing and will thereby increase your control over the technique. For example, hold your work at a slant against the flame as you move the material over its surface for better viewing.

In spite of its relative thinness, newspaper can be smoked without first coating it with acrylic emulsion. Processing untreated newspaper, however, can be tricky unless you're experienced with its combustibility. This collage is composed of several layers of superimposed newspaper, smoked without an intervening layer of emulsion.

SCORCHING

Smoke from a candle flame produces tones that range from pearly gray to charcoal black. If you wish to create tones that run from light brown to dark sienna, they can be achieved with an ordinary laundry iron or travel iron in a simple enough procedure. Place the material to be scorched over any ground that's firm enough to iron on and that won't be marred by the heat. For example, you can use either the smooth or the rough side of a piece of Masonite. (If visibly grained, wood can also contribute its pattern to the scorched material.)

Position the hot iron anywhere you wish on the material. Either let it rest in one place until the material browns, or move the iron slowly along the surface until the color of the material changes to your satisfaction. Vary the length of time you leave the iron in one place. If the contour of the form left by the iron bothers you, cut out those sections of the scorched material that please you as they are, or replace the iron over the unpleasant outlines and scorch in overlapping patterns. No fixative is needed for scorched papers or fabrics.

The procedure of holding paper and candle by hand, at a vertical slant against one another, created this wind-swept effect.

BURNING

If you follow the procedure I'm about to explain, your material will actually burst into flames. Consequently, if you're at all apprehensive about fire, or if you don't have quick reflexes, *don't try this technique.* If, after this warning, you still want to proceed, work at the sink, with the water running—and at your own risk.

Any lightweight paper you use should be folded in layers. Set fire to the folded edge, let it burn briefly, then extinguish the flame in the sink with water. Though your paper will be wet, you can nevertheless relight it. It will smoke, scorch, and finally catch fire. When you've finished, open the paper cautiously. It will reveal both burned openings and burned edges. If part of the scorched paper flakes off in gluing, simply brush these charred pieces onto the emulsion. No fixative is needed over burned papers. Try papers that vary in thickness.

Another example of paper and flame held against one another, by hand, at a vertical slant. This procedure enables you to see what you're doing and thereby increases your control over the technique.

Smoking produces tones that range from pearly gray to charcoal black. For brown and sienna tones, scorching is the best technique. This paper was scorched with an ordinary laundry iron. The brown rivulets are produced by the grain of the wood on which the paper was ironed.

To prevent the scorched areas from taking on the outline of the iron, it must be moved about quickly or lifted up before the marking is made. Here, the boat-like shape of the iron is clearly imprinted, along with dark brown scorched spots.

This gradation of tone was achieved by passing a hot iron rapidly and repeatedly across the surface of the paper.

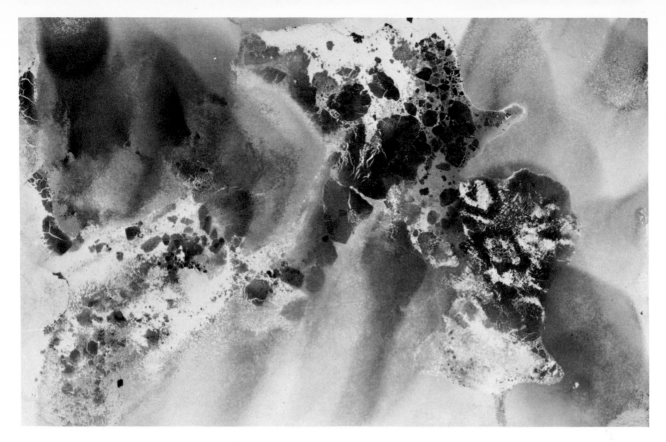

Lightweight board or, as in this example, a sheet of very heavy paper can be wetted, then processed by smoking. Dramatic, turbulent effects are the result. (See page 154.)

If part of the scorched paper flakes off in gluing, brush the charred pieces into the acrylic emulsion. No fixative is needed over burnt papers.

Composition Variée by Alberto Burri. 19″ x 23″. Courtesy, Martha Jackson Gallery, New York. Sections of gunny sacks and miscellaneous materials from a rubbish heap are adroitly joined, often by the surgical technique of suturing.

I'D LIKE TO INTRODUCE YOU to some interesting textural effects, unlike any you're likely to have tried thus far. These can be created by tearing, ripping, scratching, or cutting into layers of glued papers. If you've ever admired an aged and weathered billboard poster wall; if you recall seeing in them the contrast of faded and brilliant colors, or of lettering torn at random points, forming interesting shapes and designs; if you've noted that the torn edges of such billboards reveal a multiplicity of colors exposed by the uneven ripping; if such visual effects, made by accident and time, attract you, you can easily duplicate them at will.

Chapter Fifteen

TEARING, SCRAPING, AND CUTTING

PROCEDURES FOR TEARING, SCRAPING, AND CUTTING

Cutting, tearing, scraping, and similar techniques may be carried out directly on your collage ground (I suggest hardboard, which will withstand the blade) by gluing several layers of papers one over the other, using a series of contrasting colors, designs, or textures, and then proceeding to tear through them, scrape for texture, or cut a linear form with a single edge razor blade or a cutting knife. Before you commit yourself to working on an actual collage ground, however, it might be worth your while to try a few preliminary exercises first. For these experiments, here's a list of papers you might like to consider: charcoal, drawing, design, magazine, and newspaper; oil in water prints, and monoprints; oriental and origami papers, rubbings; sprayed papers; tissue, textured, and wrapping papers.

TEARING EVEN LAYERS OF PAPER

For a quick result, carry out this first exercise with tissue paper. Cut at least six to eight sheets of tissue all the same size. Use a variety of colors, and double some sheets to intensify their tones. Glue the tissues onto a piece of white cardboard so that your colors remain pure. Superimpose your tissues in varying sequences—warm over cool, cool over warm—so that the colors change as they merge. As you glue, note on the back of the cardboard the exact sequence you've followed in gluing the tissues. This information will enable you to duplicate the color sequence, should you ever have reason to do so. Or you can leave a small edge unglued—so that you can lift the sheets—for the same purpose.

Allow your papers to dry for approximately half an hour. A piece of wax paper placed over the collage and held in place by a heavy weight will speed the process. When the papers are dry, lift or pry up an edge and slowly rip the paper as far as it permits. Rip another area, and another—perhaps crosswise, or at random points on the collage, until you understand the process. When you're more experienced in gauging the drying time of the tissues, you'll be able, if you wish, to expose areas in more open forms before the tissues dry hard.

TEXTURING TECHNIQUE

The following exercise, which is a simple one that's worth a try, will enable you to produce rougher textures. Cut sheets, all the same size,

Rag Composition by Alberto Burri. 19½" x 34". Courtesy, Martha Jackson Gallery, New York. Burlap on a board ground has been burned and scorched, then sewn with suture stitching. Vinavil and tempera have been used for additional color.

of the following six papers, and paste them in the order presented: sprayed paper in black and white; oil in water print in red and black; Tosaryu thin textured paper in white; newspaper; cadmium red light tissue; and black tissue. Glue these papers in even layers. When they're dry, scrape, cut, and tear them in any way you please. Allow some of tne ripped surfaces to remain. To hold these ripped and loose (but still attached) surfaces in place while maintaining their rough, textured effect, brush a layer of acrylic emulsion over them. If you want to make an area smooth, rub a piece of fine steel wool over it, then brush on a layer of acrylic emulsion.

TEARING UNEVEN LAYERS OF PAPER

Since it's unlikely that in your actual collage work you'd use uniformly sized material pasted in perfectly equal layers, I suggest that you try the following exercise, which is carried out with papers cut into uneven forms and shapes. Cut or tear a minimum of five or six shapes and glue them in any sequence you choose. Because these forms are *not* uniform, your tearing, scraping, and cutting techniques will result in variations other than those you produced when you worked with uniform layers of paper. For an interesting effect, try the following papers, in uneven forms, and pasted in the sequence that they're presented: brown wrapping paper, black tisuse, newspaper, solid white typing paper, black tissue (again), and Yamato (Japanese white paper with brown flecks). Each of these papers will give you a unique effect.

VARYING THE BASIC TECHNIQUE

With your razor blade, you can make cut-outs within a solid form, as linear or as wide as you wish. The amount of pressure you need to apply to the blade will depend on the hardness of the glued surface and on the number of glued papers you're cutting into. For example, little pressure is required to produce a fine line effect (with the corner of the blade) if you're cutting into a single layer of paper which hasn't been coated with emulsion. On the other hand, more pressure is needed to produce open areas or to cut into several layers of emulsified tissue. In contrast to the tearing technique (which produces uneven edges), the razor blade enables you to make an edge as straight as you wish when you cut into layers of paper.

Once you've exposed an area by ripping, tearing, or scraping, you can easily change or add color to the cut-out portion with any of the media previously suggested: acrylic paints, inks, crayons, and the like. If, on the other hand, you're faced with a hard, dry surface that's dark or dull, and if you don't want to introduce additional color or paper, you can still enliven the area by the following texturing procedure. Simply jab the dark or dull surface with a sharp, pointed instrument (I use an ordinary compass), holding the point almost parallel to the paper and digging into the area to lift the under papers. When I rhythmically cut into such a dead section, the textured pattern I create will make that area come alive. This technique can save a dull collage.

TEARING WITH STRING OR ROPE

Other interesting effects can be made with string, thread, rope, or cord over layers of material. Glue any of these materials—placed in any pattern or configuration you wish—onto your collage support. Add the string, then paste an extra layer of tissue over the string. When thoroughly dry, tear the string from the ground to expose the string pattern. In order to make the cord or string easier to grip, leave an extra length unglued and uncovered. The string, thread, rope, or cord will be easier to release if it's been glued in one continuous piece. However, you can achieve the same effect sectionally as well. Just remember to leave extra lengths for gripping. When you pull the fiber from the ground, proceed slowly and gently so that you won't disturb the surrounding collage area. If any extra paper is released in the process of pulling the string, simply re-glue the area.

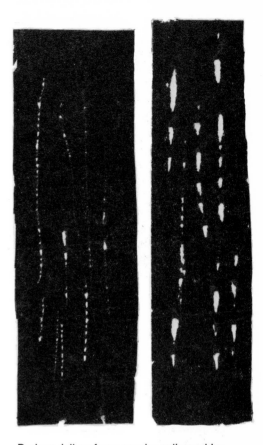

Dark or dull surfaces can be enlivened by jabbing with a sharp, pointed instrument held parallel to the paper and used to dig into it and lift it up. In the example on the left, fine line openings are made with a compass on a single layer of black tissue. For wider openings (right), increase the pressure on the compass.

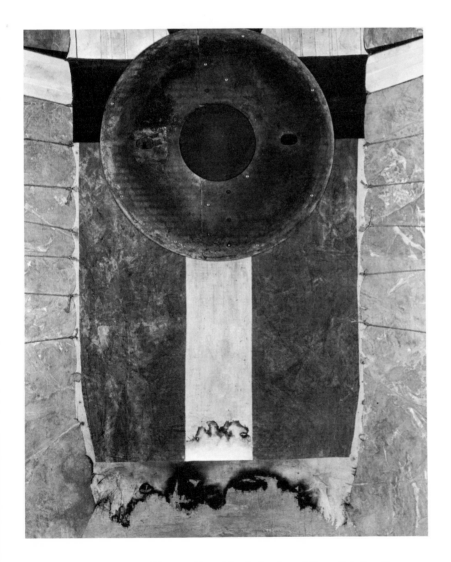

Thomas à Becket by Leo Manso. 48″ x 36″. Collection of the artist. Acrylic stained muslin, scorched canvas, and knotted string have been glued to a Masonite support cradled with wood. Over these materials, a round metal object, covered with cloth, has been bolted to the wood support. Modeling paste and spackle, used to build up textural areas, have been glazed with acrylic colors.

163

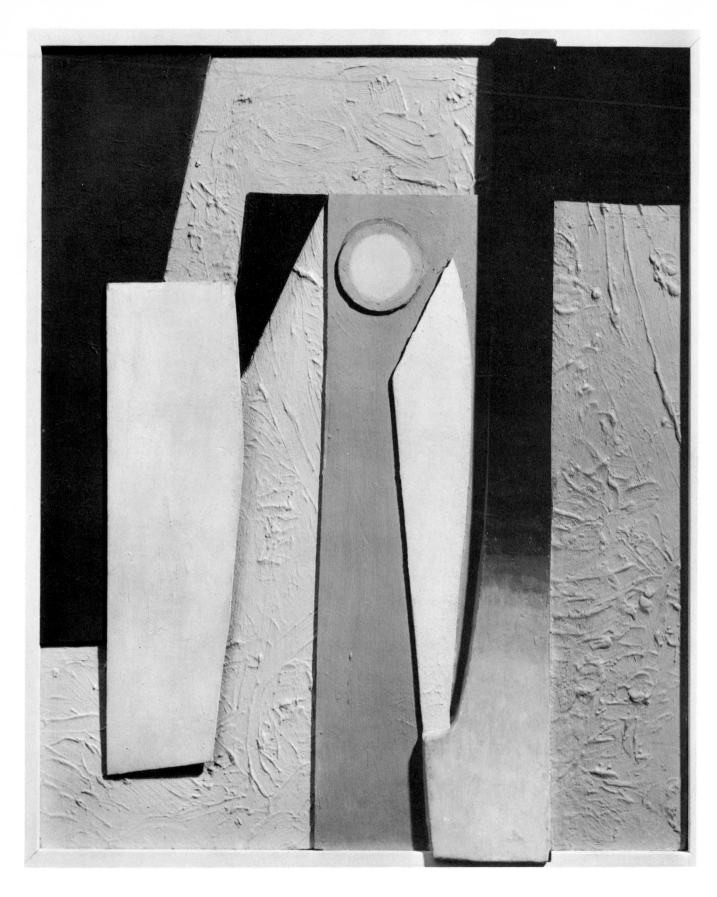

Pariser Frühling by Kurt Schwitters. 24″ x 19″. Courtesy, Sidney Janis Gallery, New York. In this textured relief collage, painted wood forms are attached to a board that has been brushed with oil in an impasto technique.

164

THE ACRYLIC GLUES which you've been using to paste your papers and cloths to grounds can be employed to create a rather unique type of material that can make an interesting contribution to your collage vocabulary. In Chapter Nine on tissues, you were introduced—though briefly—to a method of strengthening tissues and embedding bits of paper in emulsion that had been applied to glass. You might review that section because we'll go on from there. You learned that acrylic emulsions dry to a hard, transparent finish, leaving a protective, yet colorless, film on any surface. Were you to brush just the clear emulsion on glass, it would dry as a transparent sheet as thick or as thin as the amount of emulsion you'd applied. When dried and removed, the emulsion would feel rubbery. Indeed, you could actually stretch, tear, or cut it at any point.

EXPERIMENTING WITH ACRYLIC EMULSIONS

There'd be little point in preparing emulsion in clear sheet form, but let's see what happens when you combine acrylic polymer glue with materials such as papers, laundry shirt boards, dry color like pigment and scraped pastel, crayons, drawing inks, and acrylic paints. Though all the following techniques can be tried directly on your actual collage ground, I suggest that those of you who have limited experience make a few trial runs before you commit yourself to your final collage. The advantage to preparing forms in advance instead of creating them directly on the ground is that it allows you to explore possibilities while you compose. You're not definitely committed and can change your mind until you decide where your form functions best. When you try out your forms on a ground that's still slightly moist, place them lightly. Otherwise they may adhere, making removal difficult. Moreover, forms prepared in advance won't go to waste, for you can store them indefinitely in wax paper or aluminum foil until they're needed.

ACRYLIC EMULSION AND WET TYPING PAPER

To carry out the first experiment, you'll need acrylic emulsion. If you use the thick type, dilute it with water. Have several sheets of glass on hand to save time while waiting for the material to dry. Use paper that will show definite cracks (veining) when it's crushed. Ordinary white typing paper is well suited to this exercise.

Begin by brushing a thin coat of acrylic emulsion on the glass, spreading it to approximately the same dimensions as the sheet of paper you intend to place over it. Moisten (but don't soak) your paper and remove the excess water with a sponge, tissue, or toweling. Crush the moist paper so that it becomes thoroughly veined, flatten it, then place it over the emulsion-covered glass. Brush a second coat of emulsion evenly over the entire surface of the paper and let it dry. When the paper is dry, remove it with water and a razor blade, as directed in Chapter Nine on tissues. Store in wax paper or aluminum foil.

If you've crushed the paper firmly enough, the crushed or veined areas will become and remain transparent when the emulsion is

TEXTURING WITH ACRYLIC EMULSIONS AND PAINT

Typewriter paper, wet crushed to create veining, was then placed in acrylic emulsion. The crushed or veined areas become transparent when coated with emulsion. When glued to a colored ground, these transparent pieces of white typing paper will pick up and reflect the underlying color.

A

B

The acrylic emulsion technique works well on almost any fragile paper. Here, ordinary candy box paper is glued to a dark ground (A) to show its usual appearance. A single layer of the wrap (B) has been peeled off and dried in emulsion. Its pattern remains visible, yet the underlying black ground shows.

brushed over them. Moreover, the paper will be strengthened by the dried emulsion. When glued over a colored ground, these transparent areas on white typing paper will pick up and reflect the underlying color on the collage.

ACRYLIC EMULSION AND DRY TYPING PAPER

For your second exercise, use the same paper, but *instead of moistening it, keep it dry.* Otherwise, repeat the procedure by crushing, flattening, placing the paper over the emulsion-covered glass, and covering it with a second layer of emulsion. As you work with acrylic emulsion and typing paper, you'll notice that some areas of the paper remain opaque and solid looking, while other areas become transparent. Since transparency and opacity depend on how much you've crushed the paper (the more it's crushed, the greater will be its transparency when emulsion is applied), you can therefore control the results by the varying amount of pressure and moisture you exert over chosen parts of the paper.

Now proceed to experiment on your own, using colored papers and papers of varying thicknesses. Note that the crisper the paper, the better it responds to this technique.

USING FRAGILE PAPERS

Acrylic emulsions allow you to strengthen the most fragile papers in much the same way as you reinforced tissues. However, to strengthen particularly fragile papers without their disintegrating, your procedure is a bit different. Were you actually to brush a coat of emulsion over delicate paper, the likelihood is that it would fall apart. To avoid such mishaps, begin by brushing enough emulsion onto the glass so that when a fragile paper is placed over it, the emulsion will soak through the paper and actually cover its surface. Let the paper dry and remove it in the customary way.

This one-step acrylic emulsion technique can be used on a number of papers whose fragility warrants it. For example, Celotex wrap, a protective wrapping paper used to package breakable objects, is composed of several layers of finely spun, fibrous matter which separate easily. Peel off a single layer, dry it in emulsion, and it will remain transparent, gossamer thin, yet strong enough to handle with ease. Celotex so treated can be glued over any number of grounds.

The inner wrap in candy boxes, intended to keep candy fresh, is also composed of several easily separated layers. After a single sheet has been peeled off and allowed to dry in acrylic emulsion, its all-over, reversible pattern will remain clearly visible. Ordinary facial tissues, too, generally become strong and transparent when embedded in a layer of emulsion. Since facial tissues are usually manufactured in double thickness, separate them into single sheets. Oriental papers—even those as fine as lace papers—will respond favorably to an emulsion bath. And finally, any soft, absorbent paper, the weight of Japanese sketch papers, will become semi-transparent when placed in emulsion. For a more satisfactory result, moisten such papers thoroughly before you place them in emulsion.

POWDERED PIGMENT AND OTHER DRY COLORS IN EMULSION

Any material as fine as powder, dust, or hair, or as coarse as sand or even crushed marble can be enclosed within acrylic emulsion. For the first experiment, work with dry pigment. If you have none, then scrape the sides of pastel chalks to make a powder as a substitute for colored pigment. Begin by pouring or brushing emulsion onto a sheet of glass. If you prefer to pour, lift the glass and tilt it so that the emulsion spreads over a good part of its surface.

Now scrape your pastel chalks directly into the wet emulsion, or add dry pigment by tapping it on from a palette knife. Add more dry color, noting how it begins to swim about in the emulsion. If you've used only light colors, add some charcoal black for more dramatic contrasts. When completed, let the form dry, then lift it off the glass.

In an alternative procedure, repeat the entire process of adding dry color; then lift the glass and tilt it about in all directions, allowing the colors free play so that they move about and merge. Try this technique with acrylic emulsion applied in varying thicknesses. Thin layers of emulsion will react somewhat differently to dry color than thick layers will. In your experiments with these techniques, try working not only with multicolored pigments and chalks, but also with a single dry color as well which you may need at the same time.

Other possibilities include tapping gold or silver powder into emulsion, as with other dry pigments, or actually dissolving gold or silver powder, scraped chalks, and dry pigments in emulsion and then brushing this solution onto any surface. Also experiment with combinations of dry pigment or scraped chalk with crayon shavings, sand, or crushed marble. Having previously worked with cheesecloth, you might also like to try adding dry color over cheesecloth. It will easily adhere. I also suggest you test the effects produced when you add dry color to tissues. Tissues so treated can be used singly or can be glued one over the other for interesting textural effects that alternate with transparent areas.

CRAYONS AND ACRYLIC EMULSION

For this exercise, you'll need several ordinary wax crayons in good, strong colors. First add enough acrylic emulsion to your sheet of glass so that the emulsion is sufficiently thick to *enclose* the crayon shavings you'll be dropping into it. Then, with a razor blade or knife, shave the crayons directly from the sides of the crayon over the emulsion, cutting both fine and coarse pieces. If you wish, tip the glass to create patterns, then let the liquid film dry thoroughly.

Repeat this procedure, but instead of using glass, pour the emulsion directly onto a piece of cardboard. When I carried out this experiment, I used a gray laundry shirt board. I shaved the crayons into the acrylic emulsion applied over the board. Then, when the emulsion was thoroughly dry, I tore the area out of the board, exposing a lighter gray edge for a bit of contrast. Before I glued the form to my collage ground, I thinned the stiff board by removing some of the thickness from the reverse side to make pasting easier.

Drawing inks can be combined with acrylic emulsion and manipulated in various ways. Here the dried ink-emulsion form has been cut and torn.

This abstract ink drawing, opaque in some areas and transparent in others, has a fractured, striated appearance.

Ink diluted with acrylic emulsion can be painted directly on clean glass with any size brush. For ease of handling, add a coat of clear emulsion over the dried ink drawing before you remove it from the glass.

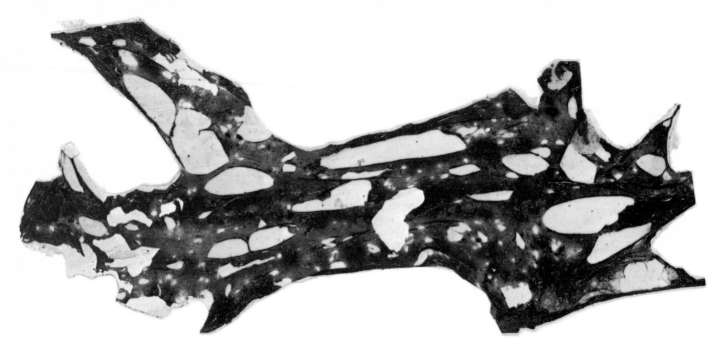

India ink, diluted with water has been added to acrylic emulsion, then stretched and torn after drying to create openings within the solid form.

For an interesting variation of the ink-emulsion technique, embed a sheet of tissue in acrylic emulsion (here, green tissue is used), then toss the ink over the paper. This effect can be carried out on tissue that has already been pasted to a ground.

INKS AND ACRYLIC EMULSION

India ink and other drawing inks can be combined with acrylic emulsion in the following way. First, pour some emulsion on glass. Dip a small, soft brush into the ink (black or other), and, with a sharp snap of the wrist, shake the charged brush directly into the emulsion. Tilt the glass to permit the ink to flow freely, adding more ink where needed. Allow the form to dry. Try this technique once again, but dilute the ink with water before you add it to the emulsion. You'll find that the ink flows somewhat more freely and also changes color slightly.

When these forms dry, you can pull, stretch, tear, or cut them at any point. This flexibility enables you to open areas within a solid form and thereby create a variety of shapes. You must be cautious, however. If your emulsion layer is very thin, it will curl, adhere to itself, and make separation difficult. To avoid this problem, use a generous amount of emulsion when you make the form.

For an interesting variation of the ink-emulsion technique, first adhere a sheet of tissue to emulsion-coated glass. Add an extra coat of emulsion. Perhaps you recall that in Chapter Three on found objects I could also create this effect directly on tissue that's already been pasted to a ground. A final technical variation can be achieved by diluting the ink with emulsion (two parts ink to one part emulsion). With this solution, you can paint directly on the glass with any size brush. When you apply ink in this way, *do not coat* the glass with emulsion first; if you do, the ink will be too runny. When dry, add another coat of clear emulsion to the surface so that you can handle the form with ease when it's removed from the glass.

ACRYLIC EMULSION AS CONNECTIVE TISSUE

In addition to its function as an adhesive, I like to think of acrylic emulsion as a connective tissue, or as a membrane capable of uniting and giving form to the most insubstantial material, as well as to material that already has body. With the help of emulsion, materials as fine as hair, feathers, or powder can be made into forms any size you like; and papers—no matter how small or diaphanous—can be strengthened and connected by placing them, side by side, in the emulsion. Perhaps you recall that in Chapter Three on found objects I mentioned paint scrapings as a possible collage material. With emulsion, you can combine your pieces of paint scrapings into colorful shapes. Thin Styrofoam sheets (used to cushion packages) can be cut into pieces, and the pieces then glued side-by-side with emulsion. To relieve the dead white for contrast, color the edges of the Styrofoam shapes.

ACRYLIC EMULSION AND ACRYLIC PAINTS.

You probably have some experience working with acrylic paints, which have a base similar to the emulsion you've been using. Because of this same basic chemistry, you can actually prepare a form in acrylic colors, just as you did with plain emulsion—by building up a form on

Instead of acrylic emulsion, you can also mix your colors with acrylic gel or modeling paste. In this example, a collage form has been made by combining white oil paint with acrylic modeling paste.

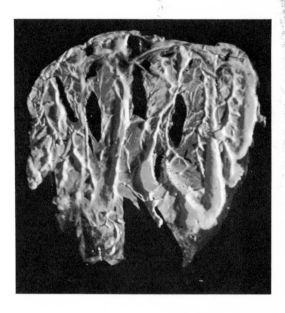

Though oil and water do not mix, oil and acrylic emulsion create the illusion of doing so. Here, white oil paint has been added to a small amount of emulsion and forced down with a palette knife so that the two "mix."

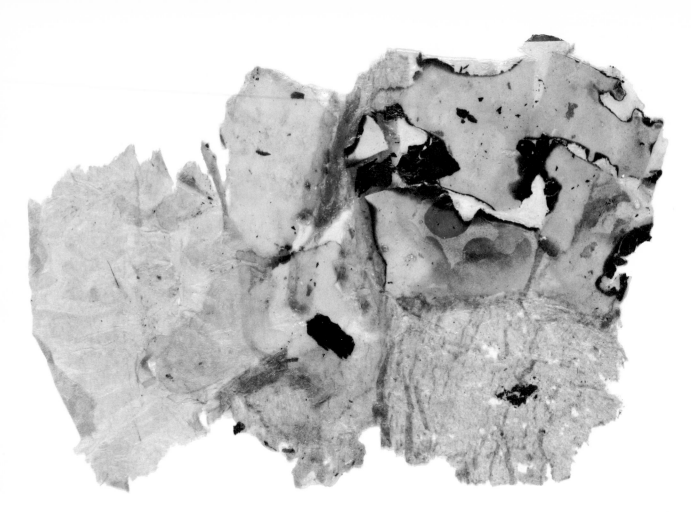

Burnt and scorched papers were combined with single sheets of Celotex and facial tissue and given form with emulsion.

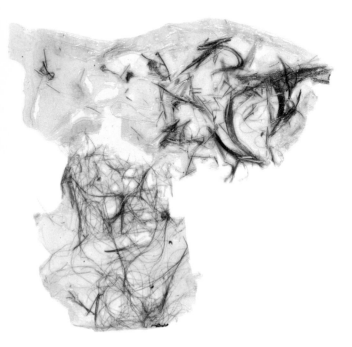

Human hair and seagull feathers are given form and unity by embedding them in acrylic emulsion, which acts as a membrane.

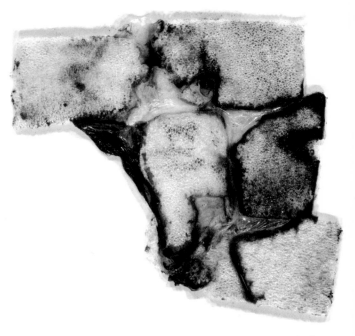

Pieces of ordinary Styrofoam have been joined in a single form with acrylic emulsion. To relieve the dead white, create contrast by coloring the edges of the Styrofoam shapes.

glass and peeling it away for pasting, or by pasting, or by applying acrylic paint directly to your collage ground.

The procedure for this technique is to brush a generous amount of pure acrylic color onto glass. Apply enough paint so that the dried form will be manageable when it's removed from the glass. If your layer of color proves too thin to remove, add a coat of acrylic emulsion, let it dry, then lift the form off the glass by wetting it to release it. Other than for thickening, no emulsion is needed with this technique.

You might be interested in trying one of the following variations of the above procedure. When the paint has dried a bit so that it's no longer runny, add other acrylic colors or inks over the original. Even when the form is completely dry or when it's been glued to the ground, you can still impose other colors over it or draw them on with inks. Another idea is to add gold spray color when the paint form begins to set. The spray creates an interesting effect which is somewhat different from the effect produced by brushing on a color. And to vary your acrylic colors, mix a little emulsion directly into the paint. Other variations may be tried by mixing casein color or gouache with acrylic emulsion. Instead of emulsion, you can mix your colors with acrylic gels. These gels can be added not only to acrylic paints, but to casein, gouache, and all water based paints as well.

Let me mention, too, that you can get some effects by "mixing" oil color and acrylic emulsion, though oil and water don't really mix. Add some oil color to a small amount of emulsion and use a palette knife to force (with ample pressure) the materials to "mix." Some of the emulsion will be lightly tinted by the paint, but most of the oil will separate into tiny particles. It is this very separation that causes an interesting and off-beat effect. Drying may take a bit longer because you're working with slow drying oil paint.

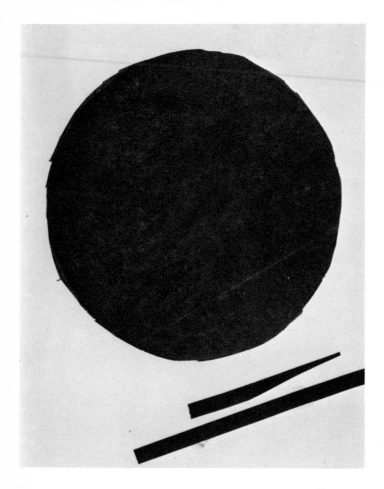

If you want a definite line of demarcation, cut a straight, hard edge (left). The same form, with torn edges (right) gives a feeling of vibration and movement.

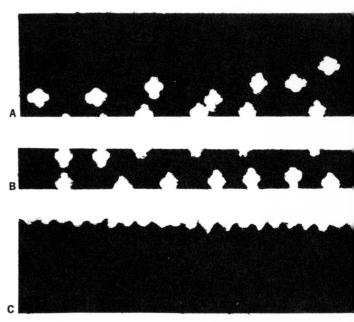

When textured Japanese papers are torn, they respond like cloth. In this illustration, Moriki paper, half waxed and veined, has been torn at the edges. The unwaxed edges have a soft, blurry appearance, which contrasts with the relatively hard torn edges of the waxed area.

The edges of paper can be cut in a number of ways to create pattern: punctured (A), notched (B), and pinked (C) examples are shown.

IF YOU WERE TO ADD strong color contrasts to the edge of a form of a work in progress, this contrast would affect both the form itself and the relationship of the form to its surrounding elements. Color, however, is only one of many means available for adding interest to edges. Edges can also be enlivened by adding texture, linear interest, or contrast; by introducing movement; by uniting small forms or breaking down non-functioning large forms so that their "inner edges" function more creatively. These devices will all affect the total picture resolution.

DIVERSIFYING AN EDGE BY CUTTING OR TEARING

You can easily cut or tear paper, cloth, leather, and other such materials. In your first collages, you probably cut your papers until you discovered that a torn edge is more interesting. Perhaps you also found out that thin, smooth paper doesn't tear as attractively as multi-ply, rough paper. Moreover, a paper that's multi-colored or different on each side produces better results when torn than more homogenous papers. Origami paper, for example, is frequently colored on one side only, with the reverse side left white. Consequently, when such a paper is torn, it will make a two-color edge. Papers that have been glued in color layers and then torn also create effective edges. Colored cardboard, illustration board, and poster board also offer contrasting edges when they're torn. Japanese textured papers, which tear like cloth, create frayed edges with threads of varying lengths. Weathered and torn billboard papers, too, can also add texture and visual interest to edges.

STRAIGHT AND UNEVEN EDGES

If you want a definite line of demarcation, cut a straight, hard edge. Such an edge has a particular relationship to the space and the forms around it which differs from a form of the same size whose edges have been torn. Uneven edges, by contrast, set up vibration and movement, creating variations in the space surrounding it and keeping the eye moving about more freely than is sometimes the case in a hard edge. When textured Japanese papers are torn, they respond like cloth: that is, the ends of their threads will vary in length and thickness. Some papers like Moriki will produce a fuzzy edge. When waxed and then torn, Moriki leaves an off-white marking at its edges which is an added design element.

CUTTING EDGES TO VARY THE PATTERN

Any cloth or paper can be altered in many ways so that the edges appear serrated, sawtoothed, pinked, jagged, notched, punctured, scalloped, frayed, or pulled (if it's woven from threads). Edges can be cut in triangles, punctured, or punctured and then cut through again for still another effect. To add a bit of pattern interest to an edge, you can cut any shape—curved or straight. Do so, however, in moderation: not every edge of every form should be altered. This is only effective if done with discretion.

Chapter Seventeen

EDGES AS TEXTURAL INTEREST

Two Natsume papers, one unwaxed (above) and one waxed (below) with torn edges.

A

B

Cloth can be altered in many ways so that its edges appear serrated, saw toothed, pinked, jagged, notched, punctured, scalloped, frayed, or pulled. The edges of the canvas cloth (A) have been frayed. For contrast, canvas cut with a straight edge is also shown (B).

Black drawing paper has been torn to create a form reminiscent of a Rorschach ink blot.

SUPERIMPOSING INTEREST OVER AN EDGE

In addition to changing the actual edge of any paper or cloth form, you can also vary its appearance by superimposing a cut-out along its edge. A cut-out that echoes the pattern of the fabric can be quite effective. A cut-out placed along the edges of forms can help unite them.

EDGES AND OVER-SIZED, NON-FUNCTIONING FORMS

When a very large form seems out of proportion to the rest of the composition, tear it into two or more parts or, if you have to, cut it. Lift and replace the parts, separating them so that the spaces between are uneven and on different levels. If torn, these edges will have a more vibrant influence upon one another and upon the rest of the composition. If tearing isn't possible, scrape the cut edge with a blade.

FOLDING AN EDGE

You can create textural interest on a paper or cloth edge simply by folding it over. The heavier body of the folded edge not only adds texture, but also contributes deeper tone interest because the doubled edge will produce a shadow effect.

USING STITCHED CLOTH FOR DESIGN INTEREST

Stitched cloth can function like drawing as a design element. Discarded fabrics with hems, edges, zipper, and seams, for example, may provide you with ready-made edges. You'll frequently find that such discards have been sewn with colored threads that add needed contrast to a work in progress. If not, you can create this contrast yourself by stitching an edge on any piece of fabric. Even a simple running stitch or chain stitch will add texture and movement.

OTHER IDEAS FOR EDGES

Many of the techniques and suggestions made previously in this book also apply to edges. For example, the gathered and fluted effects described in Chapter Twelve on cloth are perfectly adaptable to treating edges. Furthermore, almost any medium can be used to add color to an edge—oil, watercolor, gouache, acrylic, ink, and other such media are all suitable. And, of course, you can smoke, scorch, and spray edges for additional interest. Oil in water prints, monoprints, magazine papers, and newspapers can be cut and used for edges. Sand, marble dust, and other granular materials will also add texture to edges. Apply sand or similar material along the edge in the same manner you're accustomed to using—by adding a coat of acrylic emulsion to the surface and then sprinkling on the sand.

A bit of billboard paper that I discovered offered a ready-made edge (probably made by weathering) that was ideal to use for separating two forms. Corrugated board also makes an exciting collage material because it can be cut and torn to produce many different effects as an edge or for larger forms. Its natural color blends well with

A square of black drawing paper is torn vertically, moved apart, and glued to a white ground. The outer hard edges contrast nicely with the inner soft edges which stand out dramatically against the sharp white ground.

Red cardboard is torn to reveal its white interior, then glued over black cardboard, the torn edge of which is barely allowed to show.

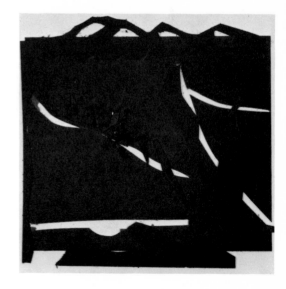

Instead of actually altering the edge of the material, you can change its appearance by superimposing cut-outs over the edge. Here cut-outs along the edge of russet paper echo the interior black forms and unite the composition.

A

Textural interest can be created on paper or cloth by folding. The heavier body of the folded edge contributes not only texture, but also tonal interest, where the doubled edge makes a shadow effect. These examples are all paper; the technique is equally suitable for cloth.

B

Overly large forms that cannot successfully function can be torn or cut into any number of parts, then replaced to work more creatively. The effect of the torn edge (A) differs considerably from the cut edge (B).

Scorched paper edges add pattern and color to an otherwise minimally interesting form.

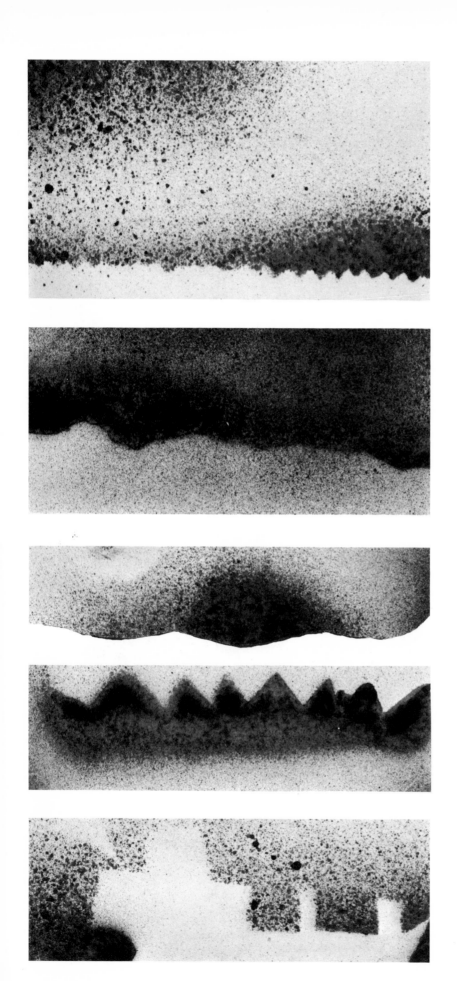

Papers can be sprayed at the edges for any number of effects, with or without stencils or objects for additional pattern.

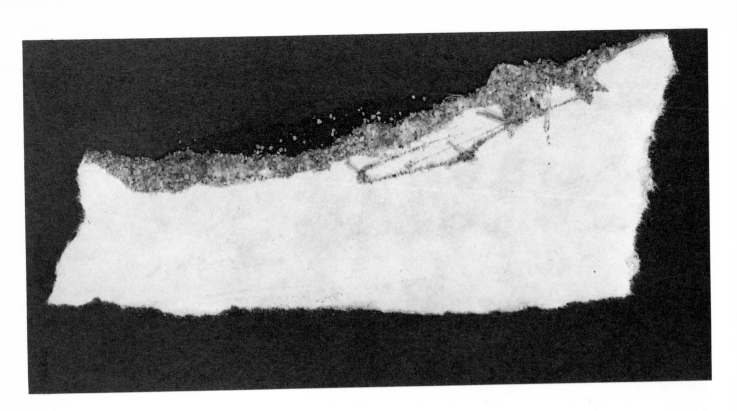

Sand, glued along the edge of a paper form, adds texture, color, and pattern to an otherwise plain surface.

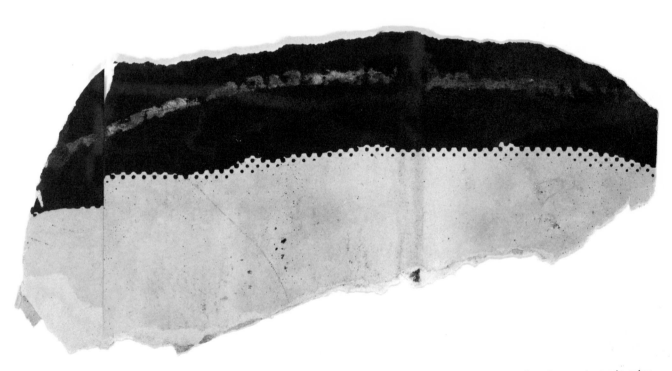

This piece of billboard paper, a found material, offered a ready-made edge that was probably produced by weathering.

many papers and cloths, yet it can be easily painted over when called for.

Before a canvas, paper, cardboard, or other such form is placed on a collage ground, you can edge its underside with paint, then place the form in position. When pressure is applied to the form, paint will squeeze out from under the edges, producing still another edge variation. Let the paint merge with other forms or control it as tightly, as you wish. Look for interesting found materials in paper or cloth that may add excitement to your collages.

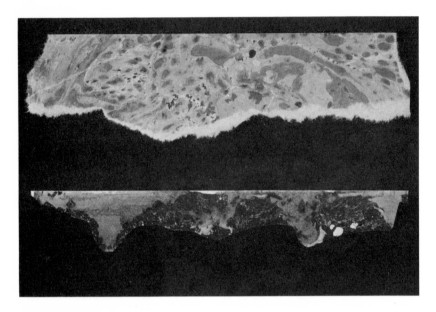

Oil in water prints have been cut into narrow strips to use as edges. Monoprints, rubbings, magazine papers, and newspapers are equally suitable.

Stitching on cloth can function as a drawing in terms of a design element. Three simple stitches here add texture and movement.

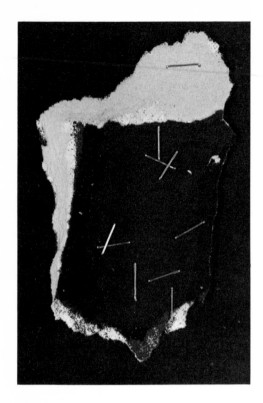

Staples can be used on cloth, paper, leather, cardboard, and plastic to introduce pattern and texture. The effect on cardboard is shown.

Erasable typing paper has been crushed and opened, then colored by brushing pastel over the striated and uneven surface. The pastel must be sprayed with fixative to prevent smudging.

Inexpensive drawing paper is crushed, then colored with oil crayon and pastel combined. Oil crayons are more suited to the crush and brush technique than wax crayons because the oil variety is softer and therefore easier to rub on.

I'VE ALREADY DEVOTED a good deal of space to considering the question of texture. The preceding chapters have included techniques for you to duplicate, as well as suggestions for you to try yourself. Perhaps they've also set your creative faculties in motion so that you've made some rewarding discoveries of your own. Before I consider the subject closed, however, I'd like to share a few miscellaneous ideas for texture that you may also find helpful.

STAPLES FOR TEXTURE

Two types of staplers—one ordinarily used for clipping papers together, the other for sealing packages—can be used to introduce pattern and texture to cloth, paper, cardboard, leather, and plastics. The paper stapler is suitable for preparing these materials in advance, while the package stapler can be used directly on a collage which has already been pasted on a heavy ground such as wood or other similar material. Hardboard such as Masonite, however, cannot be stapled.

The limitations on the size of a collage material which can be stapled depend on the size of the stapler you're using: a long stapler will reach further into an area than a smaller one. This limitation can be circumvented, however. Material that's being prepared in advance can be stapled in small pieces and then enlarged by stapling or gluing the smaller pieces into a larger one.

CRUSH AND BRUSH TECHNIQUE

This simple procedure permits you to add color over the striations that are made when coarse, heavy, or stiff paper is crushed. Over these striations you can rub or brush color in any one of several media, including paint of all kinds (fast drying ones are better), pastels, oil crayons (they're softer than wax crayons and rub on more easily), pencils, and colored marking pens.

It's possible to get a variety of markings that range from fine to broad lines, depending on the texture of the paper. Coarse, stiff paper that's been crushed will remain visibly marked, whereas soft, absorbent paper will not. Erasable typing paper, mimeograph paper, inexpensive drawing paper, and shelving paper are all suitable.

In the crush and brush technique, begin by crushing your paper very firmly so that it's well marked—even to the extent of crumpling it into a ball. Flatten the paper, but don't smooth it out; you want the markings to remain visible. Moreover, the more crushed the paper is when you apply color over it, the less color is likely to contact the ground of the paper behind the veining. Some color will rub onto the ground, nevertheless—but not enough to interfere with the total effect.

ADDING COLOR

To add color with an oil crayon, hold the side of the crayon parallel to the surface of the paper, then rub gently over the crushed area, using a back and forth motion. At first, the color will reproduce very lightly, but if you continue in the same way, it will deepen. Pastels

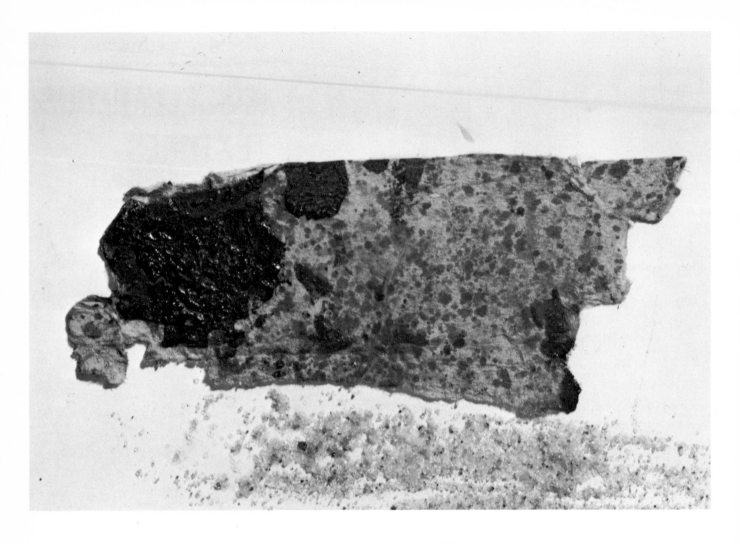

Don't overlook the possibilities of found materials in your repertoire of textural devices. I retrieved this throw-away—wrapping paper covered with tar markings —and simply added a border of sand.

The subtle texture and soft tones of this striped paper are the result of mildewing. Billboard papers, posters, layered papers of different colors, and the like can be made into unique collage materials by allowing them to mildew.

rubbed onto the surface of the paper will produce an immediate effect. Be sure to spray all pastel with fixative to prevent it from smudging and rubbing off. Acrylics and other fast drying colors should *not* be diluted for this technique; diluted acrylics will run. Use a moderate amount of color on the brush; hold the brush on its side, parallel to the paper; and stroke on the color. Oil colors may also be used, but be sure to take their longer drying time into consideration.

Once a color is dry, any other color in any other medium may be added to the background between the veined markings. If you use pencil for crush and brush, select a very soft lead and apply it in a manner similar to crayons and pastels. Felt and nylon marking pens can also be used.

FOUND MATERIALS

Be on the alert for materials of any sort that may be considered "ready-made" for your use. For example, I found a piece of paper that had evidently been used in connection with roofing tar. These accidental tar markings on the brown wrapping paper combined attractively with sand, crushed marble, wrapping paper, and various oriental papers that related in tone.

MILDEWED PAPERS

A gifted artist-photographer whom I know prepares papers for collage in a rather unique way. Using billboard papers, poster papers, layered papers of different colors, and the like, he proceeds to wet them in sea water. He then rolls these wet papers tightly and leaves them in a dark, airless closet over the winter months. During this time they mildew or mold so that the following spring he has a batch of very interesting papers ready for use. The usual pastes and emulsions can be used for gluing and preserving mildewed papers.

RUSTED TIN CANS

The same artist subjects ordinary tin cans to the mildew process. He removes both ends, flattens the tin, wets it in sea water and permits it to rust. The tin then assumes a most attractive patina of rust colors. Tins can be nailed or epoxied to a ground. One can superimpose acrylic paints, Craypas (pastel crayons that need no fixative), and other paint media, including oils. An inexpensive tin shears (purchased at a hardware store) will cut tin.

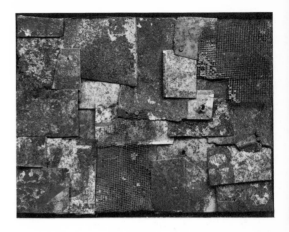

No. 2-1967 by Henry Rothman. 6″ x 8″. Collection, Mr. & Mrs. Zero Mostel. The artist reclaimed rusted tin cans from the beach, cut off their ends with tin snips, flattened the metal, then attached it to Upson board with nails and cement. Pieces of rusted screen have also been used. Craypas accents in orange, blue, and green contribute color.

Stone Drawing Interruption by Mary Bauermeister. Courtesy, Galeria Bonino, Ltd., New York. Stones and shells embedded on a wood support are interspersed with ink drawings and illustrations cut from magazines. A second layer of shells and stones is glued to a sheet of Plexiglas, which is placed over the wood, several inches from this ground, to create a feeling of space and dimensionality. Black, white, and the natural colors of the materials predominate.

THE MOST VALUABLE SUGGESTION I can make is that you try any ideas that occur to you. Don't be impeded by conventions that dictate what materials are and aren't compatible. Many of the discoveries I've made came from my determination to see what would happen if I tried unlikely combinations. Often, while experimenting with one idea in mind, I accidentally came upon unexpected, but exciting results. For example, when experimenting with hot and cold wax, I knew that waxes and drawing inks might not merge. I followed through anyway and discovered that this anticipated separation created a beguiling effect.

KEEP NOTES

It's wise to keep notes of the materials, techniques, and procedures you've used in a given collage in the event that you wish to duplicate a particular effect. Write these notes directly on a sheet of paper taped to the rear of the collage.

MAINTAIN SPONTANEITY

When planning your collage, you can maintain more spontaneity if, instead of permanently gluing your papers as you compose, you add only enough glue to place these materials temporarily. You're then free to rearrange your materials until you're committed to a particular composition.

TACK COMBINATIONS ON WALLS

When color or textural combinations strike you, tack them on your walls for future reference. Seeing them about as you work on other collages puts you that much ahead when you're ready to use them.

KEEP SKETCHES

Don't throw out your quick sketches from your student pads. Instead, tear them up and use them in collages, placing them in any order or juxtaposition you wish. De Kooning and Dubuffet are known to use figure sketches in this way, realigning the pieces so that they become formal design elements in their compositions.

LOOK OVER YOUR STOCK OF PREPARED MATERIALS

It's wise to look over your stock of prepared materials from time to time—oil in water prints, monoprints, wax papers, etc. This kind of review will help you to develop a visual memory so that you'll remember the exact material you need for a work in progress.

IMPROVE YOUR COMPOSITIONS

Beginners who'd like to improve their skills in composing can try transposing reproductions of famous paintings into collages. Though your choice is wide, it's wise to select reproductions whose forms are

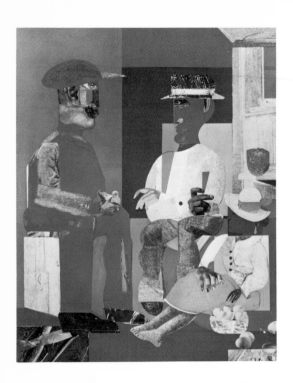

Eastern Barn by Romaire Bearden. 55½" x 44". Collection, The Whitney Museum of American Art, New York. This highly stylized, realistic collage is composed of magazine papers, photographs, and solid color art papers glued to a Masonite ground.

simple, large, and well defined. You might choose a Klee, Miro, Picasso, Braque, Matisse, or any contemporary painting. Using a very soft pencil, trace the contours and forms of the painting on tracing paper or wax paper. If you hold the reproduction and the tracing paper against a window pane, the light will illuminate the painting through the paper and thereby make tracing easier. When you've finished tracing, rub the drawing directly onto your collage ground. To do this, place the tracing face down on the ground and clip it in place to hold it firmly. With the back of a spoon, the side of a pencil, your fingers—in short, any instrument that will facilitate the rubbing process—briskly rub the back of the drawing to transfer it to your collage ground. The result will be a mirror image of your tracing. Unclip your drawing and develop your traced collage as you please, either by trying to duplicate as closely as possible the colors and textures of the original, or by using the original merely as a point of departure, making your own conscious choices regarding color and texture.

For a beginner, these exercises are valuable aids in helping you to understand basic structure, color relationships, and other problems of composition. Whether you actually work from reproductions or just study them, you'll be sped on your way towards more individualized collages as you develop your confidence and understanding.

ARRANGE FORMS IN YOUR COLLAGES INVENTIVELY

When arranging forms in your original work, overlap them, tear them, interlock them at various points, texture the edges, break up large, dull forms, and unite small detailed forms. All these devices will bring excitement to your work.

LIMIT YOUR MATERIALS

Don't use too many different types of material in the same collage. Instead, limit yourself to three or, at most, four and see how inventively you can use them. Beginners will find their work less confusing if they restrict the number of materials they work with.

MAKE AND USE CARDBORAD MATS AS A SCREEN

Cardboard mats can be used to help you select sections of paper for texture and color. That is, if you screen part of a sheet of paper or cloth by holding a mat over it, you can frequently find the best sections—ones that will contribute the most contrast or excitement to your work.

To make a simple mat for this purpose, use white cardboard, 6" x 8" or longer, that's no heavier than file cards. File cards, which can be easily cut with a scissors, are more convenient than mat board, which requires cutting with a mat knife. With this material, cut four L-shaped pieces similar to the sample corners a framer shows you when you're selecting a mat to frame a picture. These loose corners can be arranged as a screen to isolate a large or small area of a picture or a sheet of paper. The same mats can help you spot trouble areas in a collage, if you test your work in progress from time to time.

DEVELOP A CRITICAL EYE

The mat can be used as a device in the following exercise to help you develop a critical eye. Set aside three or four papers or other collage materials which vary in color and texture, yet which relate to one another. Since these materials won't be pasted down on a permanent ground, any board, piece of cardboard—even your table—will do as a support for this exercise. Freely toss your papers, one after the other, onto this support. Now arrange your mat over the papers to frame them. Study the result.

How could you improve this accidental composition? Are your shapes monotonous because they're too even? Can you change the size of a shape by overlapping it? Is one shape too large in proportion to the rest of the composition? Would it help to use the ground color as a shape by allowing it to show through? Is the space between your shapes too regular? Could you improve your color relationships by replacing the forms? Would a solid color or the use of a non-textured paper give relief to an otherwise busy area? Can you add directional movement by arranging a designed paper in conjunction with a line drawing? Can you repeat this movement elsewhere? Would your papers be more exciting if torn? Would surface texture help? A few such "self-help" exercises will deepen your understanding of the elements necessary for successful composition.

TIPS ON FRAMING

Glass isn't necessary to frame collages whose surfaces have been given a coat of acrylic emulsion or wax—as long as the collage materials have been glued to a firm ground. A collage made on hardboard may sometimes present a framing problem because it's impossible to drive nails into the relatively thin board. If you prefer to use stripping as a frame for a collage on a hardboard ground, you must glue a narrow wood frame behind the board, aligning the frame precisely flush against the outer edges of the collage. The stripping is then nailed to this wood frame where it meets the hardboard edge.

Since hardboards have become a popular artist's ground, more frames are now available for them than ever before. You can choose from narrow and wide frames, with or without inserts (a narrow strip that lies against the collage). Some frames are covered with white, gray, or tan linen mats. All types are available at professional frame shops. If you prefer, the stripping previously described can be purchased from molding dealers. Refer to the classified directory.

Recently, a stainless steel frame (which you put together from simple instructions) has appeared in art supply stores. They're available in many different sizes at a rather modest cost.

Any collage that's been made on a ground that's considered impermanent should either be transferred to a hard ground or framed under glass. Though many artists use glass, I prefer to avoid it whenever possible. There is a non-glare glass available, but be prepared for the fact that it tends to subdue colors.

What color mat or molding you choose is purely a personal matter. However, there should be some relationship between the over-all color of a collage and the color of the mat or wood molding.

Constantinople by Saul Steinberg. 22″ x 14¼″. Courtesy, The Betty Parsons Gallery, New York. The artist has combined watercolor and India ink with stationery, collage prints, labels, and the imprints of rubber stamps.

LIST OF PAPER SUPPLIERS

Your local art supply dealer purchases his papers from several sources. However, most of his imported papers come from special paper houses to which you, too, have access. Such paper supply houses offer you a far greater choice of papers (particularly oriental ones) than your local dealer is likely to have. Below are some of the paper companies in cities across the country. The list is by no means complete. For additional suppliers, refer to the yellow pages of your local telephone directory.

CALIFORNIA
Los Angeles: Max Flax, 10864 Lindbrook Drive; Zellerbach Paper Co., 4000 E. Union Pacific
San Francisco: Phillips Art Supply, 121 O'Farrell St.; Yasutomo, 24 California St.; Zellerbach Paper Co., 245 S. Spruce St.

DISTRICT OF COLUMBIA
Washington: George Muth, 1332 New York Ave.

ILLINOIS
Chicago: Carpenter Paper Co., 723 S. Wells St.; Regents Prod. Co., 251 East Grand Ave.

INDIANA
Indianapolis: Nationwide Paper Co., 151 S. Neal Ave.

KANSAS
Topeka: Nationwide Paper Co., 223 Kansas Ave.

MARYLAND
Baltimore: Barton Duer & Koch Paper Co., 81 W. Mosher St.
Cheverly: Barton Duer & Koch Paper Co., 2420 Schuster Drive

MASSACHUSETTS
Boston: Hatfield Color Shop, 59 Boylston St.; Tileston Hollingsworth, 211 Congress St.

MINNESOTA
Minneapolis: General Paper Co., 155-26 Ave. S.E.

MISSOURI
St. Louis: Tobey Fine Papers, 1424 Talmadge Ave.

NEW YORK
New York: Andrews/Nelson/Whitehead, 7 Laight St. (Minimum order required.)

PENNSYLVANIA
Philadelphia: Garrett Buchanan Paper Co., 10th and Spring Garden; Masters Art Supply, 730 W. Carpenter Lane

TEXAS
Dallas: Nationwide Paper Co., 1435 Motor St.
Houston: Nationwide Paper Co., 303 E. 66 St.

WASHINGTON
Seattle: Nationwide Paper Co., 1020 John St.

INDEX